THE COMPLETE GUIDE TO
DRAWING MANGA

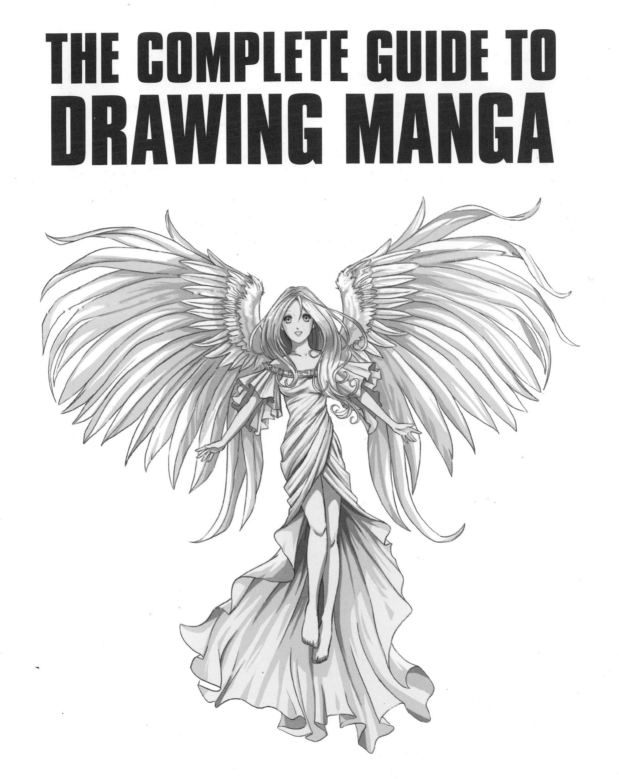

Marc Powell and David Neal

ARCTURUS

WITH THANKS TO ODA, STEVE, AILIN AND PAT

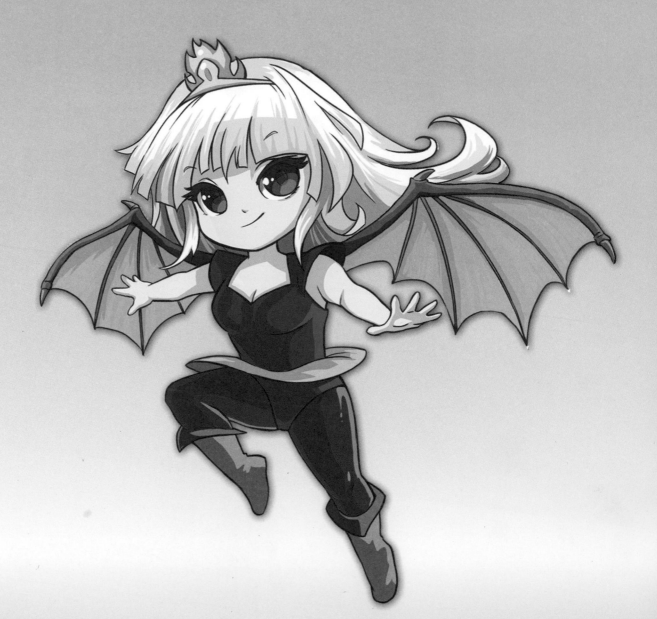

ARCTURUS

This edition published in 2014 by Arcturus Publishing Limited
26/27 Bickels Yard, 151–153 Bermondsey Street,
London SE1 3HA

ISBN: 978-1-78404-045-1
AD004102UK

Printed in China

CONTENTS

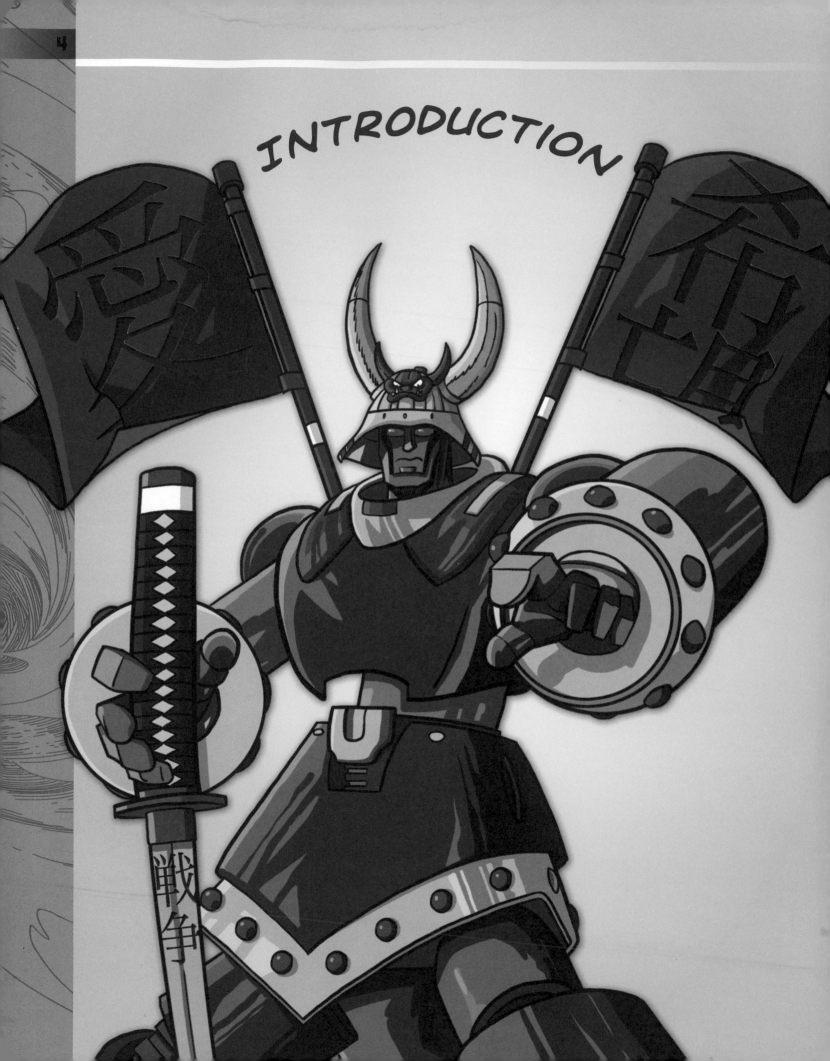

INTRODUCTION

*I*n this book, you'll find everything you need to know in order to draw manga characters successfully. Using a simple step-by-step system, we'll walk you from the start of a basic stick figure right through to fully coloured, dynamic pieces of art that you can be proud of.

We don't just stop at characters, though – we'll show you how to do everything, from creating amazing locations for your characters through to mastering panel layouts for your comic pages and composing perfect scenes. Throughout the book, we'll also give you specific tips related to different genres, along with handy mini-tips from our artists to make life easier as you move through the amazing world of manga.

So, pick up your pens and pencils and get ready to enter a world of mutated monsters, manic martial artists and all manner of characters in between!

HOW TO USE THIS BOOK

This book has been organized using a simple step-by-step system with seven stages from start to finish. Each step is layered over the previous one in a different colour, so you can easily see the new pieces that have been added at each stage. Of course, you don't have to use different-coloured pencils for each stage.

Stage 1
The basic stick figure of your character.

Stage 2
Fleshing out the basic stick figure.

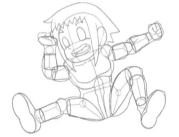

Stage 3
The completion of fleshing out and the addition of extra details.

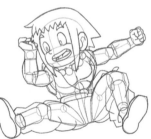

Stage 4
The completion of clothing and any accessories.

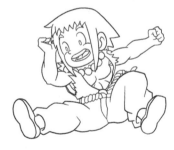

Stage 5
The inking stage, which will give you a final line drawing.

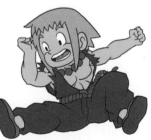

Stage 6
'Flat' colouring, using lighter shades to set the base colours of your character.

Stage 7
Adding shadows for light sources, using darker colours to add depth to your character.

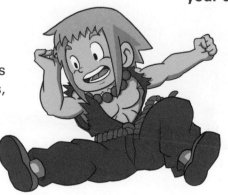

BASIC TOOLS

You don't need lots of complicated, expensive tools for your manga images – many of them are available from a good stationery shop. The others can be found in any art supplies store, either on the high street or online.

Pencils

These are probably the most important tool for any artist. It's important to find a type of pencil you are comfortable with, since you will be spending a lot of time using it.

Graphite

You will be accustomed to using graphite pencils – they are the familiar wood-encased 'lead' pencils. They are available in a variety of densities from the softest, 9B, right up to the hard 9H. Hard pencils last longer and are less likely to smudge on the paper. Most artists use an HB pencil, which falls in the middle of the density scale.

Graphite pencil

Mechanical pencil

Mechanical pencils

Also known as propelling pencils, these contain a length of lead that can be replaced. The leads are available in the same densities as graphite pencils. The great advantage of mechanical pencils over graphite is that you never have to sharpen them – you simply extend more lead as it wears down.

Ballpoint pen

Marker

Inking pens

After you have pencilled your piece of artwork, you will need to ink the line to give a sharp, solid image.

Ballpoint pens

Standard ballpoint pens are ideal for lining your piece. However, their quality varies, as does their delivery of ink. A good-quality ballpoint pen will serve you much better than a collection of cheap ones for delivery of a consistent quality of line-work.

Marker pens

Standard marker pens of varying thicknesses are ideal for colouring and shading your artworks as they provide a steady, uniform supply of ink and can be used to build layers of colour by re-inking the same area. They are the tools most frequently used for manga colouring.

White vinyl

Erasers

Everyone makes mistakes, even the world's greatest manga artists! That's why a good eraser is essential. You can buy soft, kneadable putty rubbers that you can shape to erase either small or large areas and, of course, the traditional all-purpose hard eraser is still available. A good eraser is one known as a white vinyl, which provides the right balance of gentle erasing with minimal crumbling of the eraser and without damaging your paper.

Standard eraser

Putty rubber

Templates

Very few people can draw a perfect circle freehand, so a set of circle templates is a good buy. If you don't have any templates, you can draw round various everyday items such as coins, cups and bottle lids to create your circles.

TYPES OF PAPER

The array of paper that is available can seem confusing when you're choosing a surface for your art. Your paper selection will depend on how you want your final piece to be used. Thicker papers are best for presentation pieces and posters and add a high-quality finish to your piece.

Try feeling the thickness of papers by taking the corner between your thumb and middle finger and gently flicking your forefinger across the corner of the paper. If you do this with different papers, you will soon develop a feel for the various weights.

Layout paper

Any piece of paper can be used as your layout paper. Inexpensive paper is the best choice as you will be using this paper for planning out your ideas and maybe doing sketches of heads, bodies or even hand poses before you decide on your final piece of art.

Watercolour paper

If your final piece is to be coloured, watercolour paper is the best choice as it holds colour well with very little bleeding from your original lines. It's available with a choice of surfaces — smooth, slightly textured and very textured — and you can use whichever appeals.

Cartridge paper

Paper for drawing can vary in price from expensive, extremely high quality ranges to more cheaply produced pads. Price is not always an exact guide to a better paper, though, and buying the most expensive paper will not make the lines you put on it any better!

Advanced tools

The following are considered slightly more advanced pieces of equipment and are not necessary for you to start drawing. However, they are worth investing in if you plan to do more advanced work.

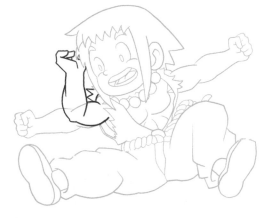

Blue pencil

These pencils are often used by artists for planning out their work, as a light line with a blue pencil won't show up when photocopied or scanned into a computer. It therefore allows the artist to try different poses or change entire body parts as he or she progresses from their rough ideas to the final pencil piece. Blue pencils can also be inked over without any problems, unlike a normal pencil.

Fine line pens

Drawing manga can involve a lot of precise detailing work, especially for clothing and hair. It's important not to make your lines too heavy or variable when drawing these details, and fine line pens will help your inking maintain a consistent line weight. They are available in varying nib thicknesses, from 0.005mm for extremely fine lines up to 0.8mm for something closer to felt-tip pen thickness.

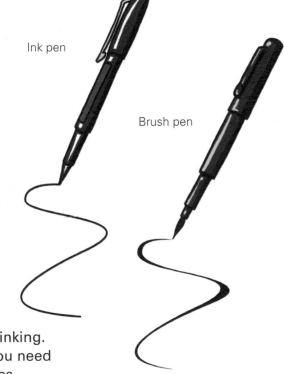

Ink pen

Brush pen

Brush pens

These drawing tools are like felt-tip pens except that they have a brush rather than a nib. You can vary the thickness of their line by the amount of pressure you apply. They can be great for flowing clothing and hair and all types of inking. The trick to mastering a brush pen is practice, as you need to learn how the brush reacts to pressure and angles.

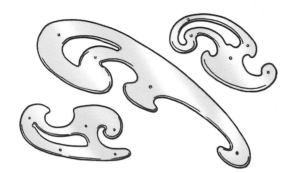

Curves

A set of artist's curves is an inexpensive aid to drawing curved shapes of various sizes and angles. Many sets of curves include circular templates cut out of the centres of the curves so they can be used for drawing circles too.

MANGA STYLES

To some people, all the images from the manga and anime industries look very similar and they dismiss the genre as simply one of cute characters with big eyes. However, that's very far from the truth. Just as the comics industry in the West has a wide variety of different styles and target audiences, so too does the world of manga. Here are a few of them.

Kodomo

The kodomo style began in the late 19th century as a way to teach Japanese children literacy skills. Aimed mainly at younger children (*kodomo* is the Japanese word for child), the stories have a strong moral basis for teaching right from wrong. Most kodomo stories are self-contained, single-issue or single-strip stories, though a few of them consist of episodic stories that run from issue to issue.

Kodomo characters are usually cute animals or chibi-style figures with small bodies, large heads and big, shiny eyes.

Shõnen

In Japan, *shõnen* means a boy's comic. Although the genre has existed since the 18th century, shõnen manga saw a rise in popularity from 1895 onwards, with its biggest boost coming in the 1950s and beyond, which carried it to the huge market it commands today. The stories are mainly based on male lead characters, singly or in teams, working towards bettering themselves. The aim is to inspire the target audience of boys aged 13 and older. The themes of shõnen manga often include fights, giant robots, science fiction and mythological monsters.

Shojo

The first *shojo* (little girl) magazines appeared in about 1903 and the genre grew from there. The late 1960s saw a significant change in the artists producing shojo-based work, with women beginning to take the lead in what had been, until then, a sector of manga dominated by male creators.

Shojo manga is primarily aimed at girls aged 10–18 years old. Even though the target age group suggests a light tone, the stories can cover anything from historical drama to science fiction. Unlike the other manga genres, shojo doesn't follow a particular style but instead focuses on the interests of its target audience. Lead characters may be male or female, and stories traditionally focus on romantic relationships or emotions. Recent years have seen a shift to stories based more around self-fulfilment and strong emotional bonds between female characters.

Seinen

The late 1960s saw the creation of the *seinen* (young men) genre in response to the growing domination of the marketplace by the shōnen style of manga. As the shōnen readers began to reach adulthood, it was realized that a new style was needed to cater for this older market and their interests.

Young men aged 18–30 years old are the primary target of seinen manga, although the genre has also been marketed to businessmen aged 40-plus. Because it is focused more on storyline and character interaction than action, it is easily confused with the shojo genre. Subject matter can range from comedy to more mature references, with everything in between.

Josei

Josei (ladies' comics) manga appeared in the 1980s in response to a demand by female office workers for manga relating to situations they encountered in their own lives. Because the content covered realistic themes rather than the idealistic relationships found in shojo manga, sales were slow at first. As the genre expanded to cover more mature themes and storylines, sales increased to the point where josei now has its own related sub-genres.

Josei reflects its much older target audience, with a life-like and sometimes more graphic approach to romance and relationships than its younger shojo compatriot. With a female readership aged 15–44, it's surprising that more recently the content has featured all-male casts rather than the expected female lead characters. Unlike the other genres, josei has not really gained popularity in the West, possibly because its themes do not translate so well for Western consumers.

PICK AND MIX

Just because a genre is dominated by a certain type of character, it doesn't mean you can't mix things up a bit. There's no reason why you can't do a shojo mecha or an angel in a kodomo style – or, if you are feeling really daring, why not try a mecha angel in the josei style?

SCALE: DRAWING FIGURES

Scale is important when drawing your characters. If the size of the upper body is out of proportion with the head or lower body, the viewer's eye will instantly detect that something about the image looks wrong, no matter how detailed or colourful the art.

An easy guide is to measure your characters by 'head height'. This means drawing the basic size of the character's head, then taking the measurements from that size. For example, a normal adult human is about seven heads high.

As you can see from the scale guide here, the distance from chin to waist is about two heads in height; from waist to ankle is around three heads; and the ankles and feet measure one head, making a total of seven heads.

When you are drawing a female character, the smaller head height will give you a slightly shorter character, while still maintaining the seven-head-height rule.

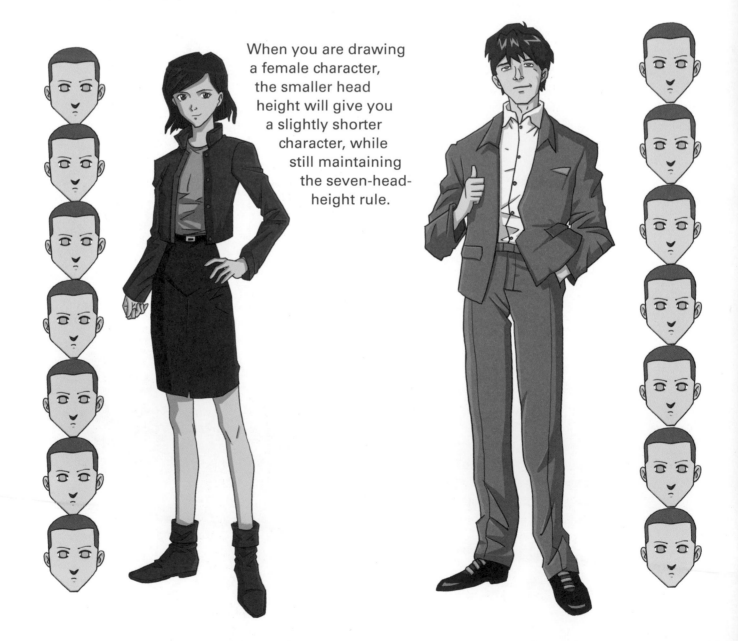

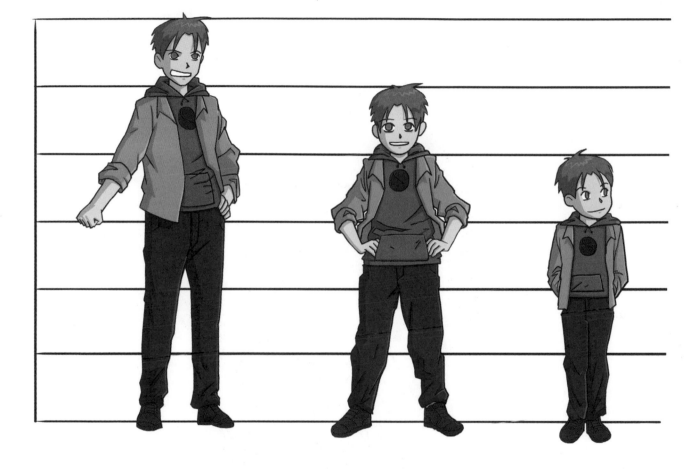

AGES 13+ AGES 8-12 AGES 5-7

When it comes to drawing children, proportions change as the head is initially much larger in relation to the body. However, sticking to the head-height rule will help you once again. Here we have three ages of children so you can see the variation in their proportions. As the child grows up, the scale gradually becomes more adult.

Chibi characters

Of course, matters of scale get a little more complicated when it comes to chibi characters, as their cuteness is based on the oversized head in comparison to the rest of the body. An average chibi is a total of two heads in height, with one head from the top of the head to the neck and one from the neck to the bottom of the feet.

As with all rules, there can be exceptions, such as larger heads which don't match up evenly to the two-head rule. As long as you remember that the oversized head makes the cuteness of the character work, you can't go too far wrong.

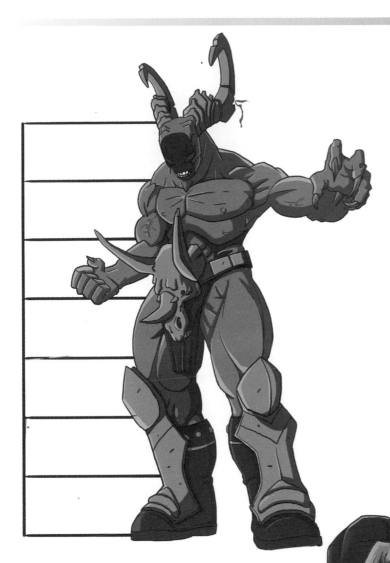

Scale: monsters

When you are drawing monsters, the same head-height rules apply. However, since monsters, demons and so forth are creatures of fantasy, you can play around with the proportions to give them a look that is even more distanced from reality.

A humanoid-type monster, drawn observing the head-height rule.

This creature departs from the head-height scale.

BASIC STICK POSES

For artists, a stick figure is the starting point for any character drawing as it provides the basis for its form and pose. This is a little more elaborate than a basic stick figure, as it is jointed and has some breadth and form so that it resembles the human skeleton. By using this construction you will be able to pose your characters in any position, while still managing to keep them looking natural and realistic.

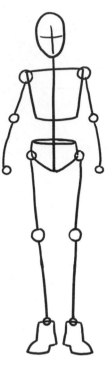

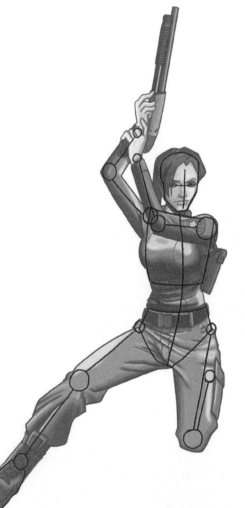

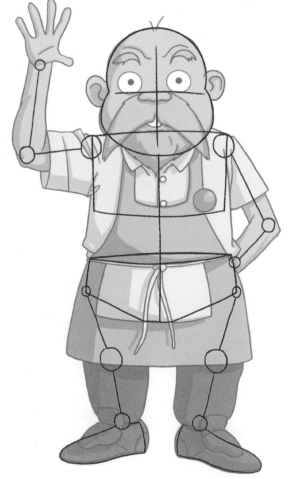

See how the stick figures of these two characters differ, with one in a basic standing pose and the other with more action.

Stick figures allow you to get your pose exactly how you want it; they enable you to make changes at the outset so that you don't have to alter your fully fleshed-out drawing. Practise drawing stick figures in different poses until you feel comfortable doing them, before moving on to a finished drawing.

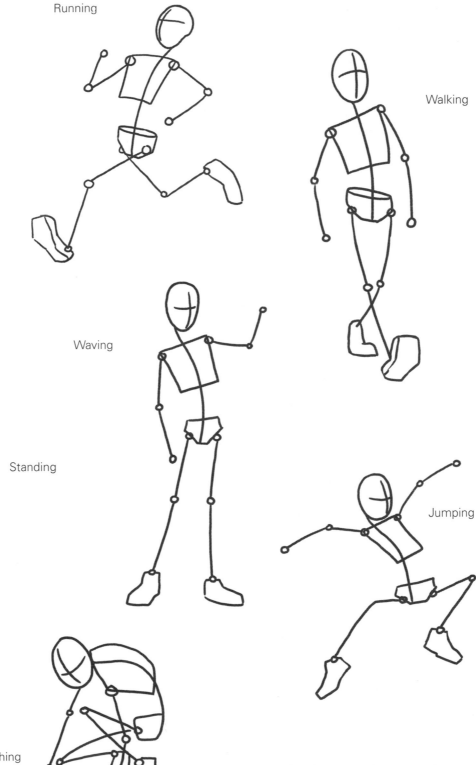

Running

Walking

Waving

Standing

Jumping

Crouching

Here are some basic poses for general use. See the next page for more action-based poses to try out.

BASIC STICK POSES: ACTION

Once you feel confident in your ability to draw basic stick poses, it's time to add a bit of action to your rather static-looking figures. You won't find it too difficult to pose your character however you want, whether that be fighting, jumping, diving or flying.

Punching

Kicking

Using the jointed stick figure will help you to keep everything in proportion in the different poses. Notice how the arms and legs apparently vary in length as you change their angles. This is known as foreshortening and, if done correctly, can add punch to some very dynamic poses. You'll find more about foreshortening on p.32.

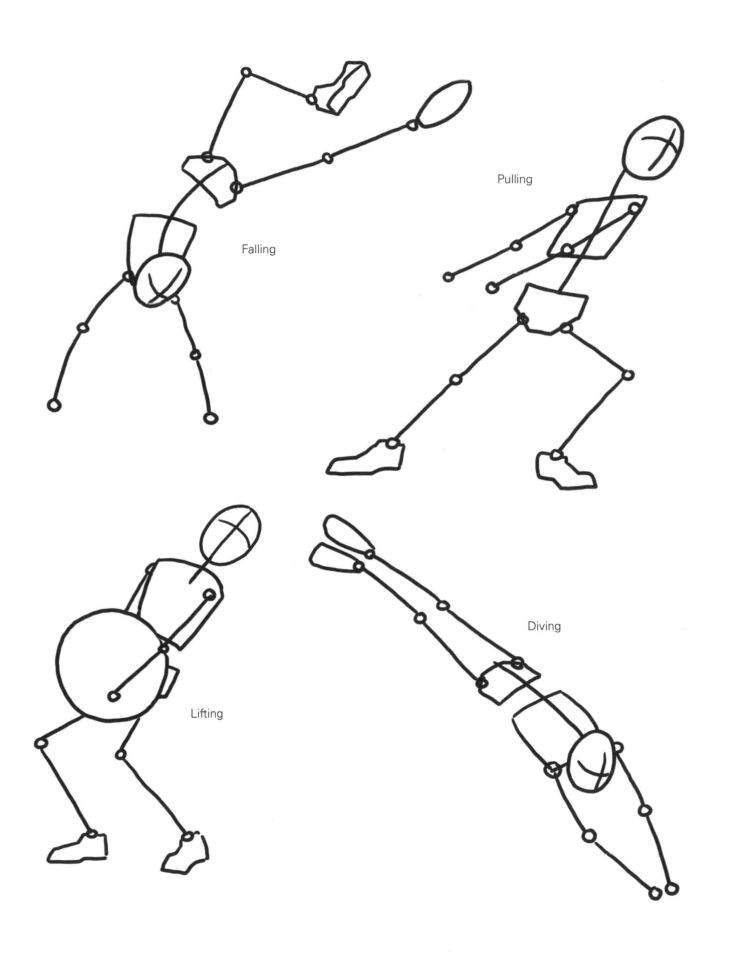

Falling

Pulling

Lifting

Diving

BASIC ANATOMY

A basic knowledge of anatomy is vital to any artist. Understanding how a body moves and pivots at its various joints, as well as the placement of muscles and how they work, will help you to pose your characters in convincingly realistic ways.

Torso

The torso is based on an inverted triangle; remembering this will help you greatly when you are adding muscle.

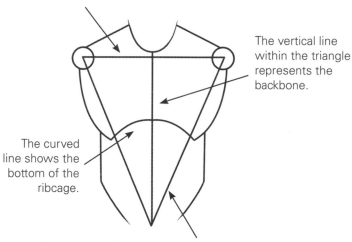

The top line represents the collarbones, which connect to the shoulders on either side.

The vertical line within the triangle represents the backbone.

The curved line shows the bottom of the ribcage.

The bottom half of the triangle marks out the area for the abdominals.

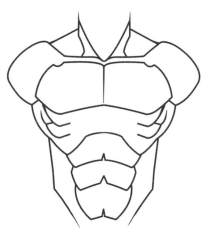

Here's how the muscles fit within the triangle.

The arms

The main aspects of the limbs are the muscles and the pivot points they control to make the limbs move. Remembering the pivot points will help you avoid drawing unnatural limb shapes and poses.

Each muscle operates the ones below it. The shoulder controls the bicep and tricep; the bicep controls the forearm; and the forearm controls the hand.

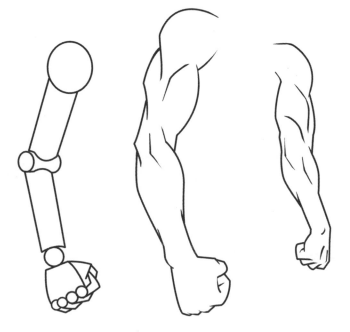

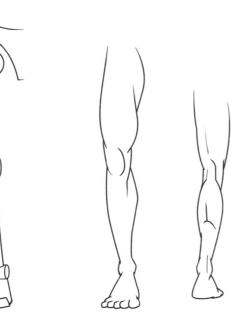

The legs
Like the arms, the legs work on the principle of muscles relating to crucial pivot points. Again, the larger muscles are at the top of the limb, getting smaller as they move down towards the foot.

MUSCLES
Notice how the leg and arm are very similar in their muscle structure. The muscle groups sit on either side of the pivot point, with the larger muscles at the top and the smaller muscles below the central pivot point.

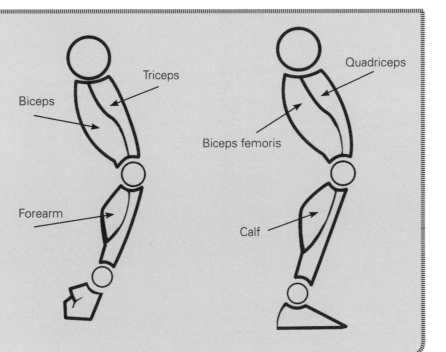

Triceps

Biceps

Forearm

Quadriceps

Biceps femoris

Calf

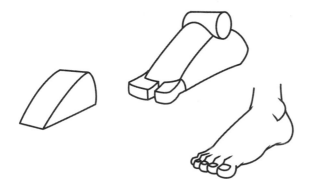

Feet
When you're drawing feet, think of a wedge of cheese as your basic starting shape.

MONSTERIZATION

Manga teems with demons and beasts of every description. These amazing creatures can spring from wherever your imagination takes you, as you can easily take basic human figures and turn them into monsters.

Horrible heads

The characteristics of the human face are so familiar that even slight changes to what we expect to see will help to bring out the beastly side of your creations.

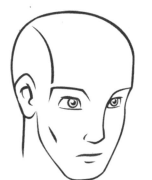

A basic human head is your starting point for creating something monstrous.

Shading can produce hollowed-out eyes and misshapen teeth.

You can warp the shape of the skull and add horns.

Brutalize features by giving your character a strong brow-line and outsized jaw.

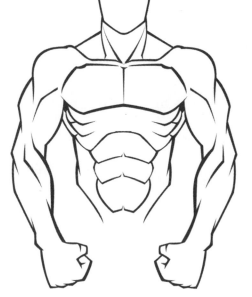

Beastly bodies

Most things in nature grow in a way that is based on symmetry. This means that when we see something that is lopsided or asymmetrical we tend to regard it as odd and somehow wrong. You can use this to your advantage in any beast design. Mutation is another way of making an effective monstrous figure.

Using what we already know of anatomy, we can play with proportion to emphasize the power of a character. Here, large shoulders and forearms hint at the beast's brute strength, but because they remain symmetrical the image doesn't look too unsettling.

Mutated anatomy

See how the additions we have made to a basic body shape have created something monstrous.

Place things such as eyeballs or bony protrusions out of their natural position.

Try swapping hands for claws or long, spindly talons, or introducing elements from other creatures.

Only slight adaptations are needed to transform a normal arm. The hand is replaced by a talon-like thumb and two long fingers from which the wing membrane is suspended.

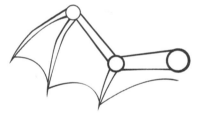

This wing has similar pivot points to a human arm.

Time for tentacles

Multiple tentacles can be confusing to work with. The trick is to draw each one as a simple line before thickening them out. From that point, if you treat each strand as a three-dimensional tube you will find it easier to visualize the form as it twists and overlaps itself.

EYES

The eyes play a major part in manga and many people will recognize the style of the eyes before they identify other aspects of a manga character. The tips here show you how to position the eyes correctly and how to master the intricacies of designing eyes to give them maximum impact.

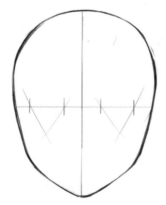

Creating eyes

First draw a basic face shape and divide it in half horizontally and vertically. Mark the outer and inner edges of the eyes along the horizontal line. Once you have the two marks for each eye, draw angled lines to form a V-shape below the eyes. Where these points cross will be the lower edge of the eyes.

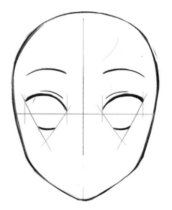

Create curves above and below the horizontal line to mark out the upper and lower eyelashes. Add another pair of curves higher up for the eyebrows – remember that these can change depending on the expression you are drawing.

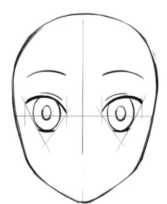

Use curves on each eye between the two eyelashes to form the main shape of the eyes. Mimic a smaller version of the curve to form the pupils. Notice how the curves stay within your guidelines and how the eyelid overlaps the iris of the eye a little to give a relaxed look to the expression.

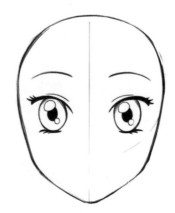

Draw smaller circles overlapping the pupils top and bottom and leave those white to show light bouncing off the surface of the eye. Thicken the lash lines and add a few upturned lines at the outer edge to show the lashes.

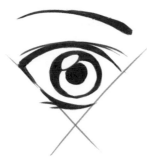

Leaving white space all the way round the iris will create a surprised or scared expression.

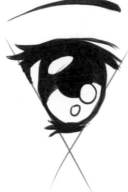

Shading the top part of the iris indicates the shadow created by the upper lid and lashes and gives more depth to the eye.

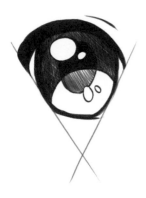

Large pupils and irises combined with plenty of light reflections are a good way to make the eyes look cuter. This is typical of the chibi style of manga.

A deep curve like this with a little flick at the end is the way to draw a typically manga-style, happy, closed-eye expression. Combine it with a big grin for maximum effect.

Adding lots of little lines within the iris is an easy way to create more natural-looking eyes.

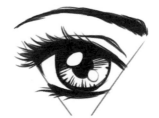

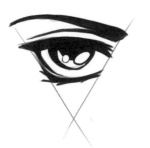 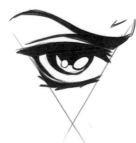

Bringing the inner edge of the eyebrow closer to the top of the eye will create a sultry or frowning look. Exaggerating the angle of the eyebrow will create an angry or calculating expression.

HAIR

There are so many ways of drawing hair that they could take up a whole book on their own. You can just do basic shapes and add simple lines to define the flow of the hair, as you will see in many of the illustrations in this book, or you can draw more elaborate hair which will really add to your character.

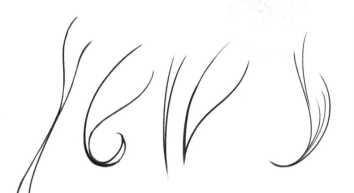

Manga hair can be very complex, but you can break it down into basic shapes to make it easier to draw. These shapes can vary in size, shape and thickness; they are often thicker at the top and curve at the bottom to create depth and volume.

You can combine these basic shapes to arrive at something that more closely resembles hair. The more strands you add, the more detailed the hair becomes.

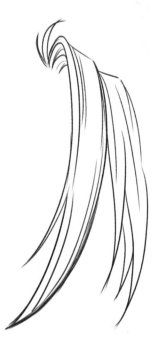

The hair can be long and flowing or short and spiky.

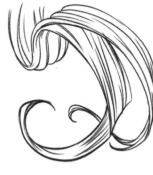

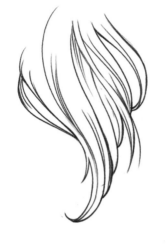

Strands of hair naturally overlap and twist across one another. This helps with the illusion of movement in your drawing and gives it a three-dimensional feel. Make your hairstyles interesting by creating lots of twists and curls.

If you are depicting a character in dynamic motion, draw the lines of the hair in the direction of movement.

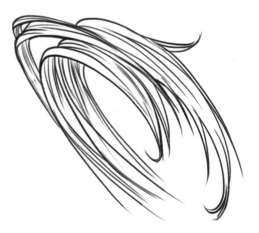

Here is a simple, neat way to create a finishing edge to hair if you don't want spikes or curls.

EXPRESSIONS

Almost any face can be completely transformed by some simple changes to eye and mouth shapes to convey different emotions.

A simple way to practise is to draw a basic head shape a number of times. Look at yourself in the mirror as you pull faces; note down the different shapes of your eyes, mouth and so on and try out different combinations on your artwork to see how closely you can match your own expressions.

Here are some simple facial expressions to show you how to make your characters display their emotions.

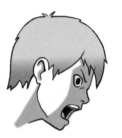

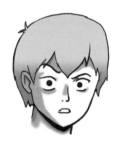

Anger
Angling the eyebrows down, narrowing the eyes and making the mouth into a thin line will give your character a look of seething anger as if they are about to explode.

Surprise
Raised, pointed eyebrows coupled with wide eyes and an open mouth shape make your character look like they have been caught off-guard by something.

Embarrassment
A slightly wide-eyed look and subtle shading across the nose and cheeks (use a pale red tint if you are adding colour, to hint at blushing) create a feeling of embarrassment for your character.

Happiness
Narrowing the eyes and adding a wide smile gives the effect of the character's cheeks rising as part of the smile without you actually having to draw the cheeks.

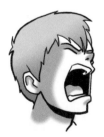

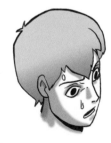

Sadness
Tilting the head down and closing the eyes will show sadness, while adding streaks of tears down the face will really hammer the emotion home.

Goofy
One eye closed and the tongue popping out will give your character a completely goofy look.

Rage
A step up from anger, rage is expressed by more defined eyebrows and a much more open and angled mouth.

Fear
Wide-open eyes and large pupils, as well as a partly open mouth, illustrate fear.

Head shapes

A character's head shape can indicate a lot about his or her personality – for example, jovial shopkeepers can be happy and round-faced, while villains in manga tend to have more pointed, narrow faces.

There are three basic shapes to start with when drawing heads: squares, circles and triangles. Experimenting with the different shapes can create some unique characters. Remember to bear in mind the character of your subject and try to lean towards using the traditional shape that's appropriate – though of course it's ultimately your artwork and if you want to create a character with a happy, round face who shocks everyone by being totally evil, that is up to you!

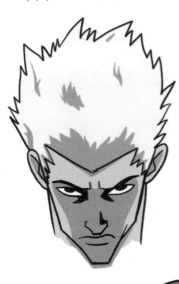

Triangular
Heads with sharp, pointed angles are good for villains. The sharp, angled style also lends itself well to drawing elves and other magical folk.

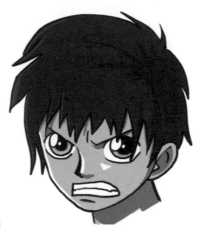

Oval
A lot of manga faces are based on the oval; it's a versatile shape for both male and female characters.

Circular
Comical characters are usually depicted with circular heads. The circular shape means you won't need a lot of definition in the face, but you'll need to concentrate on the eyes and mouth a lot more in order to convey the character effectively.

Square
Square, angled cheeks and chins and an overall square look to the head are useful for creating muscular, beefy, but not too smart henchmen.

PERSPECTIVE & FORESHORTENING

Artists use a number of tricks to help build depth and make characters seem much more solid and real. Among them are perspective and foreshortening.

Perspective helps you to create distance in your images and gives the impression that a two-dimensional drawing is actually three-dimensional, turning it into a true piece of art.

Foreshortening takes perspective a step further and allows the warping of your images to create realistic movement, allowing your characters to 'come off the page' more.

The rules for both of these techniques can be easily remembered with the acronym SOS – size, overlap and surface.

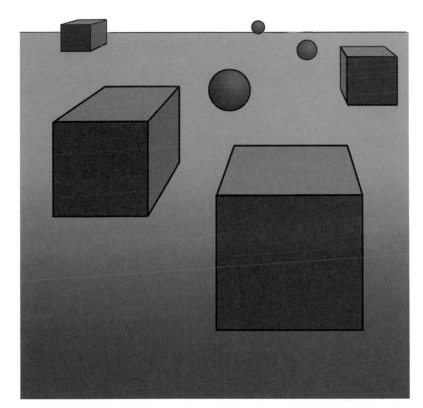

Size
Objects that are closer to you will always appear to be larger than items that are further away. Notice how the items in this image give the impression that they are at different distances from the viewer, just by virtue of their size.

Overlap
Items in front of one another look nearer to the viewer and overlap items behind them. Adding a simple amount of overlap to an image can make it appear more convincing.

Surface

The viewer will see mainly the front surface of an item that is straight ahead on their eye level. Little can be seen of the top surface of this cube, but its presence gives depth and solidity to the image.

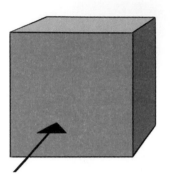

Here the same cube is viewed from a higher viewpoint with an arrow showing the angle of vision.

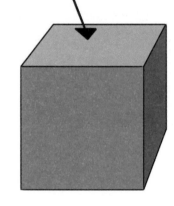

When the cube is viewed from a higher eye level, the size of the top surface increases.

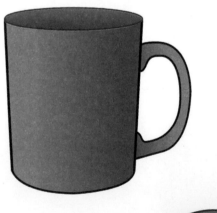

Foreshortening

The term foreshortening refers to the way an object appears to change shape and size when it is seen from a different angle. Artists use this visual trick to create the illusion of depth and give weight and three-dimensional effects to what is actually a flat piece of artwork.

A simple way to see this is to take a cup and look at it from directly above. You will see a circle. Now tilt the cup away from you and you will see the circle becomes an oval.

Let's take a simple head shape, on which we have placed construction lines. Notice how the features of Head 1 are all in the expected proportions, since it is directly vertical, looking straight towards you. When the head is tilted back (Head 2), the top half of the head looks smaller, as it is further away, while the lower part appears larger because it is closer to you.

Perspective and foreshortening are useful tricks to learn. There are many ways of creating perspective in your drawings. We shall look at more of these on pp.248–9.

HEAD 1

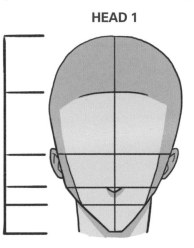

HEAD 2

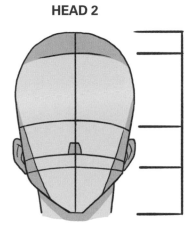

As with all drawing, practice is key. It is worth drawing simple shapes many times from different perspectives until you understand how to use these techniques to fool the viewer's eye into seeing depth and dynamism in your artwork.

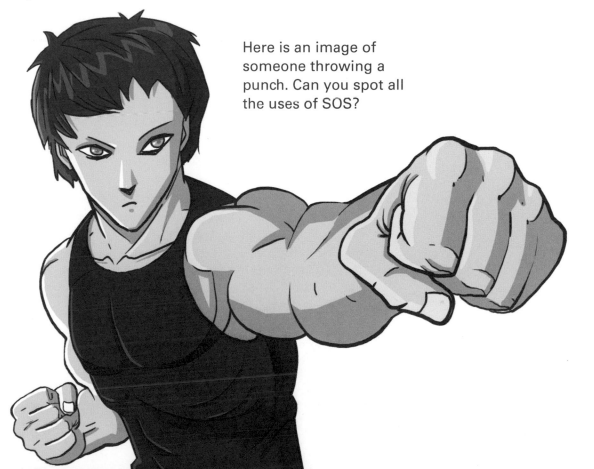

Here is an image of someone throwing a punch. Can you spot all the uses of SOS?

ADDING EXCITEMENT

The easiest way to add movement and excitement to your images is to use effect lines. These appear much more in manga than in Western-influenced comic artwork and are an important part of the manga artist's storytelling toolkit. Effect lines in manga can be broken down into two categories: focus and motion.

Focus lines

If you want to draw attention to the actions or emotions of a character, an effective way to do this is to add focus lines – straight lines of varying widths radiating out from a single point.

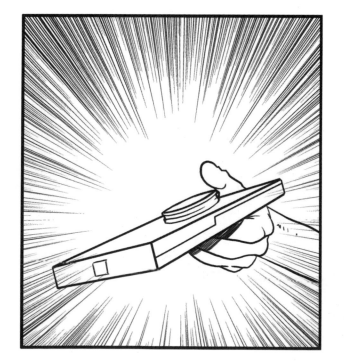

In the two examples here, the left-hand image shows someone holding a control button of some type. The addition of focus lines immediately adds drama to the piece and makes the button seem much more important, as if the character is about to press it and set off something devastating.

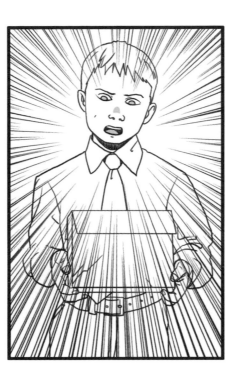

Emotions play a large part in manga artwork and focus lines can be used to show a wide range of them by drawing the reader's eye to the character's reaction.

These panels show a character with a package he has just discovered. See how much more surprised he seems by the contents with focus lines added.

Drawing focus lines

Focus lines are simple to draw and work best as a starburst-type effect. The centre of the starburst is the part of the image you want to draw attention to. Here are some examples of focus starbursts.

ARTIST'S TIP

Try laying a thin sheet of paper over your original picture and experimenting by drawing focus lines of different thicknesses on the overlay.

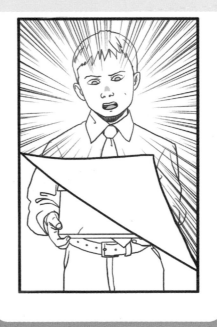

ADDING MOVEMENT

Motion lines are a very important way of adding movement to your illustrations. They become even more significant if you are drawing an entire strip rather than just a single image.

Motion lines can be applied simply to show a character taking multiple actions in a single panel. On the left, the character is turning her head and dropping an item.

Increasing the amount of motion lines shows speed and power.

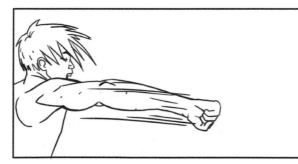

Motion lines should follow the direction in which the object is travelling. Here the motion lines make the image look as if the fist is moving from the left to the right.

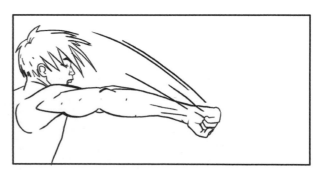

By changing the angle of the lines, but not the actual image, the fist has become a downward-swinging punch.

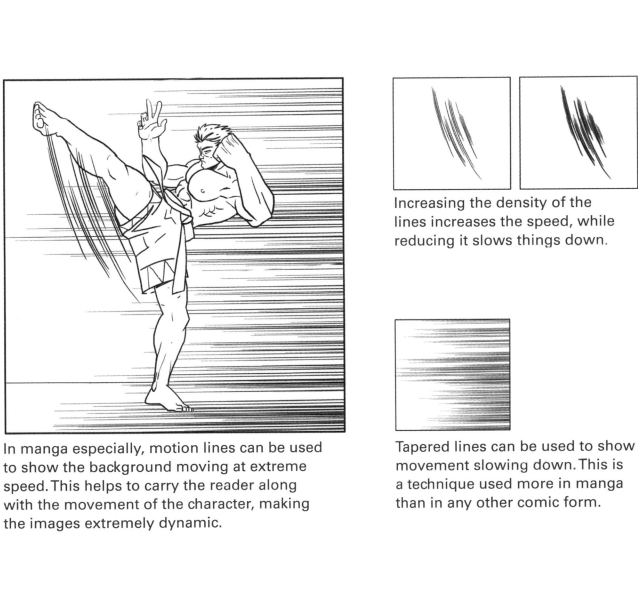

In manga especially, motion lines can be used to show the background moving at extreme speed. This helps to carry the reader along with the movement of the character, making the images extremely dynamic.

Increasing the density of the lines increases the speed, while reducing it slows things down.

Tapered lines can be used to show movement slowing down. This is a technique used more in manga than in any other comic form.

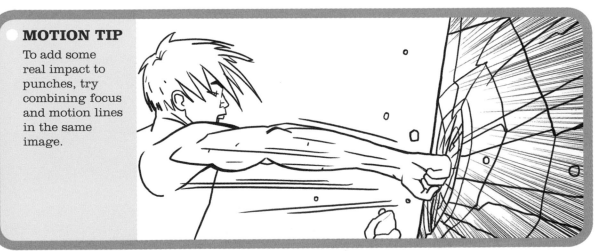

● **MOTION TIP**

To add some real impact to punches, try combining focus and motion lines in the same image.

POWER KICKS

A large proportion of manga involves hand-to-hand combat at some point. The question with static images is how to communicate the power and speed that characterizes these encounters. In the first of our handy tips pages we'll show you how to add some real power to your combat sequences.

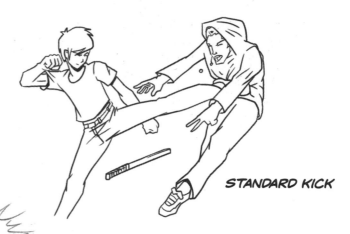

Here we have a powerful kick to an attacker. While it looks cool, it lacks power and impact. Overall, it is a static image.

STANDARD KICK

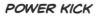

POWER KICK

Now look at the image and see how much more action, movement and impact it conveys. By not showing the entire leg as it strikes the opponent and leaving a blank area at the point of impact, the artist allows the viewer's imagination to fill in the impression of energy and power.

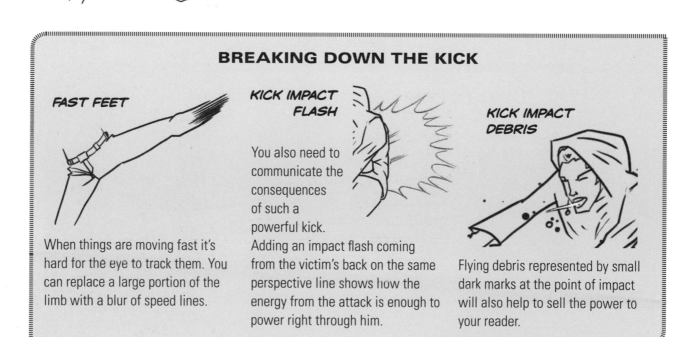

BREAKING DOWN THE KICK

FAST FEET

When things are moving fast it's hard for the eye to track them. You can replace a large portion of the limb with a blur of speed lines.

KICK IMPACT FLASH

You also need to communicate the consequences of such a powerful kick. Adding an impact flash coming from the victim's back on the same perspective line shows how the energy from the attack is enough to power right through him.

KICK IMPACT DEBRIS

Flying debris represented by small dark marks at the point of impact will also help to sell the power to your reader.

ADVENTURE

Whether hunting for lost treasure, protecting a town from a gang of bandits or sailing the seven seas, adventure covers a wide range of subjects and characters.

Many of the characters are most comfortable when drawn in the Shonen style, as the context and situations in which these characters mostly appear is ideal for boys aged 13 years and older.

Prepare to enter a world of rugged heroes, deadly gang members and girls who can certainly look after themselves.

TIPS AND TRICKS

Adventure manga can be a fast and frantic genre. Here are a few handy tips to help give your art more impact.

Action panel to panel

Because you are working with static panel pieces, keeping your action moving and your reader interested from panel to panel is key. In this simple, four-panel strip we show how you can make your adventure flow from panel to panel.

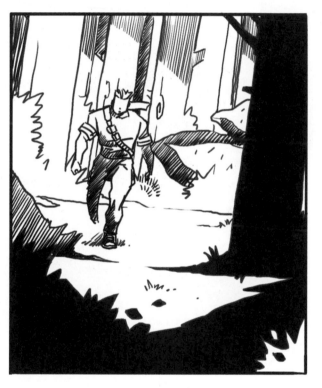

PANEL 1

It is important to suggest the atmosphere of your location in your first panel. This is obviously a large, enclosed forest, but the shadow in the foreground lets the viewer know that something sinister is lurking there.

PANEL 2

Hinting at danger has more effect than showing it straightaway. Here you can see that something is happening outside the panel and our hero knows danger is approaching.

PANEL 3

Now you can really kick the adventure up a notch by using focus lines and playing with perspective to create the dynamism of this T-rex crashing through the trees after your hero.

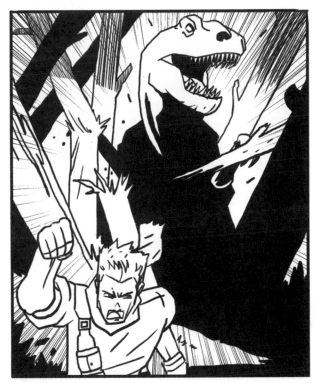

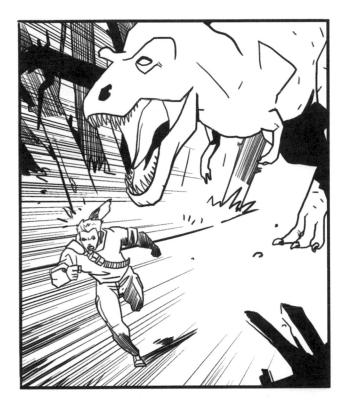

PANEL 4

Once the main action is reached the background detail can be reduced to a minimum. You established the location in your previous panels so now you can focus purely on the action.

TAKEN TO THE LIMIT

Characters in adventure stories often have a larger-than-life personality and style to them. This can be used to your advantage, especially when drawing villains, because exaggerating their characteristics helps you to bring out the less-than-likeable facets of your bad guys.

Ordinary pirate
Here is a realistic approach to a manga pirate – scary and sinister. He could do with a little extra something – but what? Let's see . . .

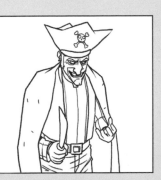

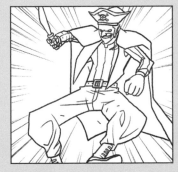

Pirate extraordinaire
The character leaps into life when illustrated in a cartoon style. This approach allows you to show him in more exaggerated and dynamic poses.

MUSCLE THUG

Muscle men appear in almost every area of manga, punching their way through fight tournaments and backing up shady criminals as hired help. There is always a place for the guy who looks as though he spends all his down time at the gym.

STEP 1
This muscle-bound thug has a very wide chest and shoulders. Bear this in mind when you draw your basic stick figure.

STEP 2
Add form to his body using cylinder shapes. His upper arms and thighs are especially bulky. Draw in the lines of his thick neck and the basic shapes of his hands.

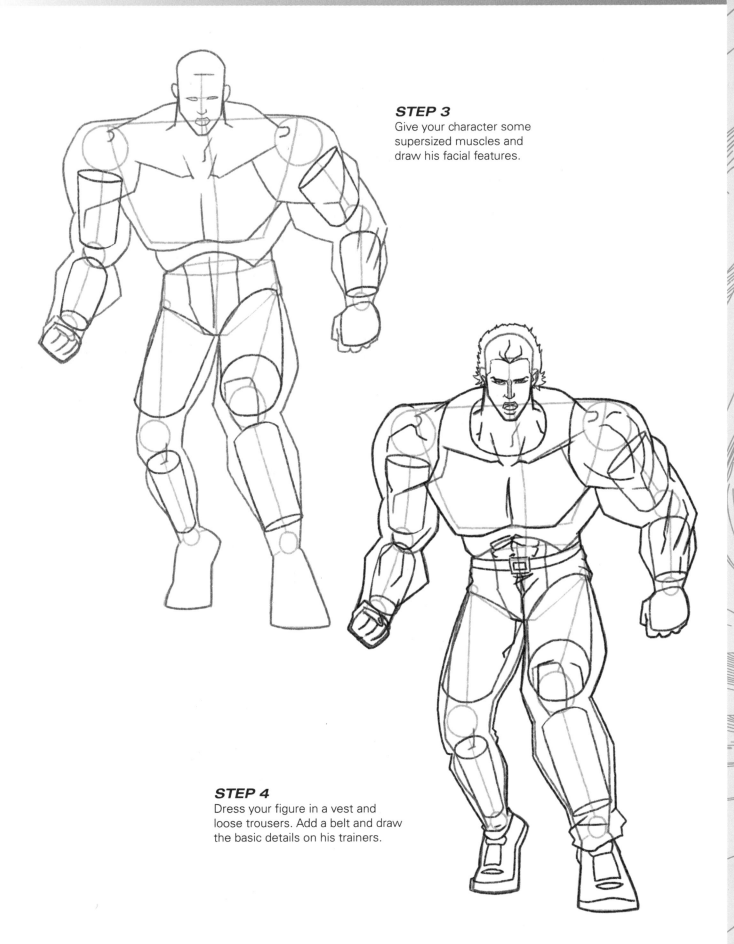

STEP 3
Give your character some
supersized muscles and
draw his facial features.

STEP 4
Dress your figure in a vest and
loose trousers. Add a belt and draw
the basic details on his trainers.

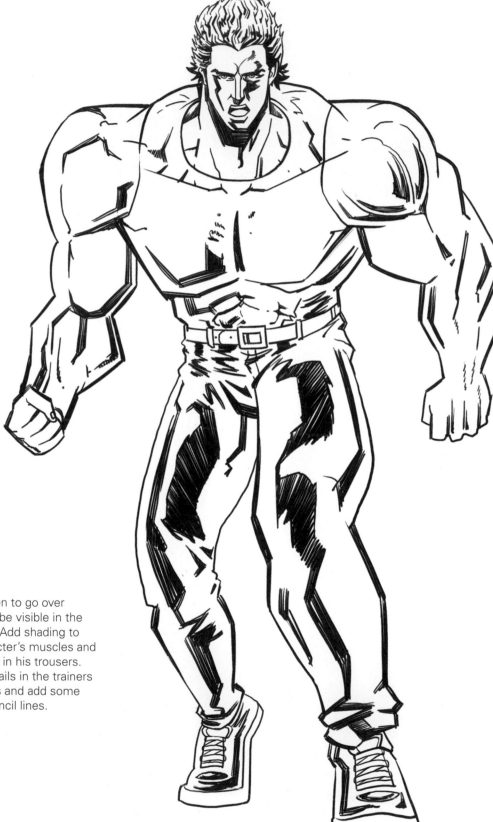

STEP 5
Use your lining pen to go over the lines that will be visible in the finished drawing. Add shading to define your character's muscles and show the creases in his trousers. Complete the details in the trainers and facial features and add some hair. Erase any pencil lines.

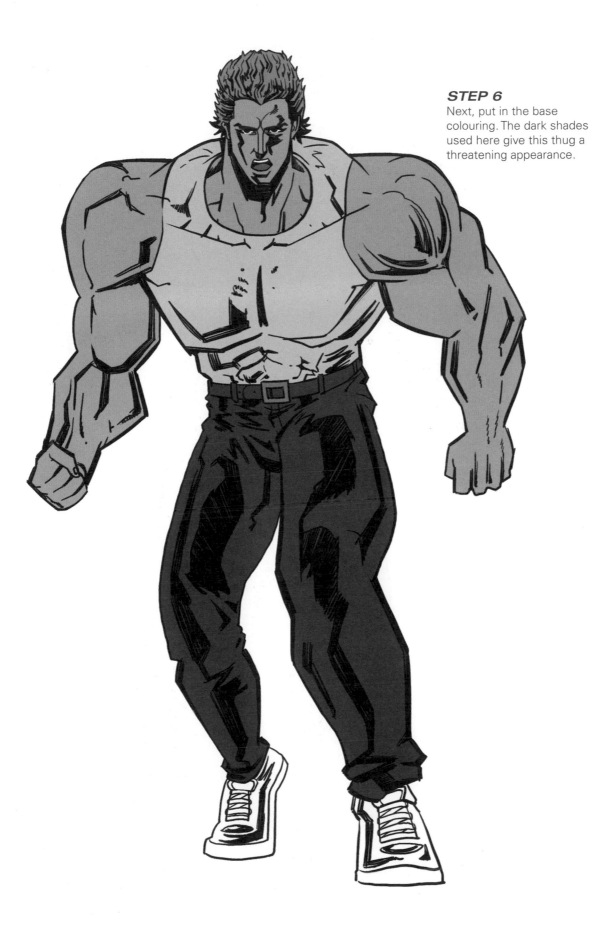

STEP 6
Next, put in the base colouring. The dark shades used here give this thug a threatening appearance.

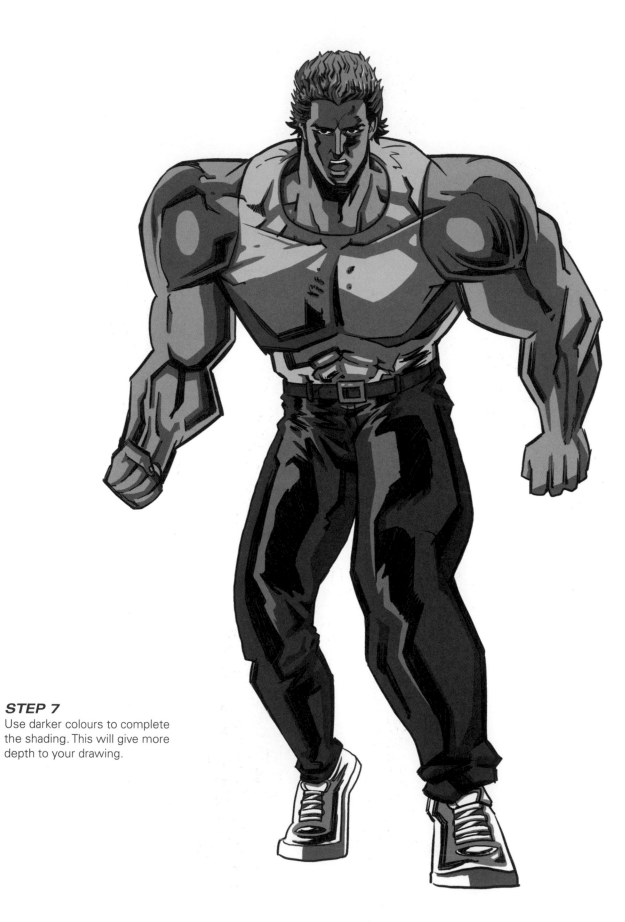

STEP 7
Use darker colours to complete the shading. This will give more depth to your drawing.

THE GUNFIGHTER

This Seinen-inspired cowboy is aimed at older male audiences. A style like this usually features in character-based storylines, rather than in all-out action sequences. Of course, that's not to say he can't sling that gun of his when he needs to . . .

STEP 1

First, draw a basic stick figure. Visualize the pose you want and use this as your starting point. Remember to make sure that the proportions of your character are correctly balanced.

STEP 2

Expand the stick figure into simple cylinders to give your character form.

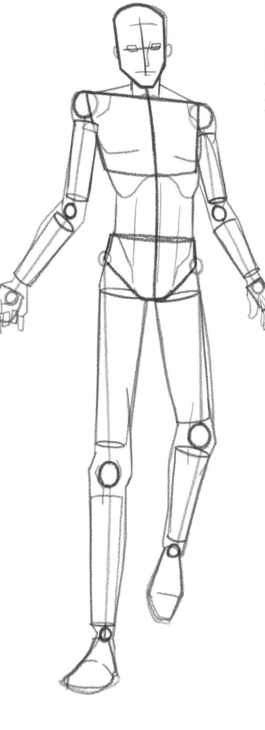

STEP 3
Using the cylinders as the basis of the drawing, add simple anatomical features such as the chest, limbs and hands.

STEP 4
Next, draw the clothing over the basic anatomy, taking care to show how the fabric drapes around the body. This is also the time to add any extra items such as the cowboy's hat and gun.

STEP 5

With your lining pen, put in the details that are to be visible in the finished drawing. Don't line your basic stick figure or the construction cylinders you used to build the figure.

STEP 6
Use your shading pens to add depth to your figure, bearing in mind the angle of light you have chosen and making the shadows consistent with this.

ARTIST'S TIP

Here is the shading isolated from the rest of the line. The light source is coming in from the left. Notice how the shading is heavier furthest away from the light source.

Light source

STEP 7

Choosing lighter shades, complete the colouring of your character and finish off his hair and hat. Using more muted colours for his clothing will help to create texture.

FEMALE HERO

Characters in manga should never be taken at face value. Sweetness and innocence can quickly turn into a whirlwind of fists, feet and blades at the command of a heroine who is ready to do anything to defend her friends and herself.

STEP 1
Draw a basic stick figure in a running pose, with right foot raised and knee crossing the left leg. Her left arm is foreshortened, as her elbow is pulled back. Female characters have rounder heads and pointier chins than males.

STEP 2
Expand the stick figure's arms, legs and neck using cylinder shapes to give form to your character. Draw the basic shapes for her hands.

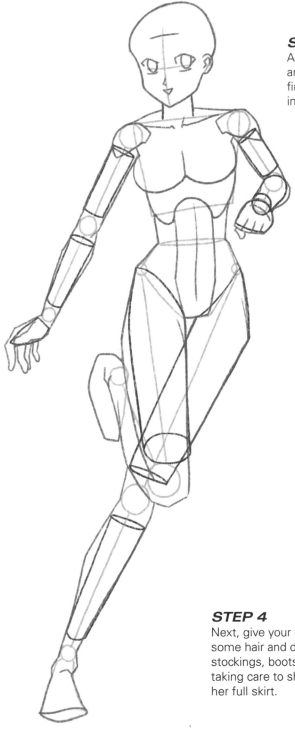

STEP 3
Add the anatomical details to her arms, legs and torso. Draw her fingers and basic facial features, including her extra-large eyes.

STEP 4
Next, give your character some hair and draw her dress, stockings, boots and choker, taking care to show the gathers in her full skirt.

STEP 5
Add the final details to your heroine's clothes and use your lining pen to go over the lines that will be visible in the finished drawing. Erase any pencil lines.

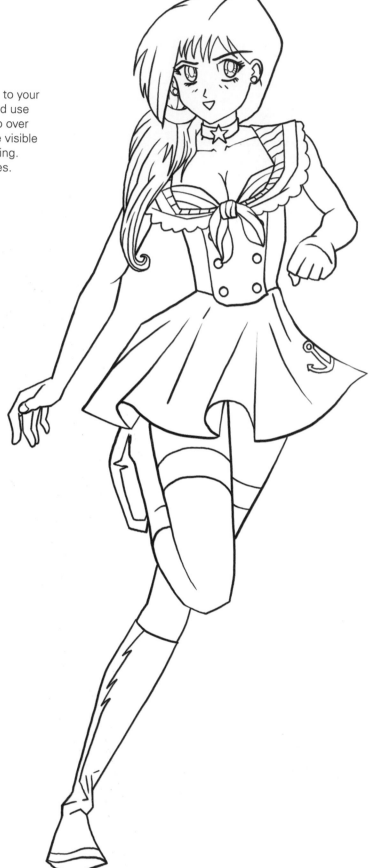

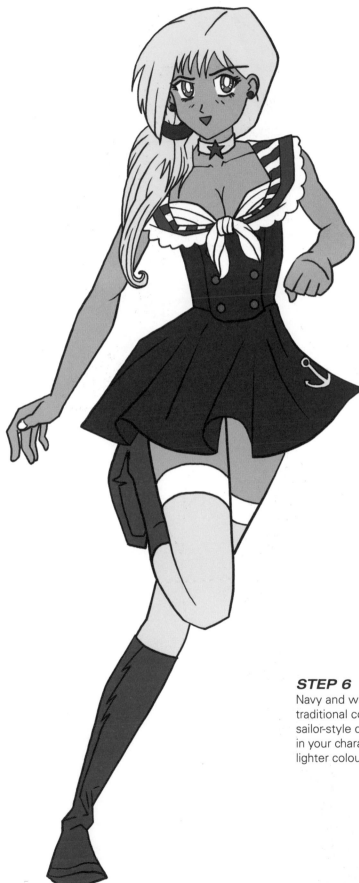

STEP 6
Navy and white are the traditional colours for her sailor-style dress. Colour in your character using lighter colours.

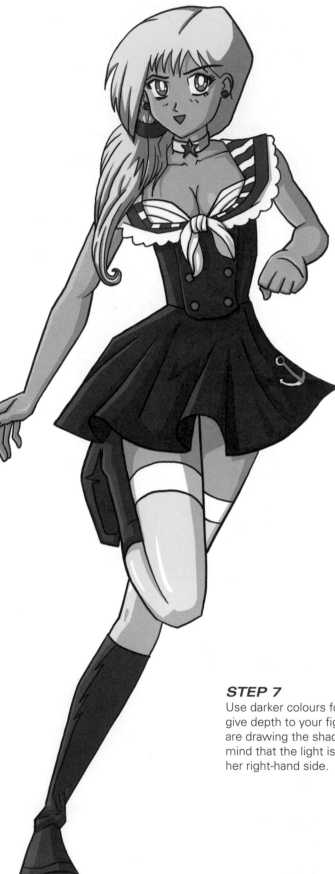

STEP 7

Use darker colours for shading to give depth to your figure. When you are drawing the shadows, bear in mind that the light is coming from her right-hand side.

THE ADVENTURER

At some point you will need a hero character to help move your story along. He could be the leading part in your world or a bit player. Either way you are going to have to create a rough, rugged guy with a steely gaze who looks like he has some enthralling stories to tell.

STEP 1
Draw a basic stick figure with right arm raised and right leg in front of his left.

STEP 2
Use cylinder shapes to give bulk to your character's arms and legs, then draw the lines marking his neck and the basic shapes for his hands.

STEP 3

Draw the muscles in the arms, legs and torso and add the basic facial features. Now draw the hands and the handgun. The fingers and thumb of the Adventurer's left hand should be wrapped around the gun's grip.

STEP 4

Add details to the hands and facial features and give your character some hair. Now it's time to draw his clothes, ammo pouch and the straps of his bandolier.

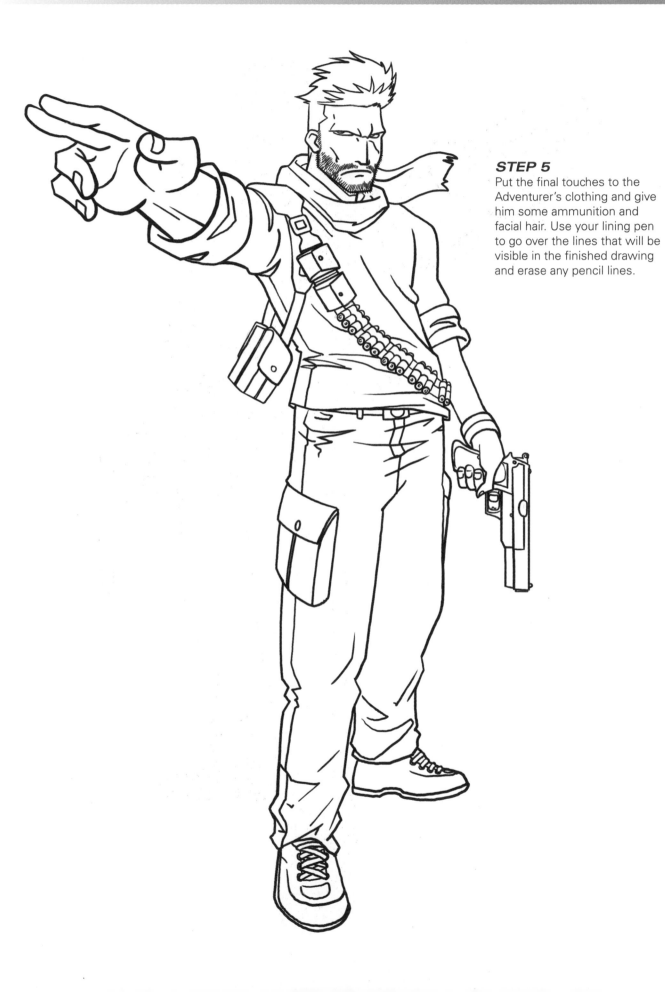

STEP 5
Put the final touches to the Adventurer's clothing and give him some ammunition and facial hair. Use your lining pen to go over the lines that will be visible in the finished drawing and erase any pencil lines.

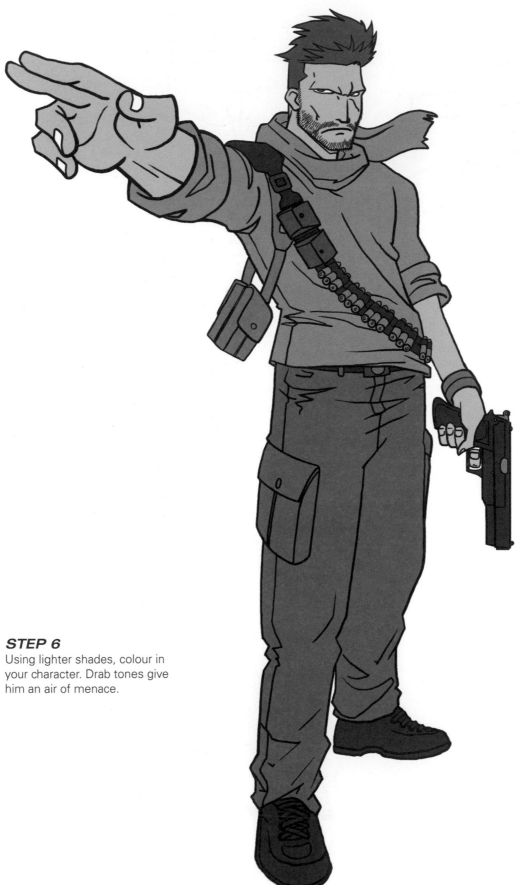

STEP 6
Using lighter shades, colour in your character. Drab tones give him an air of menace.

STEP 7
Use shading to give depth to your character. Bear in mind the direction of the light when you are drawing the shadows.

● ARTIST'S TIP

Remember to make the outline thicker on items that are closer to the viewer to help create depth in your character.

YAKUZA ENFORCER

Tattoos are traditionally found on underworld characters, so adding them can lend an air of menace to an otherwise handsome guy with a stylish wardrobe. A second glance would lead you to cross the road and keep your head down.

STEP 1
Draw a basic stick figure with his head tilted upwards and slightly angled towards his right-hand side. His right arm is raised at the elbow and his eyeline is higher because of the angle of his head.

STEP 2
Use cylinder shapes to give form to the arms, legs and neck, and draw in the basic shapes for the hands.

STEP 3

Draw the basic anatomical details and facial features. His right hand is clenched and the left will be hidden in his pocket.

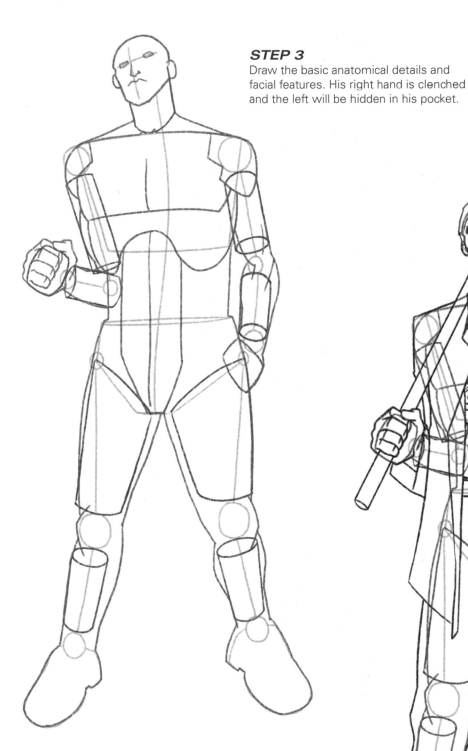

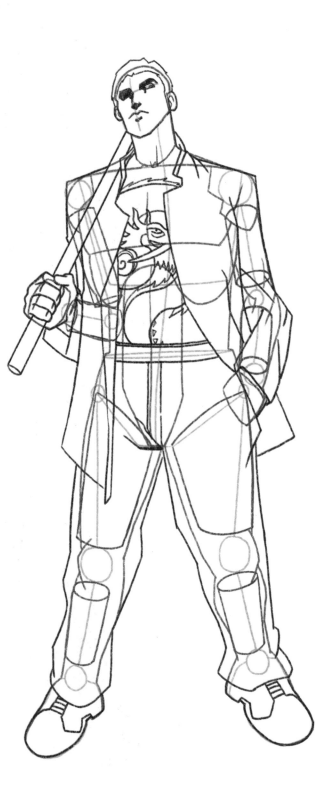

STEP 4

Draw the character's loose jacket and trousers, along with his shoes. Next draw the outline of the tattoo on his chest, complete his facial features and give him some hair. Finally, draw the stick in his right hand.

STEP 5

Use your lining pen to go over the lines that will be visible in the finished drawing. Add a shadow under the gangster's chin and use shading to show the creases in his clothes, then colour his hair black. Erase any pencil lines.

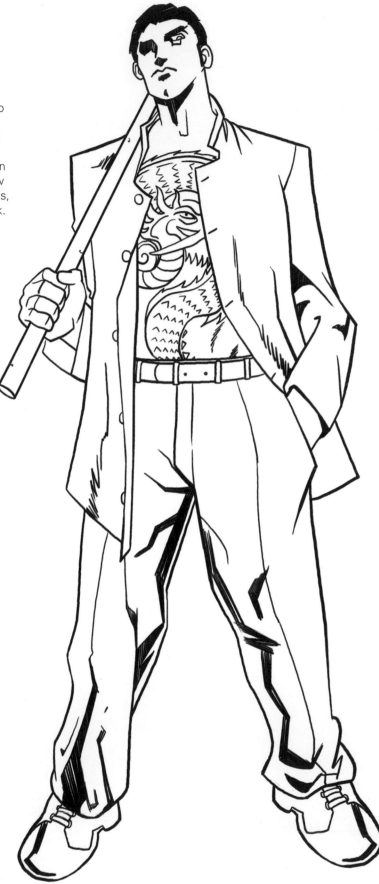

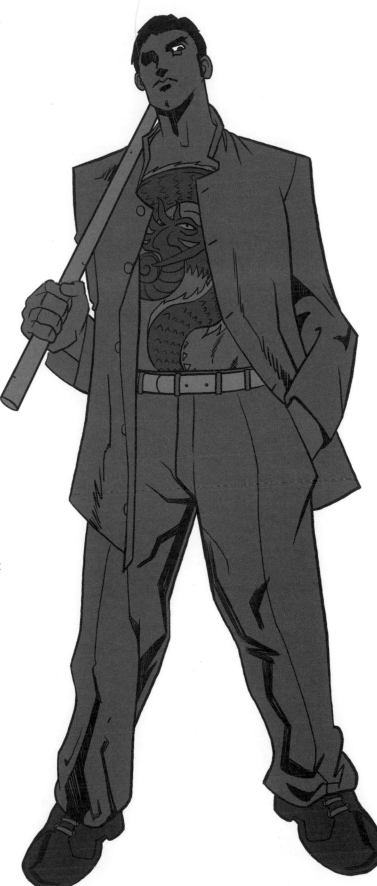

STEP 6
Add colour, using a lighter shade for his suit and a reddish-brown for his skin.

STEP 7
Use darker colours to complete
the shading and colour the
gangster's dragon tattoo.

MARTIAL ARTIST

This type of character is very popular in manga and features heavily in many stories. He might look like something straight out of a video game, but that's no reason not to learn how to create your own best-of-three-rounds martial artist.

STEP 1
Draw a basic stick figure. Note how this character's right shoulder is angled towards you in an aggressive pose and how his chin is jutting forwards in the direction of his shoulder.

STEP 2
Use cylinder shapes to give form to your character's arms and legs. The limbs on his right-hand side should be bulkier than those on the side angled away from you. Add the basic shapes of his clenched fists and the lines of his neck.

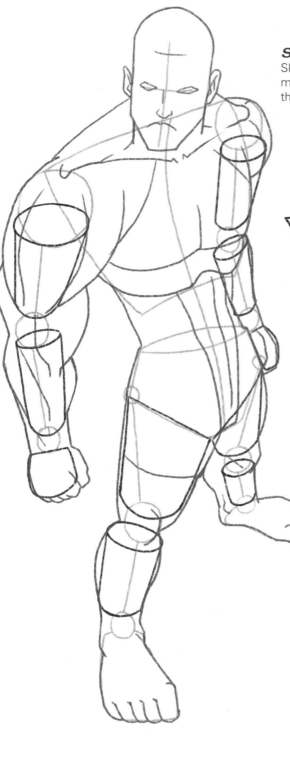

STEP 3

Sketch in the martial artist's powerful muscles, add the fingers on his right hand, then draw his toes and basic facial features.

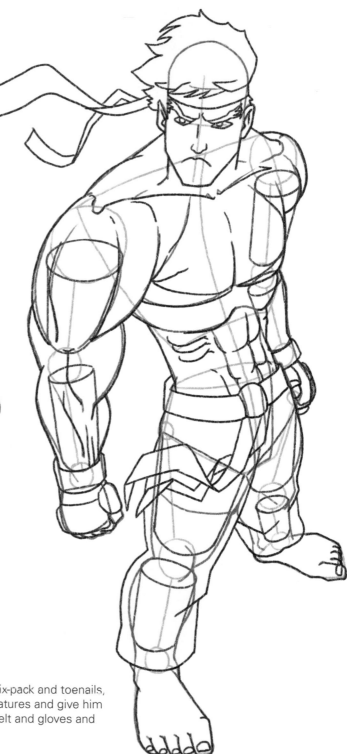

STEP 4

Complete the figure by drawing in his six-pack and toenails, then add the final details to his facial features and give him some hair. Add a headband, trousers, belt and gloves and your martial artist is ready for action.

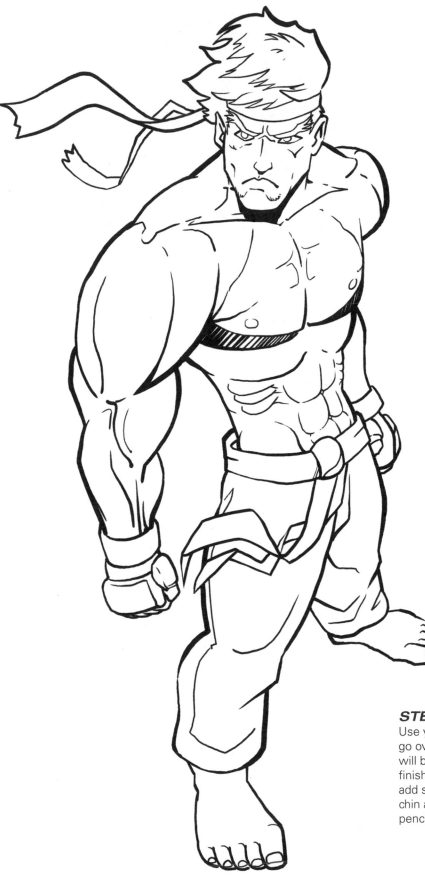

STEP 5
Use your lining pen to go over the lines that will be visible in the finished drawing and add shading under his chin and pecs. Erase any pencil lines.

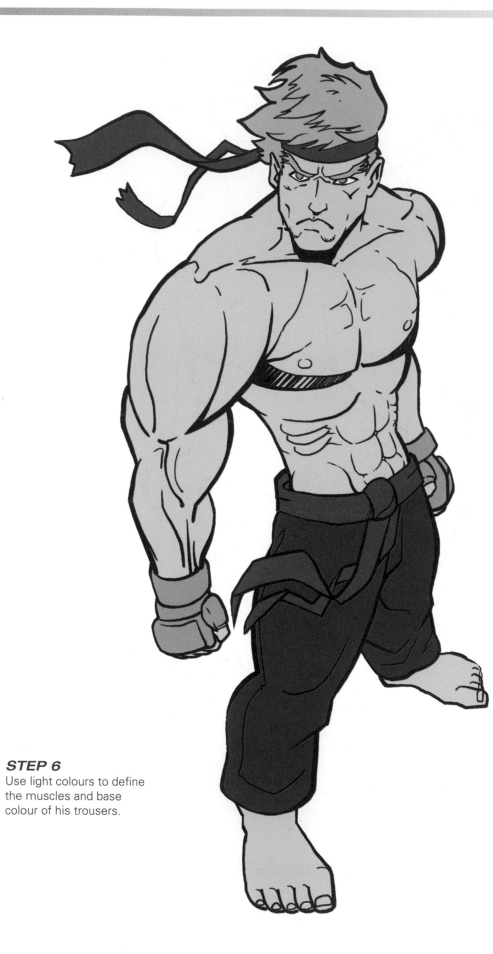

STEP 6
Use light colours to define the muscles and base colour of his trousers.

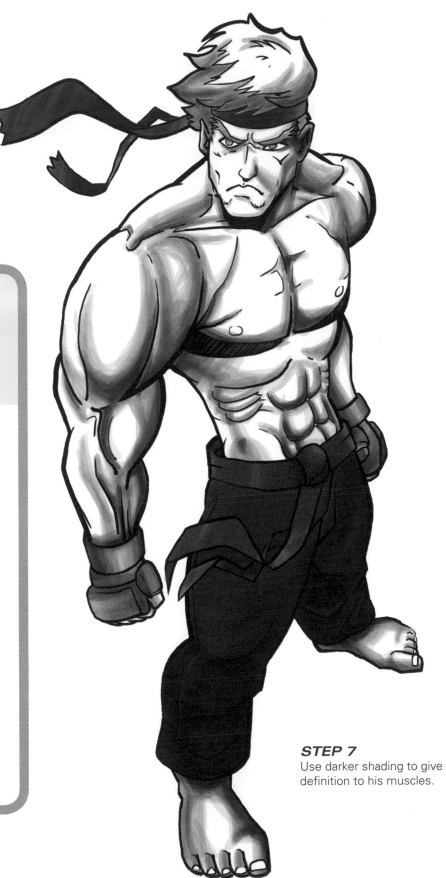

ARTIST'S TIP
Making your character's shoulders slightly out of scale and much wider in comparison to the hips will give the illusion of looking down on a character.

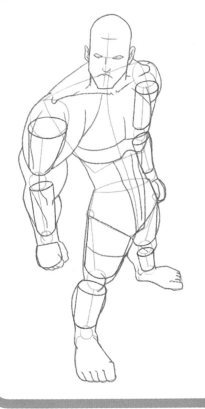

STEP 7
Use darker shading to give definition to his muscles.

PIRATE

Imagination is the only thing that can limit the manga artist. Here we decided to relocate the potential for action from gritty streets to the high seas. But as this is manga, there is nothing to stop our pirate setting course for the gleaming city.

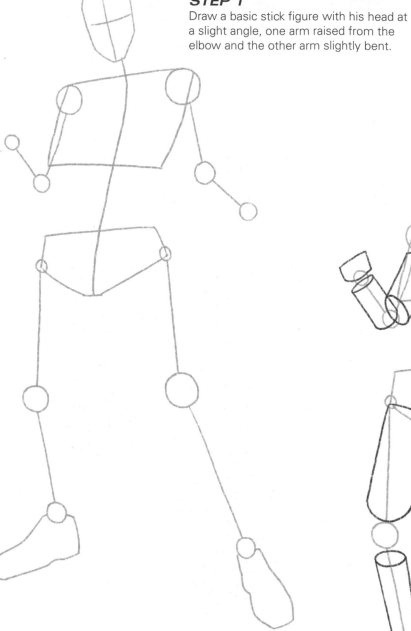

STEP 1
Draw a basic stick figure with his head at a slight angle, one arm raised from the elbow and the other arm slightly bent.

STEP 2
Use cylinder shapes to bulk out the arms, legs and neck, and draw in the basic shapes for the hands.

STEP 3
Sketch in the anatomical details, then give your pirate facial features, including a wide, malicious grin. Add the fingers, along with a sword in a scabbard.

STEP 4
It's time to dress your pirate in a long, flowing shirt, breeches and boots. Give him a belt, a tricorne hat and long hair. A dagger strapped across his body and a couple of gold bangles complete the figure.

STEP 5

Use your lining pen to go over the lines that will be visible in the finished drawing. Add shading under the pirate's chin and complete the details on his belt, clothing and weapons. Finish off his facial features and colour his hair black. Erase any pencil lines.

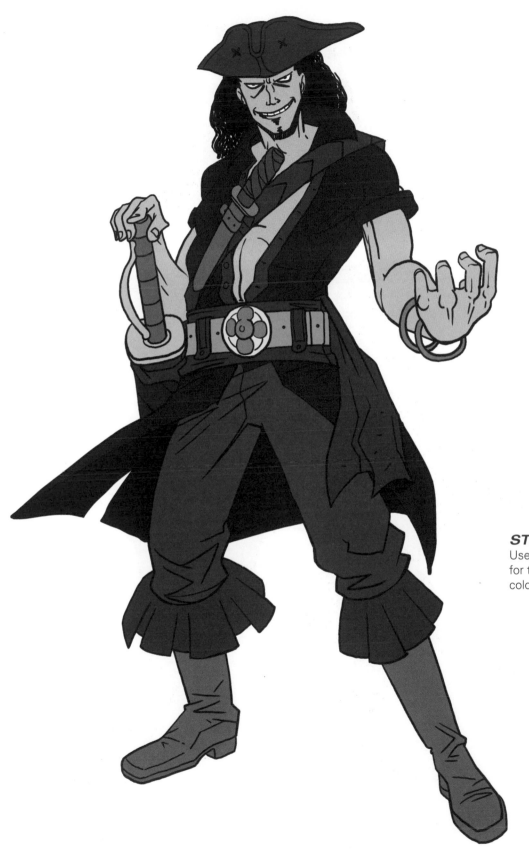

STEP 6
Use lighter shades
for the first stage of
colouring.

STEP 7
Use darker colours to complete the shading, and really bring out the creases in the character's clothing.

FANTASY

Manga is rich in all kinds of weird and wonderful creations that draw heavily on the spiritual influences and stories of ancient Japan. Almost anyone or anything in this group can mutate into a monster or demon before your very eyes.

Fantasy creatures can be found in almost every area of manga, whether it be police officers battling for their lives against a genetic mutation, or high school girls collecting magical pets – the fantastic is never far away!

TIPS AND TRICKS

There's no limit to what you can allow your characters to do in a fantasy world. Giving your creations some special powers is a great way to set them apart from the more mundane characters in your story.

Now you see me . . .

Let's take a look at giving your characters some invisibility skills. Starting with the basic head shape, plot out the shape of the disappearing body by using a line like this.

Draw in the head and shoulders and then thicken the squiggle line to help make the crackle effect of the magic.

Complete the detail of the head and add shading to the squiggle. Electrical bolt effects can be created by extending the line in places.

Finish the shading on the head and shoulders. Add small patches of shading for extra crackle effects and particles of debris to help complete the impression of chaos.

Putting in focus lines and sound effects will add further drama.

Unleash nature

You are invariably going to want to give your characters some of the more impressive elemental powers. Let's look at some options.

Fire

Plan the shape and trajectory of your fireball with a basic sketch. The darker inner section will eventually represent the burning core.

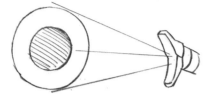

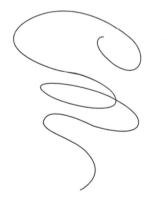

Using your basic sketch, round off the front of the fireball. Show small flames flowing down the edges of the fireball away from the direction of travel.

Strengthen the outer line and add dark shaded patches to represent burning bits and charred embers within the central core. Accentuate the drama by adding extreme shadows to the launcher.

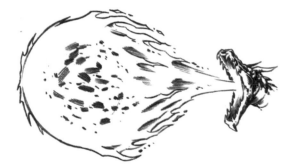

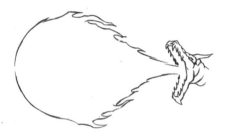

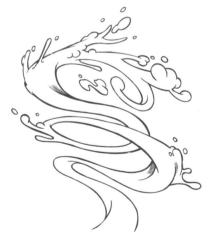

Water

Water is a flowing element, so a curling line is an excellent place to start when creating your water blast. Keep it fluid and avoid any sharp angles in your curves.

Duplicate your original line to create the rest of the water blast. Think of the water as a thin, stretchy piece of gel that can twist and bend upon itself, but which will not break.

Use shading to give texture to your water. Add drops of flying water and small splashes wherever the water changes direction.

CRAZY WIZARD

Japanese folk tales are full of wizards with magical powers honed from their martial arts skills or pacts with demons and spirits. This character could pass for a friendly old man, but cross him and his wizardry will be unleashed!

STEP 1

Draw a basic stick figure with his arms raised from the elbow and his right foot resting on a rock. We are looking up at him, so his eyeline is higher than normal.

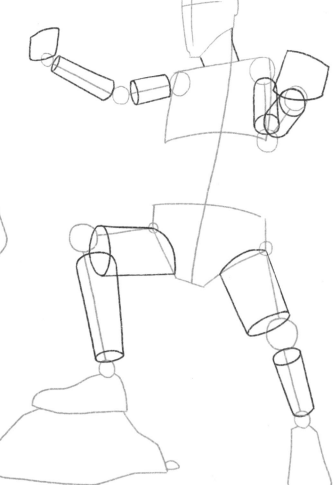

STEP 2

Use cylinder shapes to give form to your character's arms and legs. Draw the lines to mark the sides of his neck and sketch in the basic shapes of his hands. His left hand is in the foreground, so it is larger than the right.

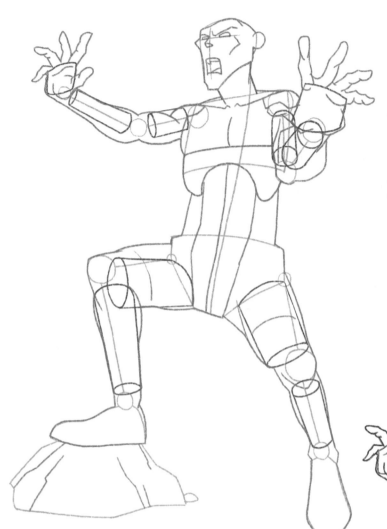

STEP 3

Add your character's basic anatomical details and facial features. Draw his hands with the palms facing forwards. Add some detail to the rock beneath his foot.

STEP 4

Give your character a large moustache and complete his facial features, adding shading under his chin. Draw his clothing and shoes.

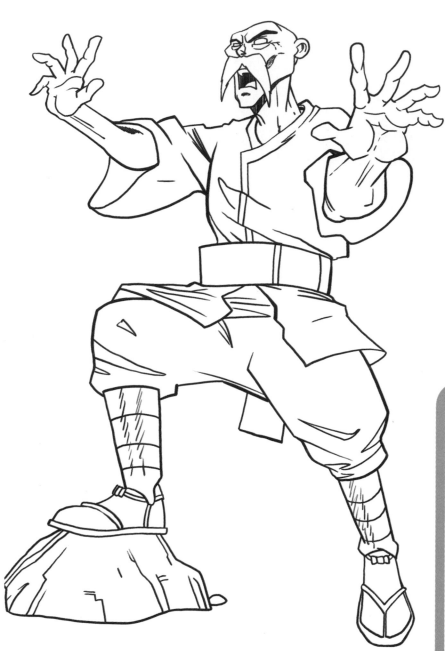

STEP 5

Use your lining pen to go over the lines that will be visible in the finished drawing and erase any pencil lines. Add details to the wizard's clothes and shading to his face, neck and arms.

● ARTIST'S TIP

Remember that you can make any final adjustments to anatomy, clothing and so forth at your final pencil stage. The construction steps are guides to help you reach this stage.

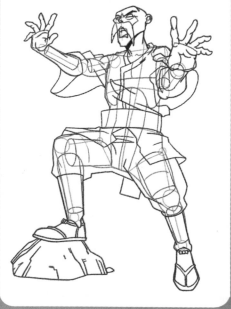

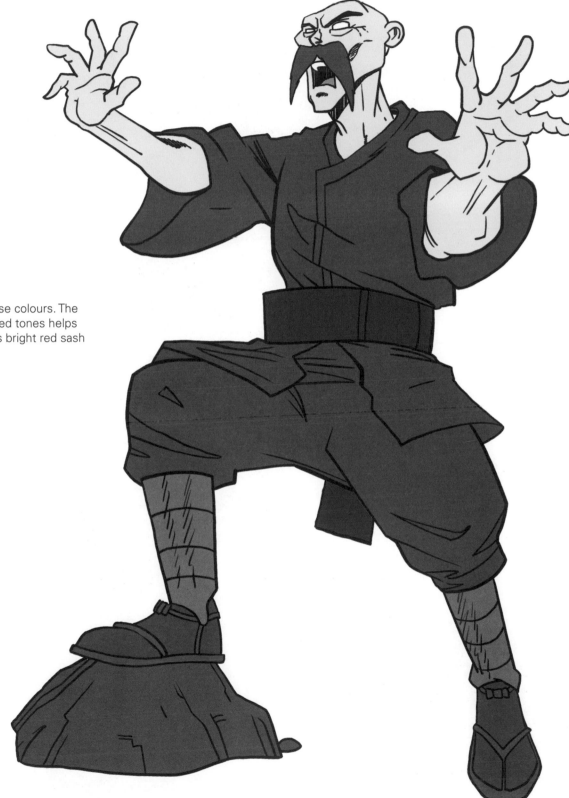

STEP 6
Add the base colours. The use of muted tones helps to make his bright red sash stand out.

STEP 7
Use colour to add more
shading to your image and
draw the yellow electrical
flashes between the
wizard's hands.

DEMON

No fantasy story would be complete without a demonic presence causing trouble for the heroes. Our demon is not the master of all demons, but you can imagine a bunch of them creating problems . . .

STEP 1
Draw a stick figure of a creature in a crouching position, with a long tail and branch-like projections from its shoulder blades. These will become its wings.

STEP 2
Use cylinder shapes to give form to the demon's arms, legs and the first two sections of its wings. Draw horn-like shapes to complete this stage of the wings, then sketch in the basic shapes of the hands.

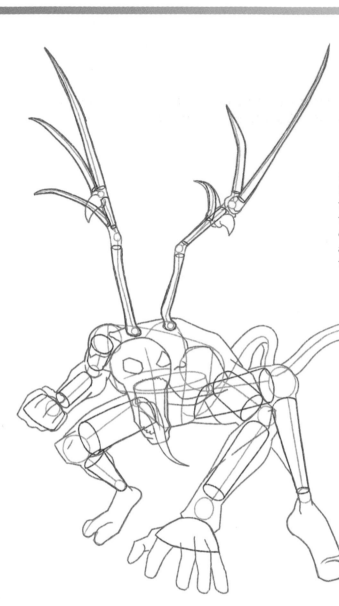

STEP 3

Draw the demon's muscular torso, arms and legs, then draw its two-toed feet, its clenched right fist and the outstretched fingers of its left hand. Draw the outline of the tapering tail and the bones of its wings, adding claws to the wing joints as shown. Now draw the eye sockets, open mouth and long tongue.

STEP 4

Arm your demon with a mouthful of sharp teeth, toe claws and long fingernails. Now draw its wings and large, wing-like ears.

STEP 5
Use your lining pen to go over the lines that will be visible in the finished drawing, and erase any pencil lines. Define the demon's muscles and add the details to its hands, feet, tail and wings.

STEP 6
Add the basic colours as shown. The details of the body are more obvious because the red has not been used for the legs.

STEP 7
Darker shades of the base red have been used to add shadows. These add definition to the drawing and give a menacing character even more bite.

MUTATED BOSS

The idea of a large corporation meddling with genetic experiments to create something abominable is very disturbing. The warping of human features in this character has turned it into something truly alarming.

STEP 1
Draw a basic stick figure with a long tail and two horns attached to the sides of his head.

STEP 2
Use cylinder shapes to bulk out this freakish figure's arms and legs. Draw the outlines of his curved horns and tapering tail, then sketch in the basic shapes of his hands.

STEP 3

Add your character's basic facial features and long tongue. Now draw his muscular legs and torso, and his relatively normal right shoulder and arm. His left shoulder has mutated into a strange growth with a porthole, his left hipbone is jutting out and his left hand is armed with long, sharp claws.

STEP 4

Give your mutant a set of teeth, two more horns on top of his head, and long hair. Add details to the porthole, the barbs on his left arm and the tubes protruding from his left arm and legs.

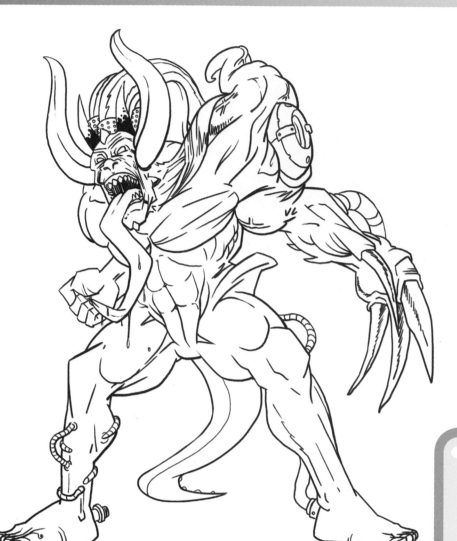

STEP 5

Use your lining pen to go over the lines that will be visible in the finished drawing, and erase any pencil lines. Add some initial shading and draw in the barbs at the end of the mutant's tail, then put the finishing touches to his body, face, horns, hair and the tubes attached to his arm and legs.

● ARTIST'S TIP

Notice how the construction cylinders on the left arm are much larger, to show the warped arm design from the mutation.

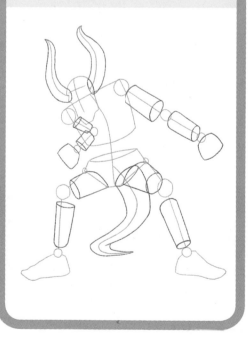

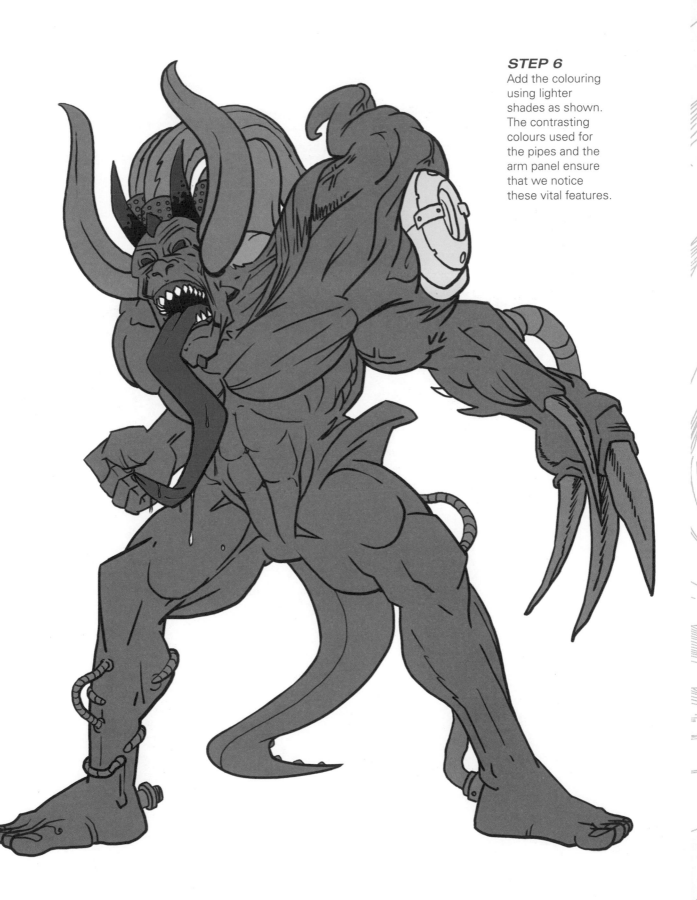

STEP 6
Add the colouring
using lighter
shades as shown.
The contrasting
colours used for
the pipes and the
arm panel ensure
that we notice
these vital features.

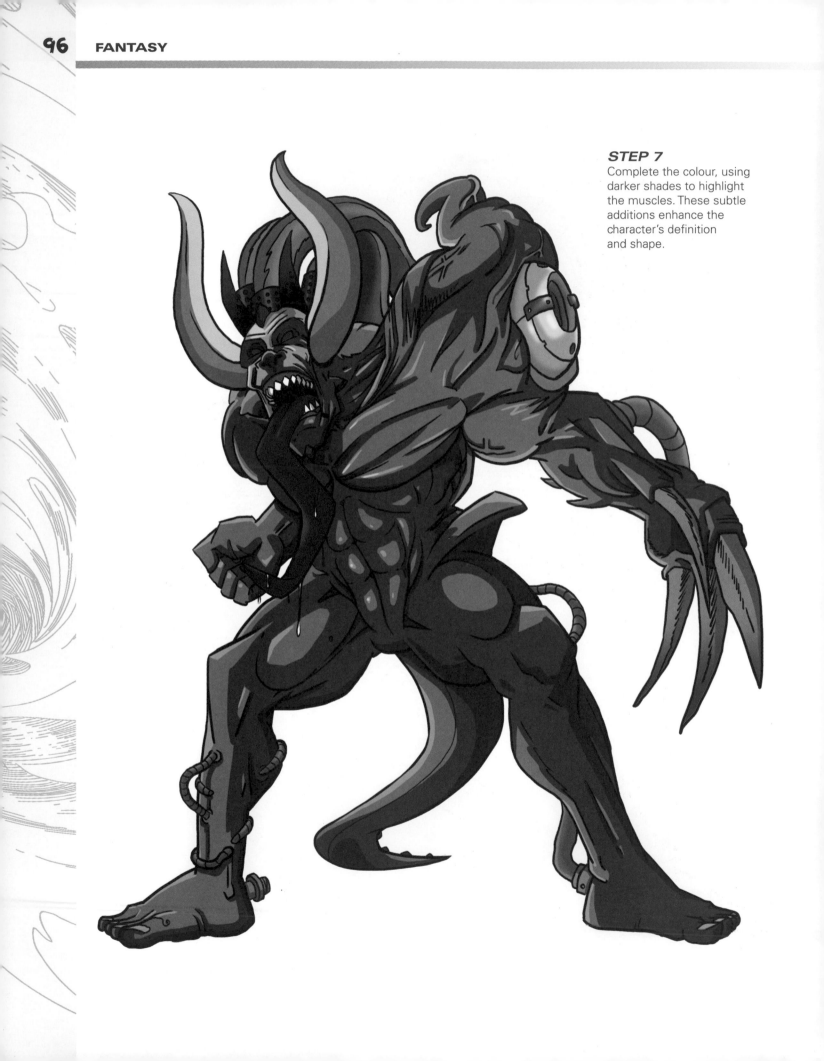

STEP 7
Complete the colour, using darker shades to highlight the muscles. These subtle additions enhance the character's definition and shape.

DRAGON

Dragons come in many shapes, sizes and conformations. We have chosen a slightly humanoid-based dragon to demonstrate the expressiveness of the poses that can be achieved with this style.

STEP 1

Draw a basic stick figure of a creature in a standing position, with a long tail and raised 'arms' with three 'fingers'. These will become its wings.

STEP 2

Use cylinder shapes to give form to the dragon's neck and legs – note that the lower legs are each made up of two cylinders. Now draw cylinder shapes for the wing bones. Those at the end of each 'finger' should taper to a point. Draw the outline of the tail, then divide it into sections.

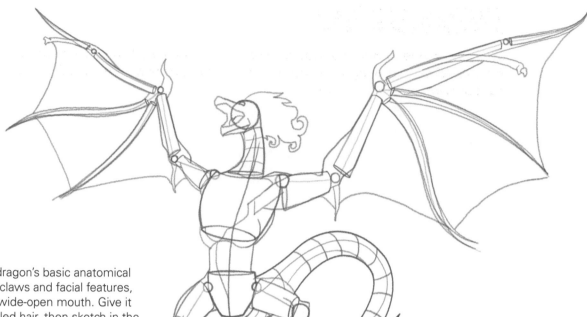

STEP 3
Draw your dragon's basic anatomical details, toe claws and facial features, including a wide-open mouth. Give it flowing, curled hair, then sketch in the wings, adding claws at the wing joints and the tops of the wings as shown.

STEP 4
Draw sharp teeth, a curled horn, and knee claws to add to your dragon's fearsome appearance. Define the muscles in the arms, legs and torso. Now add ragged edges to the wings and more detail to the hair.

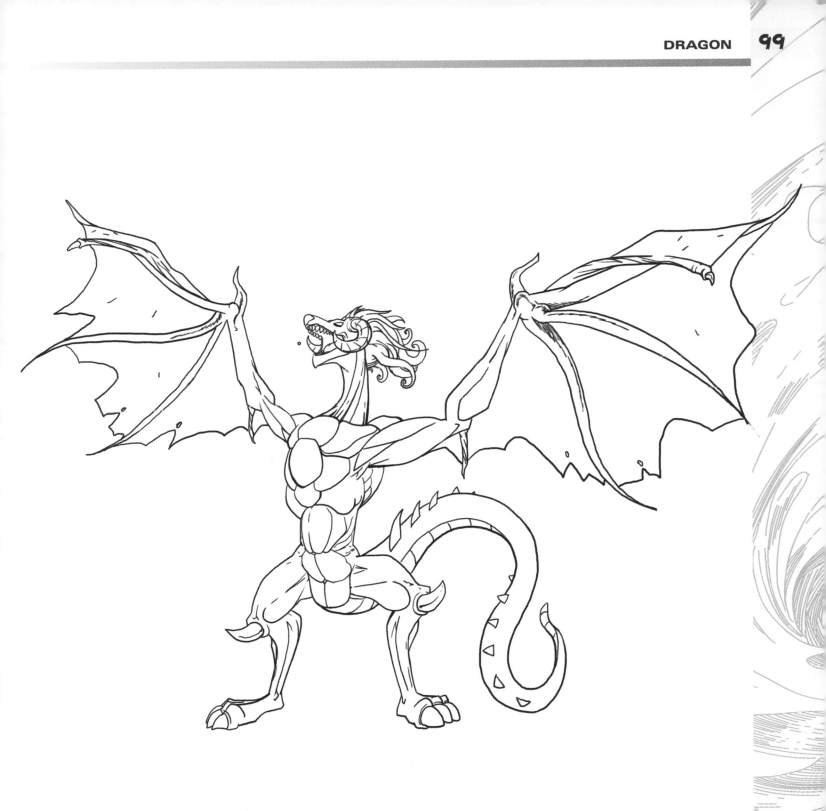

STEP 5

Use your lining pen to go over the lines that will be visible in the finished drawing and erase any pencil lines. Add detail to the dragon's wings and draw the end of the horn visible on the far side of its face. The top of the tail has sharp barbs and the sections can be seen on the underside. A bead of spit flying from its mouth is a nice finishing touch.

STEP 6

Add the base colouring as shown. An all-over grey would not have made the most of this character. Notice how different, yet complementary colours have been used, most significantly for the chest plate and the under part of the tail.

STEP 7
Use lighter shades to add highlights to your drawing and darker colours for the shadows.

WARRIOR MONK

The warrior monks of feudal Japan were both fighting men and disciples of Buddhism. In manga stories they are often depicted as itinerants whose message of peace can quickly change to armed aggression if the need arises.

STEP 1

Draw a basic stick figure with his right arm raised from the elbow and his left arm extended alongside a large stick.

STEP 2

Use cylinder shapes to bulk out your character's arms and legs. Draw the lines to mark the sides of his neck and sketch in the basic shapes of his hands. Draw the outline of the long stick he is holding.

STEP 3

Add your character's basic anatomical details and facial features. He has muscular arms and legs and a square chin. Now draw his hands – the fingers of the right are raised above his head and his left fingers are wrapped around the stick.

STEP 4

Draw the monk's huge hat, which will be in front of the stick. Add shadows around his eyes where they are shaded by the hat. Draw his clothing, including a long cloak, wristbands and boots.

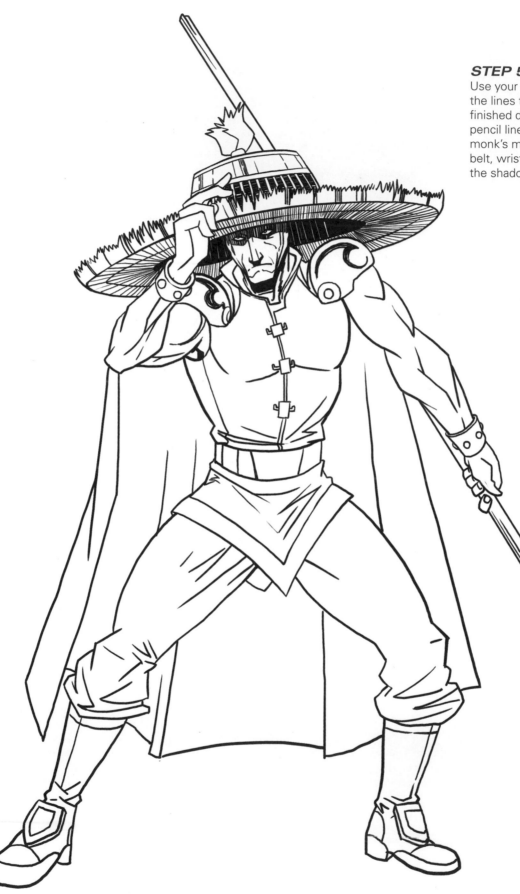

STEP 5
Use your lining pen to go over the lines that will be visible in the finished drawing, and erase any pencil lines. Add details to the monk's muscles, clothes, hat, belt, wristbands and boots, and the shadow under his chin.

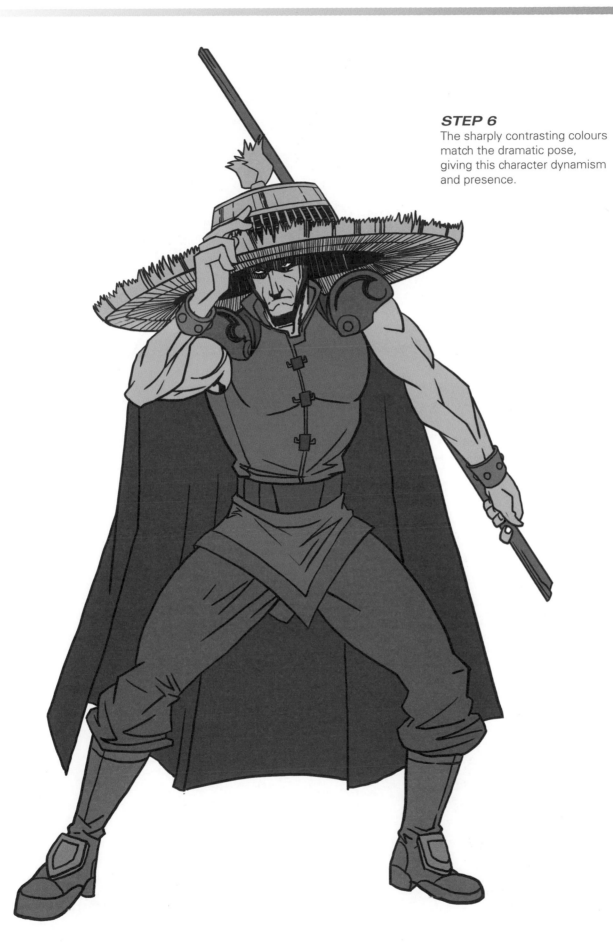

STEP 6
The sharply contrasting colours match the dramatic pose, giving this character dynamism and presence.

ARTIST'S TIP

To get vibrant colours in your painting, try adding more than one coat of colour to your character, slowly building the tone until you get the hue you are looking for.

STEP 7

Use darker colour to add shading, which will give depth to your character.

CUTE

Small and fluffy with eyes the size of dinner plates, it can only be the squishy world of cute artwork. The chibi style dominates this genre. It is one of the most recognizable in all manga and particularly loved by smaller children. Almost any character can be shrunk and turned into quintessential cute.

This set of projects includes a mix of kodomo and chibi styles.

TIPS AND TRICKS

Chibi characters are defined by their exaggerated proportions and huge, expressive eyes. Any character can be given this treatment. A chibi head can be drawn with a rounded face or a strong jawline.

Rounded face

To make a rounded chibi face, draw a line through the centre of the circle and extend it just below the lower edge.

Add small lines extending from the sides of the circle to form the sides of the chin.

Join the two lines from the sides to complete the chin. Now start adding hair and facial details.

Strong jawline

Start with a circle and draw a line vertically through the centre. Extend the line a little further than for the rounded face.

Draw the side lines as before, taking them further to meet the centre line.

Join the two lines, but at a much sharper angle than for the rounded face.

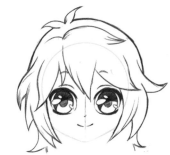
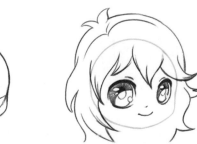
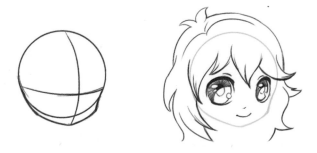

If you want to show the head at a slight angle, add the chin on one side, with an extra horizontal line slightly below centre for the eyes to sit on.

To draw the head with strong jawline at a slight angle, follow the lines for the chin.

CHIBI FEATURES

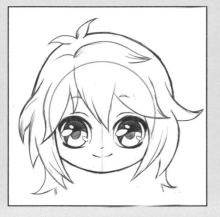

Here are some extra pointers to bear in mind when creating your chibi.

The hairline sits much higher than in traditional characters, as cute chibi hair is usually quite voluminous. The faint line here shows the top of the head and where the hair is placed.

Chibis are often drawn without a defined nose. If you do want to add one, make it very small (often a small line will do) and on the same level as the lower eyelashes.

The eyes are always very large, with many extra light reflections, and they dominate the face.

ACCESSORIES MATTER

Cuteness is an essential ingredient of chibi characters and this is increased massively with the addition of accessories. You can add flowers, animal ears, large goggles, headwear – just about anything you want – but ask yourself, 'Would this look better if it were oversized on the character?'

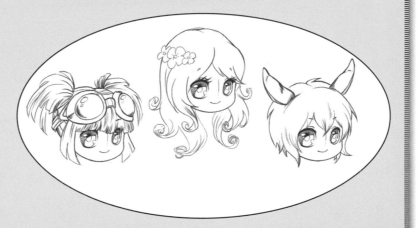

EXPRESSION SESSION

Chibi characters can be drawn with very exaggerated expressions, which gives you the chance to really let loose when giving your characters emotions. Here are a few examples for you to try.

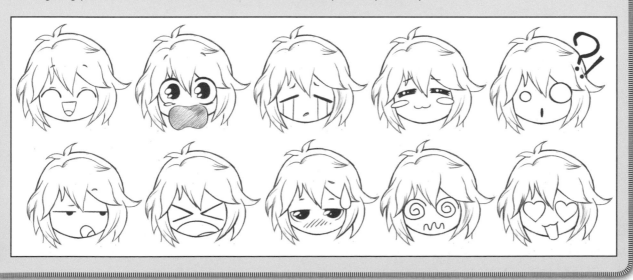

DARK FAIRY

Not every character drawn in the chibi style has to be all sparkly and nice. A mischievous fairy with a cute profile can be just as dangerous a protagonist as a fire-breathing dragon.

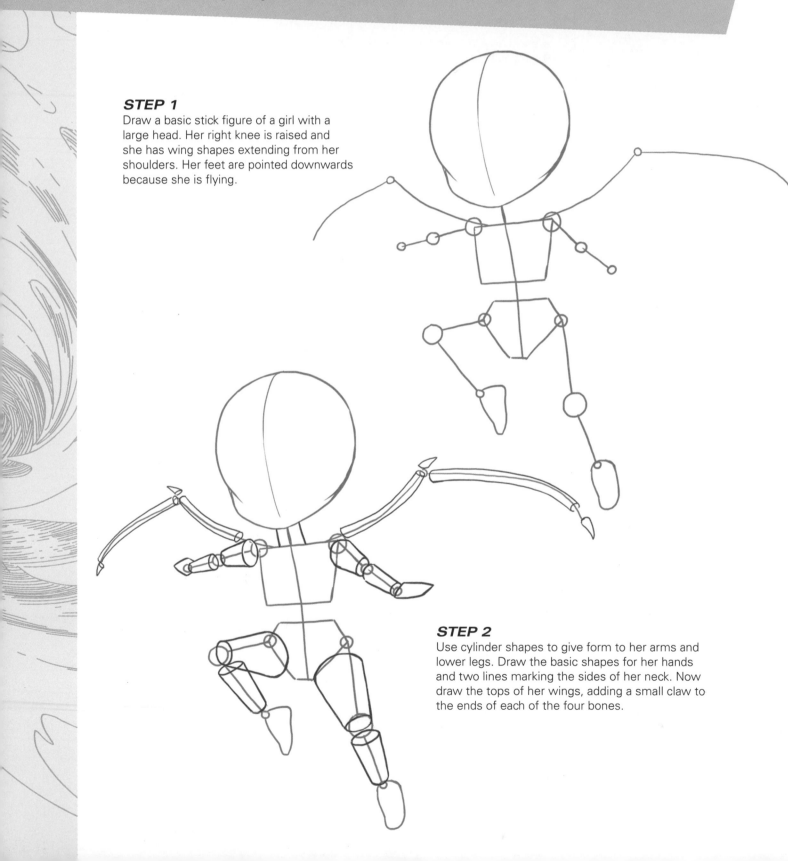

STEP 1
Draw a basic stick figure of a girl with a large head. Her right knee is raised and she has wing shapes extending from her shoulders. Her feet are pointed downwards because she is flying.

STEP 2
Use cylinder shapes to give form to her arms and lower legs. Draw the basic shapes for her hands and two lines marking the sides of her neck. Now draw the tops of her wings, adding a small claw to the ends of each of the four bones.

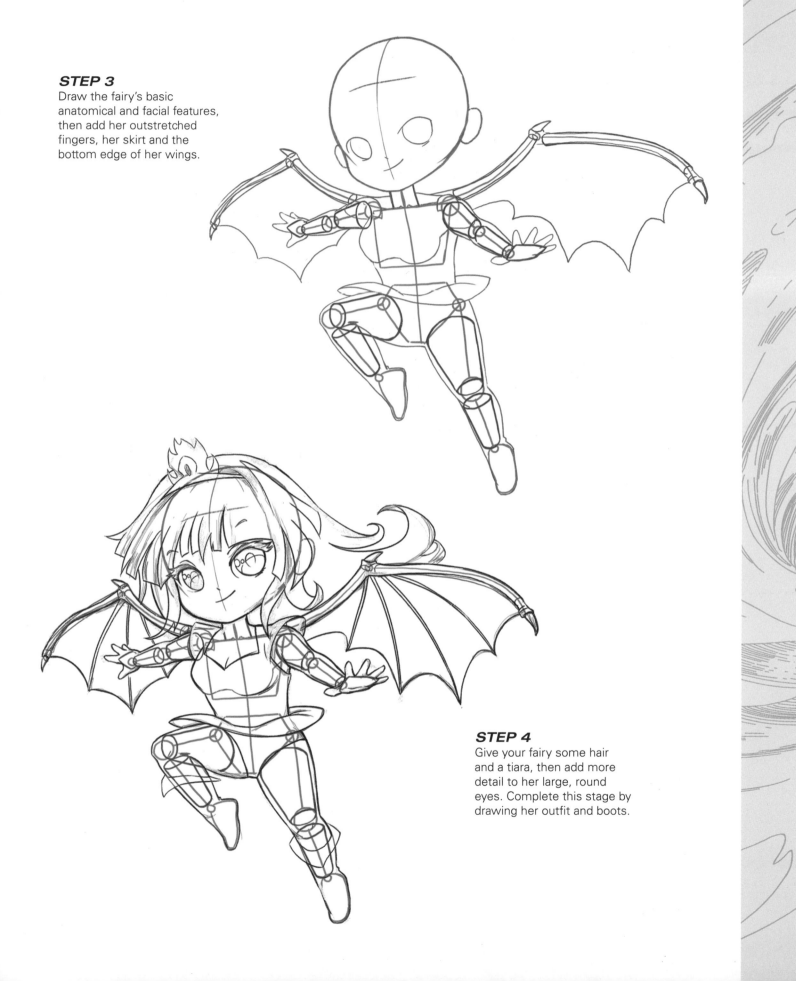

STEP 3
Draw the fairy's basic anatomical and facial features, then add her outstretched fingers, her skirt and the bottom edge of her wings.

STEP 4
Give your fairy some hair and a tiara, then add more detail to her large, round eyes. Complete this stage by drawing her outfit and boots.

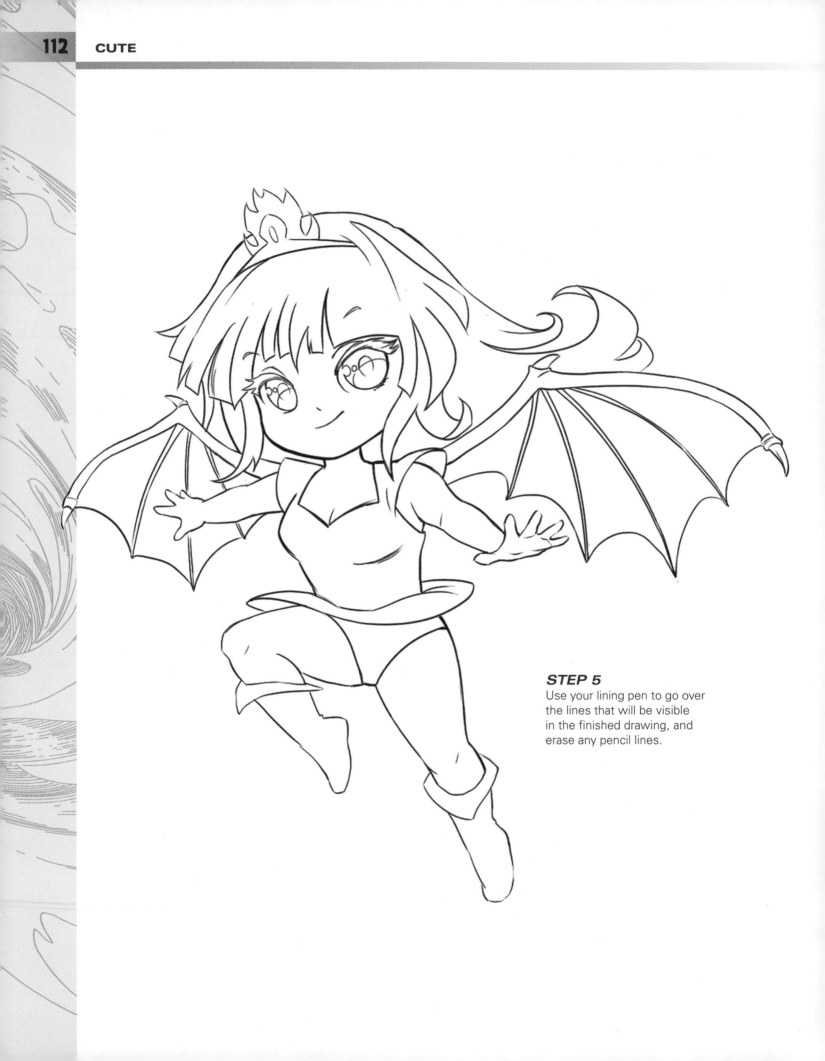

STEP 5
Use your lining pen to go over the lines that will be visible in the finished drawing, and erase any pencil lines.

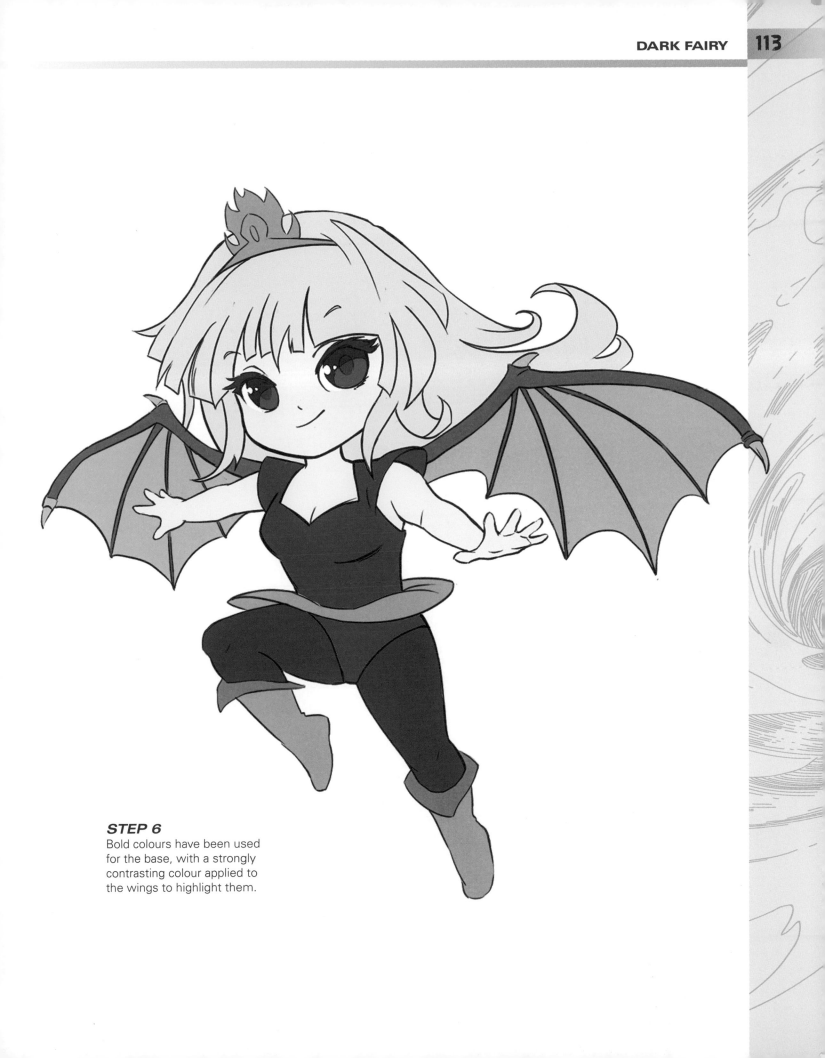

STEP 6
Bold colours have been used for the base, with a strongly contrasting colour applied to the wings to highlight them.

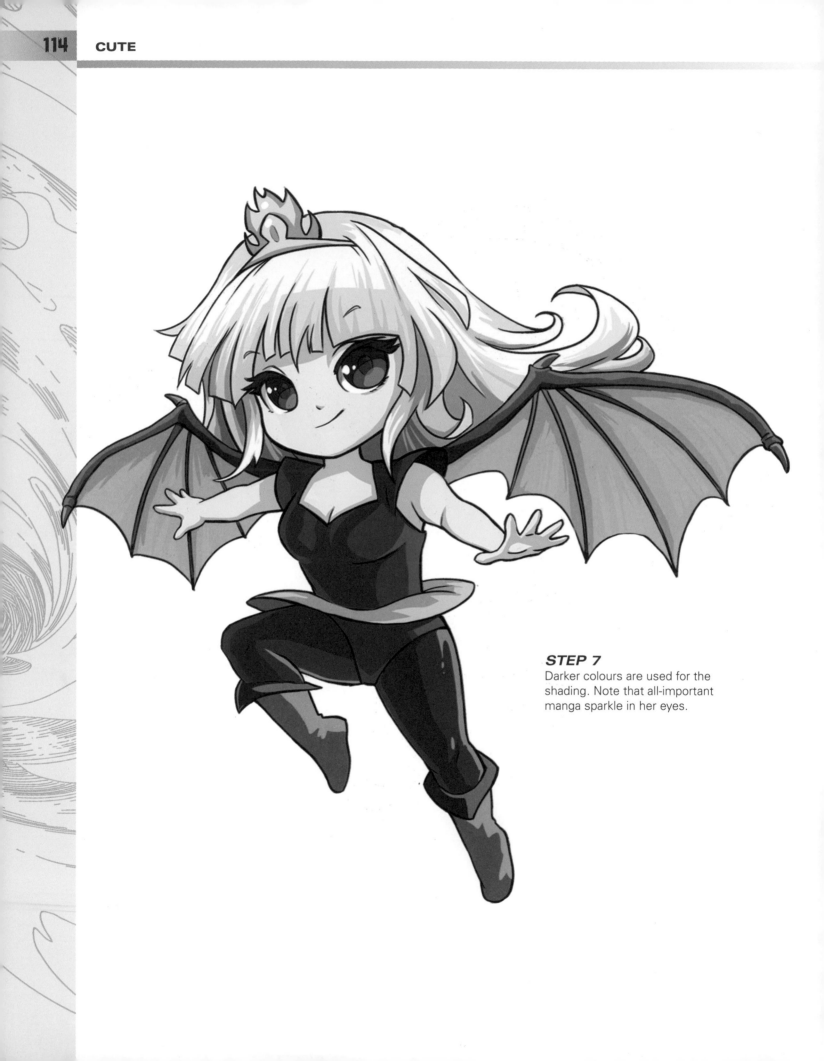

STEP 7
Darker colours are used for the shading. Note that all-important manga sparkle in her eyes.

KIGURUMI KID

Once a kid puts on an animal suit, it could be days or even weeks before you'll see them out of it. But then again, as the kigurumi street fashion craze proves, many young people love to spend the day wearing animal costumes.

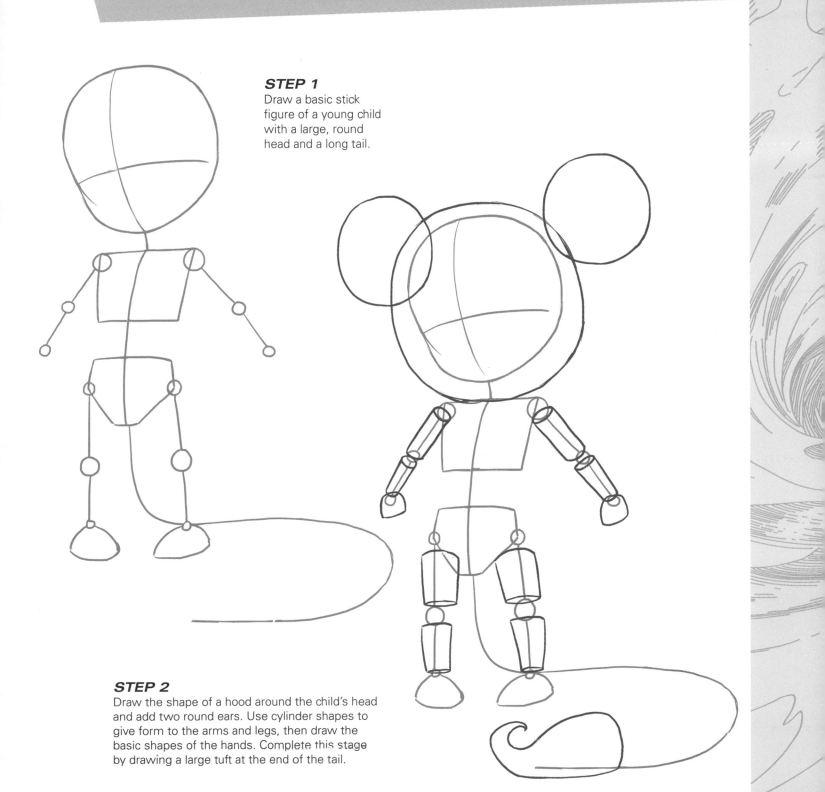

STEP 1
Draw a basic stick figure of a young child with a large, round head and a long tail.

STEP 2
Draw the shape of a hood around the child's head and add two round ears. Use cylinder shapes to give form to the arms and legs, then draw the basic shapes of the hands. Complete this stage by drawing a large tuft at the end of the tail.

STEP 3
Draw the child's basic facial features and hands and the outline of the animal suit. Add the animal's eyes, nose and teeth to the top of the hood and draw the insides of the ears.

STEP 4
Add details to the child's eyes and the animal's face on top of the hood, then draw the child's hair. Finish off the tail, add a zip to the suit and draw the stitching on the shoes. Add shading under the child's chin and draw some whiskers on each side of the hood.

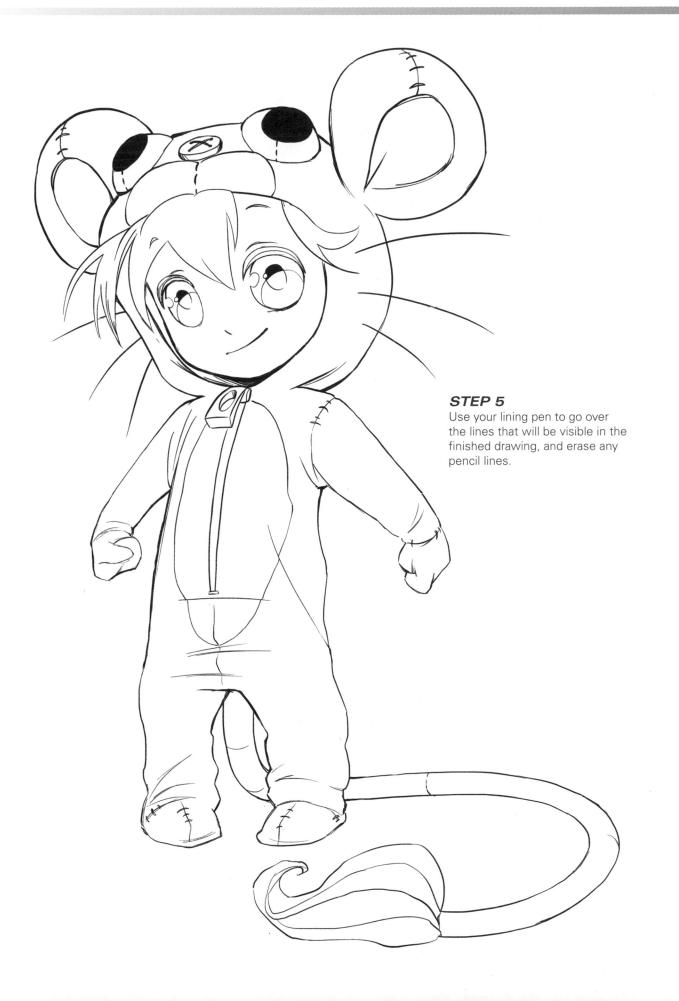

STEP 5
Use your lining pen to go over the lines that will be visible in the finished drawing, and erase any pencil lines.

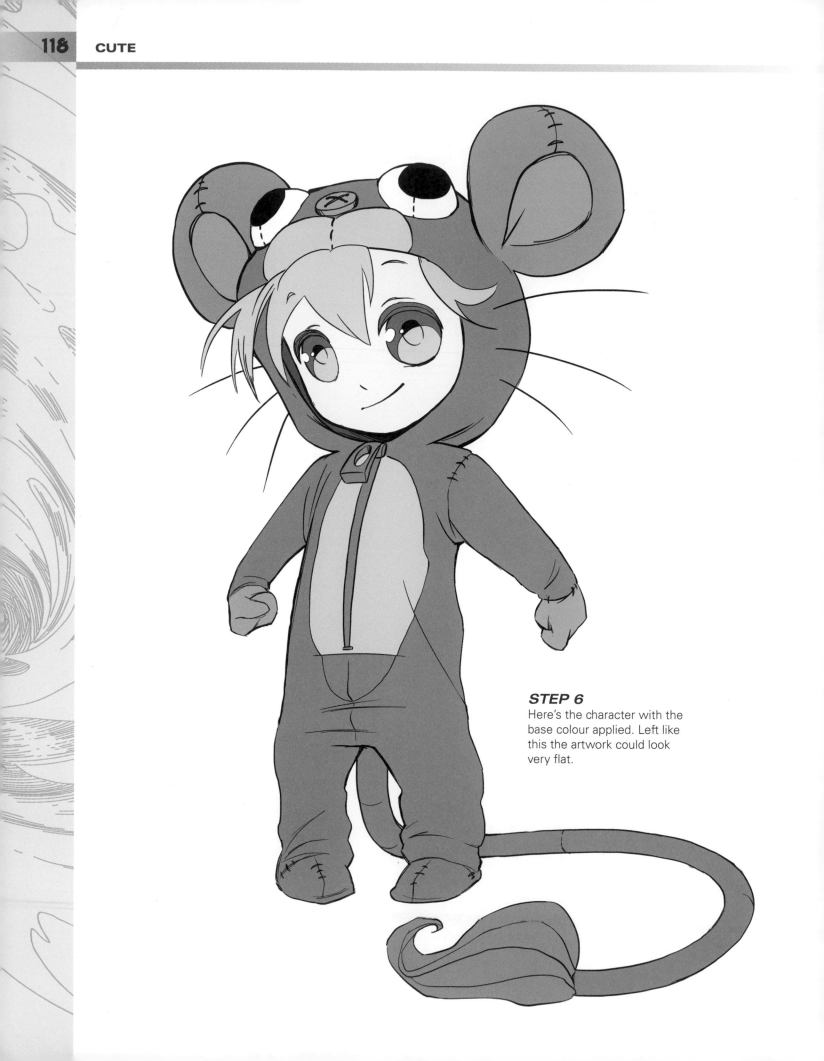

STEP 6
Here's the character with the base colour applied. Left like this the artwork could look very flat.

STEP 7
The subtle use of shadows wherever the material folds or gathers has created texture and dimensionality.

● ARTIST'S TIP
Using muted pastel colours will help to add to the child-like element and overall cuteness. Brighter, more solid colour choices would lose the innocence you are trying to capture with this character.

BUBBLEGUM GIRL

The dominant element in this artwork is the character's hair. Despite the disparity in size, we didn't pass up the opportunity of adding detail to her dress, thereby bringing balance to the composition.

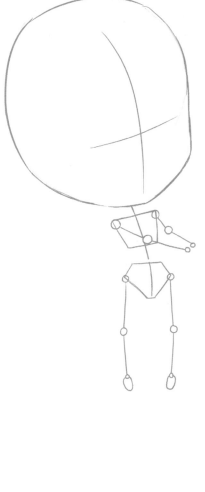

STEP 1

Draw a basic stick figure of a girl with a huge head, which is turned slightly to her left. Her arms are extended to her left-hand side and her hands are close together.

STEP 2

Use cylinder shapes to give form to her arms and lower legs and draw two lines marking the sides of her neck and the basic shapes for her hands. Now draw the girl's hair, which is tied up in bunches on either side of her head, and her flared, knee-length skirt.

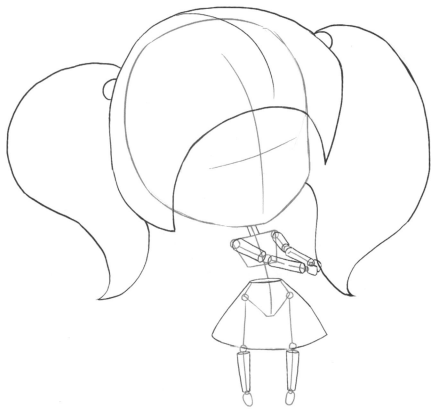

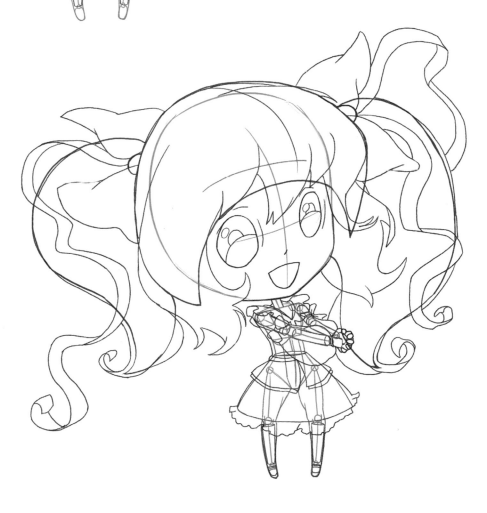

STEP 3

Draw her basic anatomical features, including her large, rounded eyes, button nose and open mouth. Then draw her fingers, which are clasped together.

STEP 4

Add more detail to the girl's eyes and hair and draw the large bows and curling ribbons tying up her bunches. Now draw her shoes and dress with its frills, bows and long, puffed sleeves.

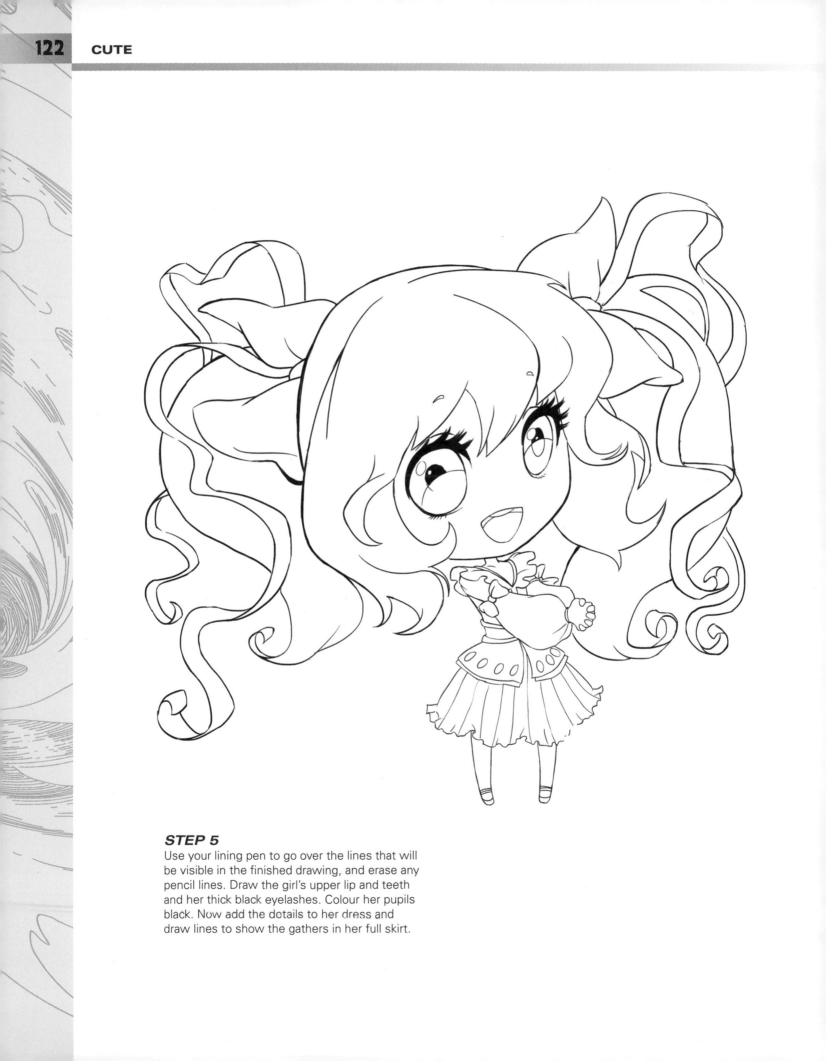

STEP 5

Use your lining pen to go over the lines that will
be visible in the finished drawing, and erase any
pencil lines. Draw the girl's upper lip and teeth
and her thick black eyelashes. Colour her pupils
black. Now add the details to her dress and
draw lines to show the gathers in her full skirt.

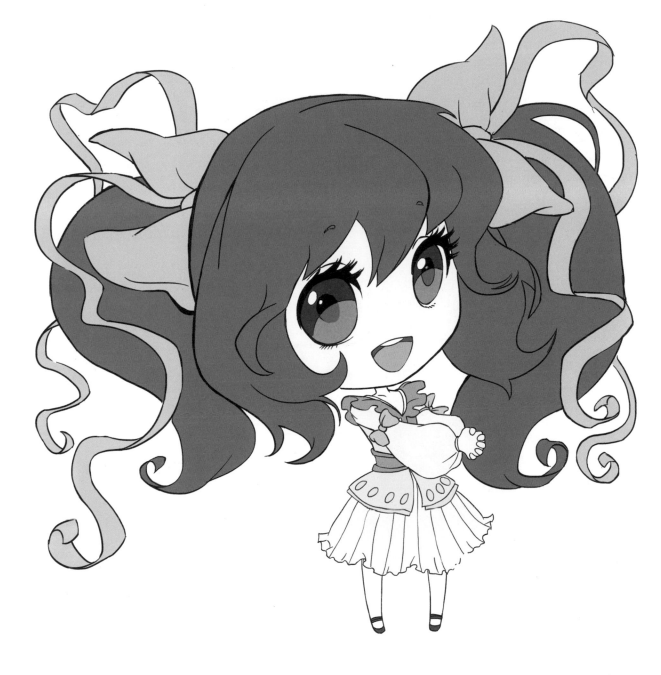

STEP 6
A pretty pale pastel shade has been used for the dress to give the character an extra dose of cutenesss.

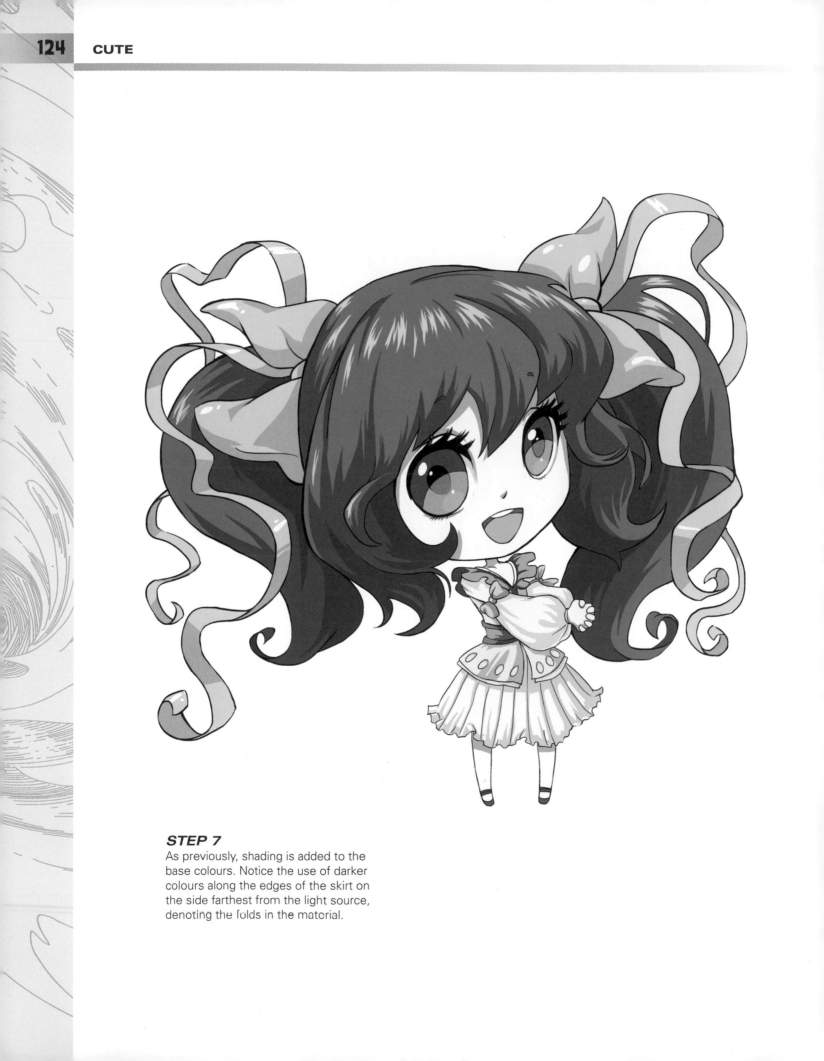

STEP 7

As previously, shading is added to the
base colours. Notice the use of darker
colours along the edges of the skirt on
the side farthest from the light source,
denoting the folds in the material.

GOTH GIRL

Creating a character like this little goth allows you to maintain a cute edge to your work while introducing a sombre storyline. She might love clothes and making a statement with them, but she can cope with life's gritty challenges as well.

STEP 1
Draw a basic stick figure of a girl with a large head and long legs. Most of her right arm is hidden behind her body.

STEP 2
Use cylinder shapes to give form to her legs and left arm, then draw two lines to mark the sides of her neck and the basic shape for her left hand. Complete this stage by drawing her flared skirt.

STEP 3

Draw the girl's basic anatomical and facial features, then draw the curled fingers and thumb of her left hand.

STEP 4

Add detail to your character's wide eyes. Now it's time to draw her long, flowing hair and elaborate outfit, including her hat, striped sleeves and stockings, boots and fingerless gloves.

STEP 5
Use your lining pen to go over the lines that will be visible in the finished drawing, and erase any pencil lines.

STEP 6

We used a very strong shade
for her dress to ensure
her outfit would not be
completely upstaged by her
hair colour.

STEP 7

Pay close attention to the hair when adding shadows and highlights to ensure it is really given shape and definition. It is one of this character's most striking features, so spending the extra time will pay dividends.

● ARTIST'S TIP

The face of your character is really important, as in real life this is naturally the first place you look when connecting with another person. Here the pale skin framed by dark hair creates an area of high contrast that draws your eye to her face. The cool green of her eyes also helps them stand out against the warm reds and purples.

MINI-MONSTER

What would manga and anime be without small collectible monsters? When it comes to designing them, try basing your monster's features on those of an existing animal and then distorting them.

STEP 1

Draw a stick figure of a creature in a sitting position, with its left front leg raised. It has two very large, pointed ears and a long tail with two horn-like projections towards the end.

STEP 2

Use cylinder shapes to give bulk to the creature's front legs. Draw a cone shape to form the tail and add the outlines of the two projections at the end. Draw circles for its nose and mouth. Two blunt horns close to the front edges of the ears complete this stage.

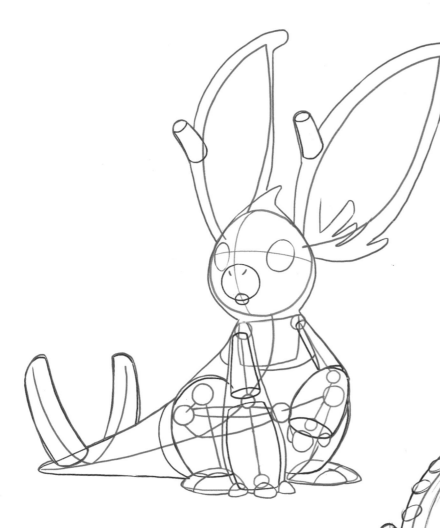

STEP 3
Draw the outline of the mini-monster's body. Now draw the edges of the ears and the basic facial features. Add a point to the top of the monster's head and draw its feet and claws.

STEP 4
Complete the monster's face and ears and add small raised bumps to its ears, face and body as shown.

STEP 5
Use your lining pen to go over the lines that will be visible in the finished drawing, and erase any pencil lines.

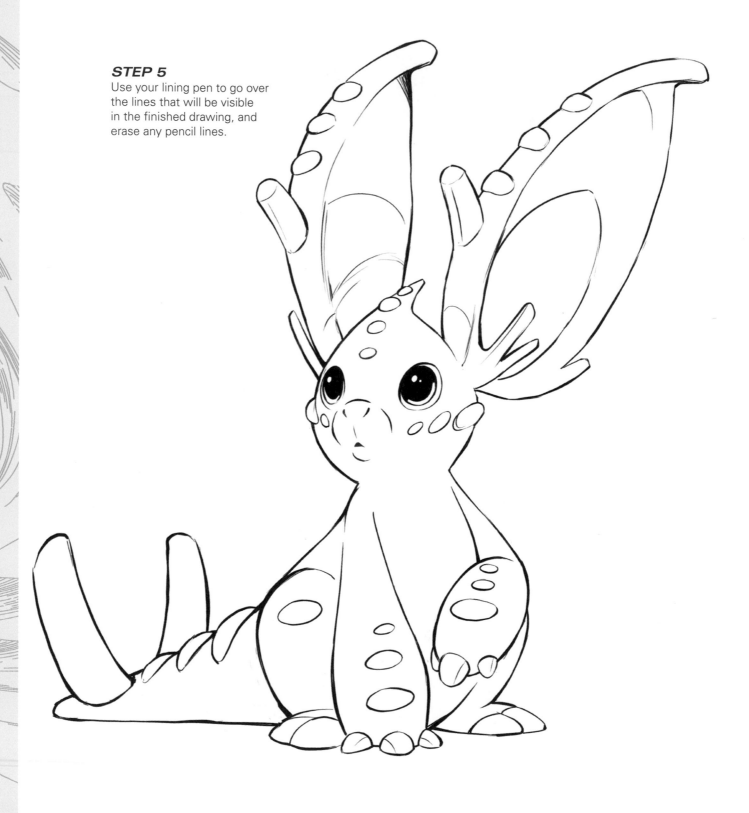

STEP 6
The base colouring involves lots of different shades for the ears, tail and main body. These will be blended together at the next stage.

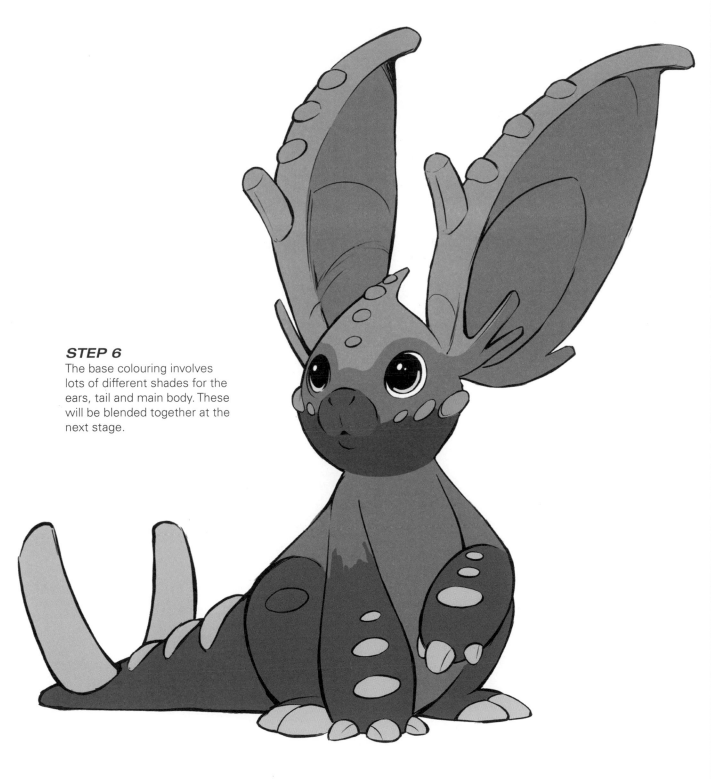

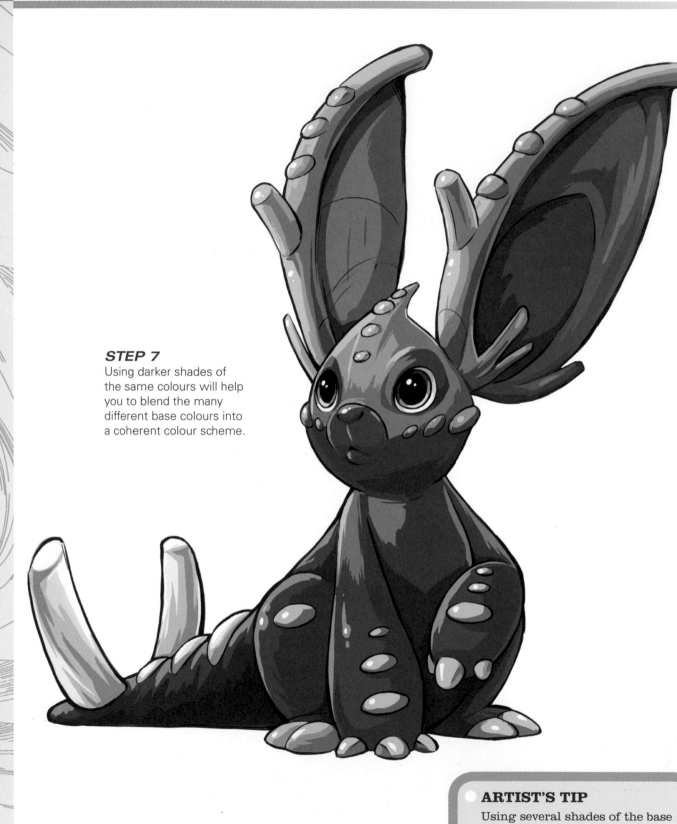

STEP 7
Using darker shades of
the same colours will help
you to blend the many
different base colours into
a coherent colour scheme.

● **ARTIST'S TIP**

Using several shades of the base
colours creates an intriguing,
detailed colouring effect. Don't
forget to add highlights where
light reflects the most to make
the creature's ears and scales
look shiny.

ACTION

Now is a time for heroes. They may look like members of a bad biker gang or innocent maids, but this doesn't mean that when the time is right they won't step into the action and emerge as heroes.

Every story needs a character you can root for. In this section you will find winners – characters who won't let you down. But don't take your heroes for granted; they may surprise you when you least expect it.

TIPS AND TRICKS

Action manga is all about turning the mundane into something exciting. This can be done in a number of ways – the use of focus lines, perspective and dynamic angles can all work together to turn the dull into the amazing.

This two-panel image of a car driving along a road could be used as a transitional panel to show a character covering distance, but it just isn't exciting.

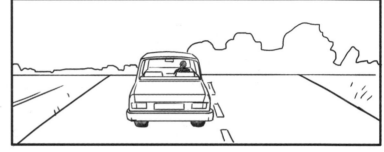

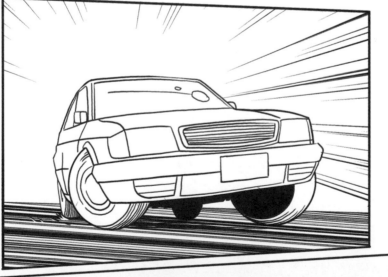

Now take a look at the next panels. Changing the angles of the car and the shape of the border boxes to make them more dynamic has already given a lot more movement to the scene. The addition of focus lines adds a sense of urgency.

A great tip is to use opposing angles to add even more action. Having the car slanted at one angle while the horizon slants at an opposing angle is an excellent way to achieve this.

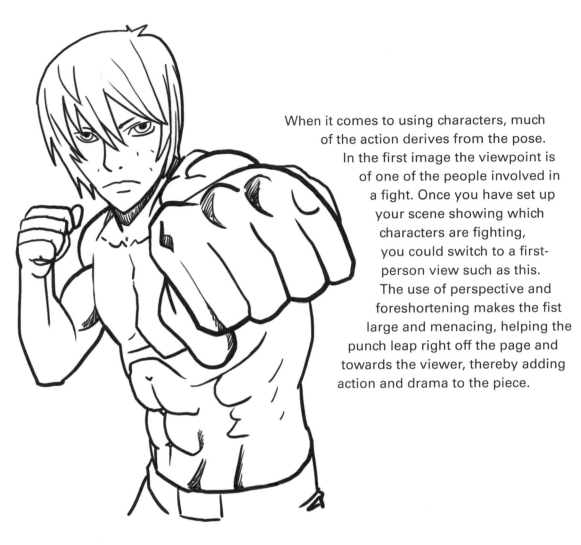

When it comes to using characters, much of the action derives from the pose. In the first image the viewpoint is of one of the people involved in a fight. Once you have set up your scene showing which characters are fighting, you could switch to a first-person view such as this. The use of perspective and foreshortening makes the fist large and menacing, helping the punch leap right off the page and towards the viewer, thereby adding action and drama to the piece.

The next technique, of basing your drawing on perspective lines, takes a little more planning at the rough stage, but effectively indicates the power and flow of a scene.

A triangle technique is used for the flow of the perspective lines, enabling the entire movement of the attack to be shown in a single panel. The leading foot shows the fighter is stepping forwards into the attack, while his leading fist is about to connect a punch. The use of perspective then leads your eye towards his trailing fist, which suggests that it will follow up the original attack with a strike upwards towards the opponent's head.

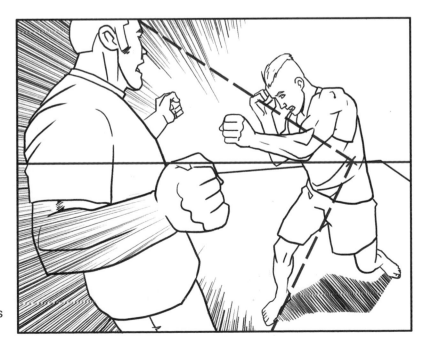

HEROIC BOY

Not all martial artists have to be muscle-rippling, angular, heroic types. Sometimes it's nice to mix things up a little by putting all that fighting power into a small, excitable package.

STEP 1

Draw a stick figure of a boy jumping in the air with his arms and legs outstretched. As he is young, his head is larger in proportion to his body than that of an adult. His pose means that his legs are foreshortened and the soles of his shoes are visible.

STEP 2

Use cylinder shapes to give bulk to his arms and legs and draw the basic shapes of his hands.

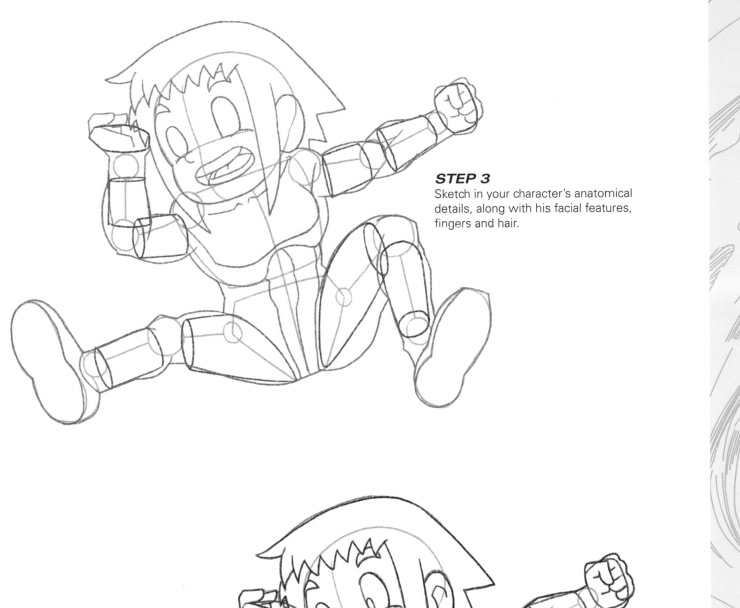

STEP 3

Sketch in your character's anatomical details, along with his facial features, fingers and hair.

STEP 4

Add details to the facial features and give the boy some clothes and a necklace of large beads.

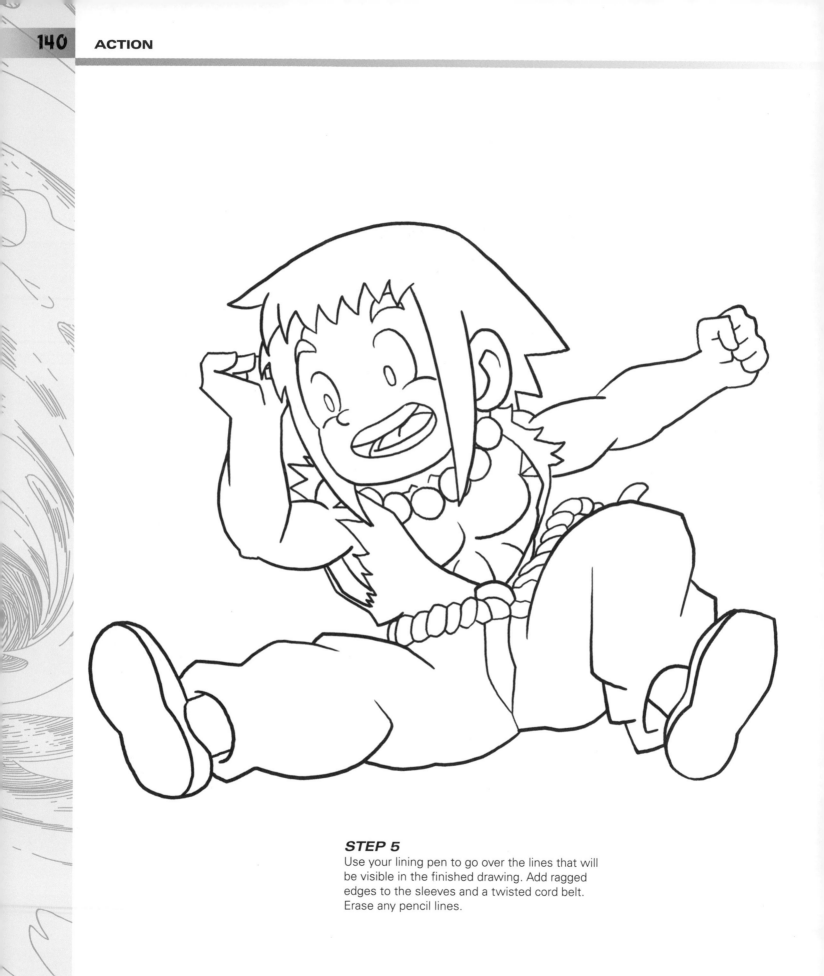

STEP 5

Use your lining pen to go over the lines that will be visible in the finished drawing. Add ragged edges to the sleeves and a twisted cord belt. Erase any pencil lines.

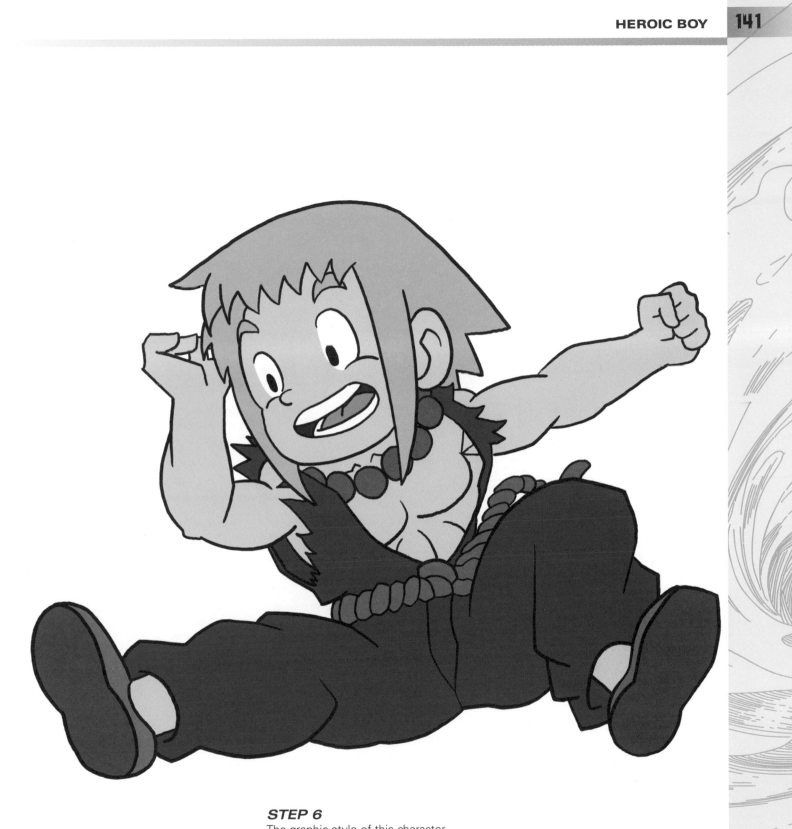

STEP 6
The graphic style of this character lends itself to the application of strong colours with hard edges for the base colouring.

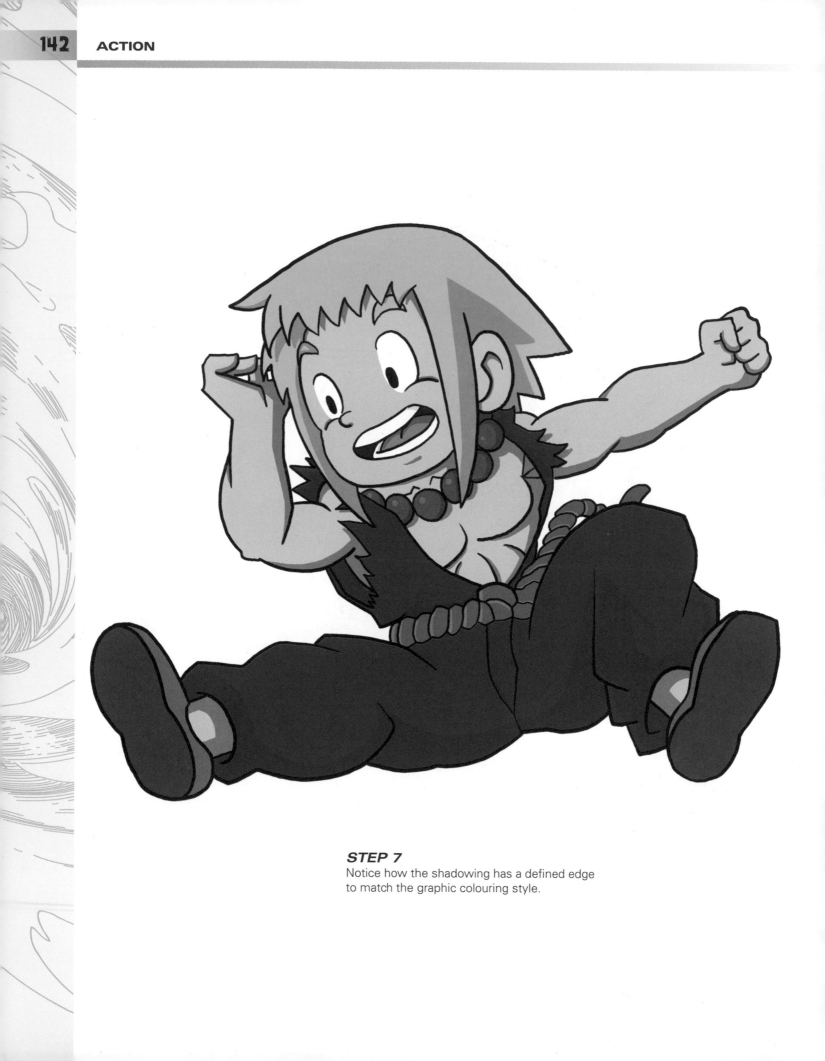

STEP 7
Notice how the shadowing has a defined edge
to match the graphic colouring style.

BIKER GANG GUY

One of the most iconic characters in anime for Western audiences is a biker gang member. For your own creation you can design an entire look, and choose to clad him in leather, denim or something more futuristic.

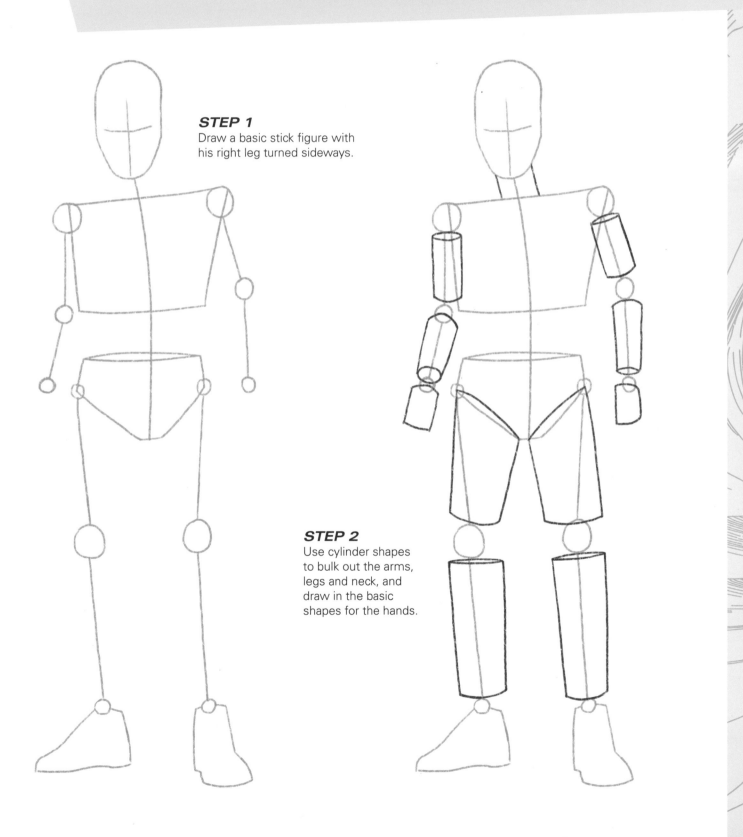

STEP 1
Draw a basic stick figure with his right leg turned sideways.

STEP 2
Use cylinder shapes to bulk out the arms, legs and neck, and draw in the basic shapes for the hands.

STEP 3

Sketch in the anatomical details, including the extended fingers on the left hand and the closed right fist. Add the facial features. The biker gang member's eyes are hidden behind his goggles.

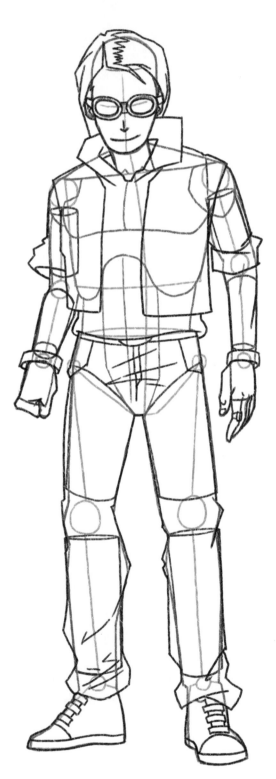

STEP 4

Draw the character's clothes and accessories, then draw his hair.

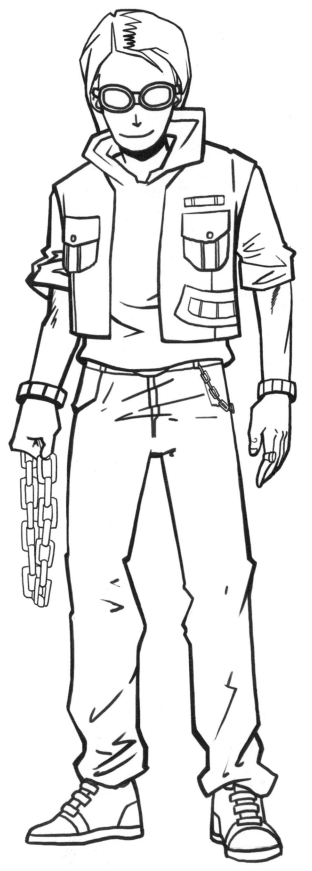

STEP 5

Use your lining pen to go over the lines that will be visible in the finished drawing. Add a shadow under the character's chin and mark the creases in his clothes. Then draw the chain in his right hand and the chain hanging from his belt on the left. Erase any pencil lines.

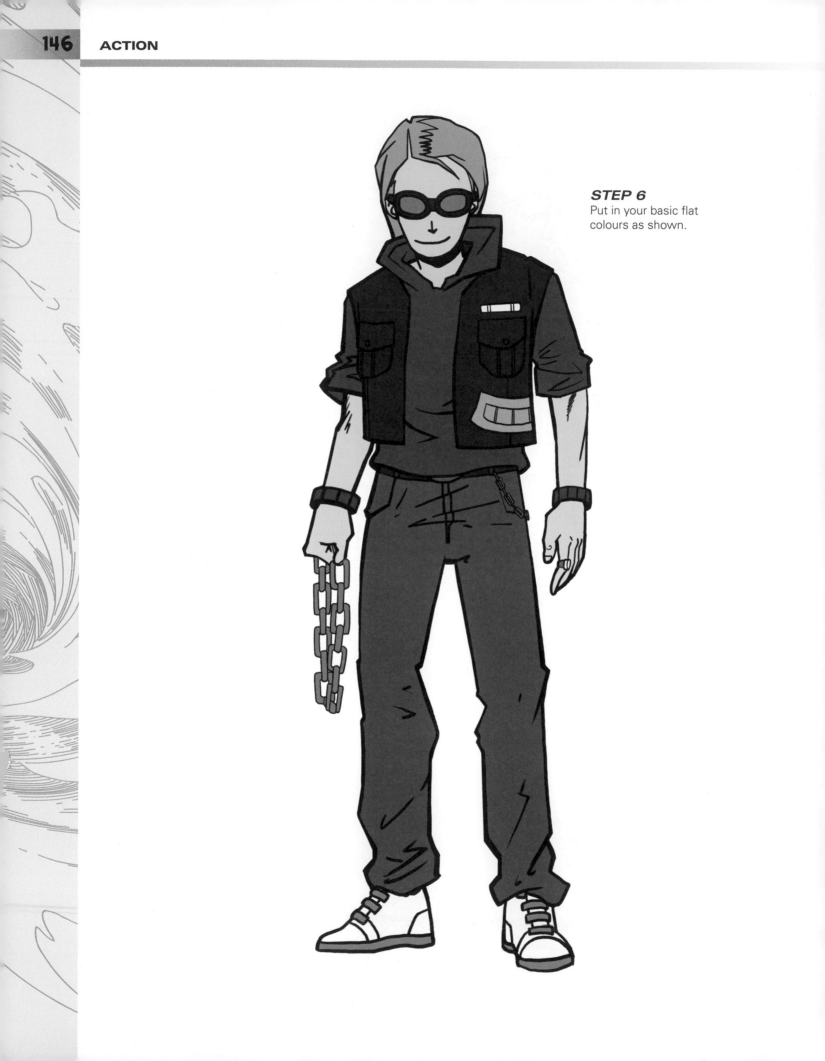

STEP 6
Put in your basic flat colours as shown.

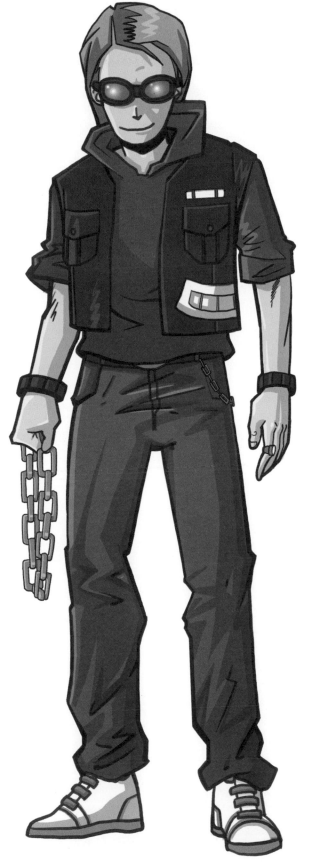

STEP 7
Add colour to complete the
shading and show the creases in
the character's clothing.

FEMALE COP

The heroes of many survival-horror games are female cops. Their overall shape allows for much more athletic-looking poses. A man in the same role would need to be more muscled in order to sell the role.

STEP 1
Draw a stick figure in a kneeling pose with her right leg extended and both arms raised to her right-hand side.

STEP 2
Use cylinder shapes to give form to the arms, legs and neck, and draw in the basic shapes for the hands. Only the upper part of her left leg will be visible in this drawing. Draw the gun held between her hands.

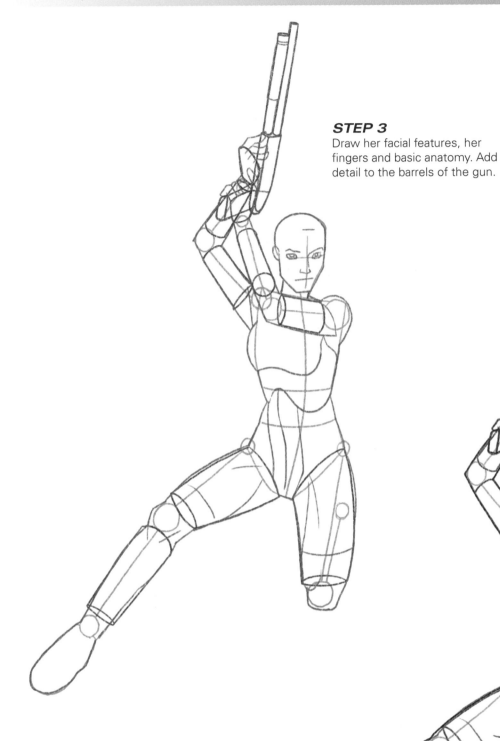

STEP 3
Draw her facial features, her fingers and basic anatomy. Add detail to the barrels of the gun.

STEP 4
Give your cop some hair, complete her facial features and draw her clothing, marking in the creases in her trousers. Add her shoulder holster, belt and right boot.

STEP 5

Use your lining pen to go over the lines that
will be visible in the finished drawing. Draw
a shadow under your cop's chin and add the
details to the gun, holster, belt and boot. Then
draw the police badge on her left sleeve. Erase
any pencil lines.

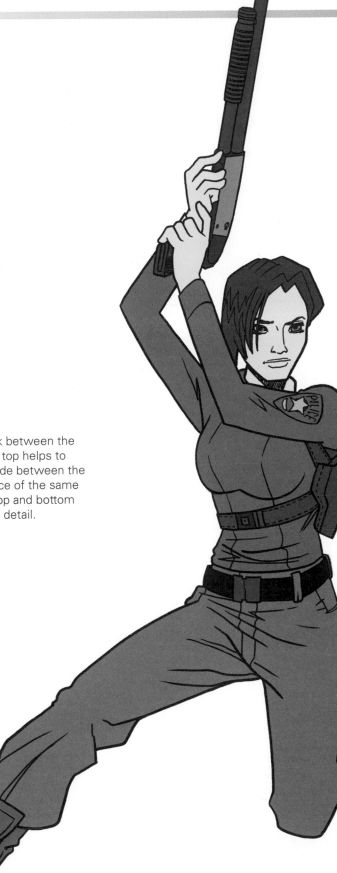

STEP 6

The natural break between the trousers and the top helps to make a clear divide between the colours. Avoidance of the same colour for both top and bottom will preserve the detail.

ARTIST'S TIP

Use plenty of folds in the clothing to help add to the dynamic action of the pose.

STEP 7

Use darker and lighter colour to add shading and highlights to give shape and depth to your drawing.

HEROINE MAID

Putting extremes together can be very effective. Here the maid outfit combining with the massive gun has you wondering how the story brought these two elements together.

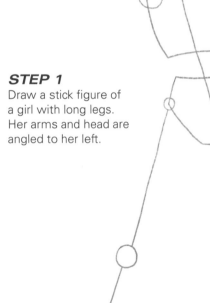

STEP 1
Draw a stick figure of a girl with long legs. Her arms and head are angled to her left.

STEP 2
Use cylinder shapes to give form to her arms, legs and neck, then draw the basic shapes of her hands.

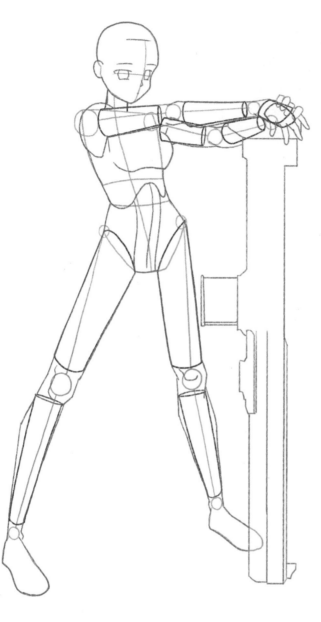

STEP 3
Draw your character's basic anatomical details, along with her facial features, including her extra-wide eyes. Add her fingers and the large weapon her hands are resting upon.

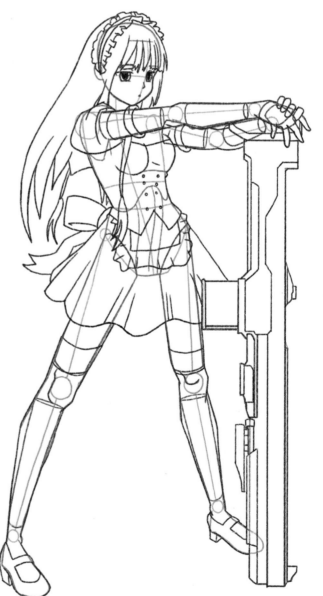

STEP 4
Add details to the facial features and give the girl long, flowing hair. Her right ear is hidden beneath her hair, so there's no need to draw that. Now draw her maid's outfit and long stockings.

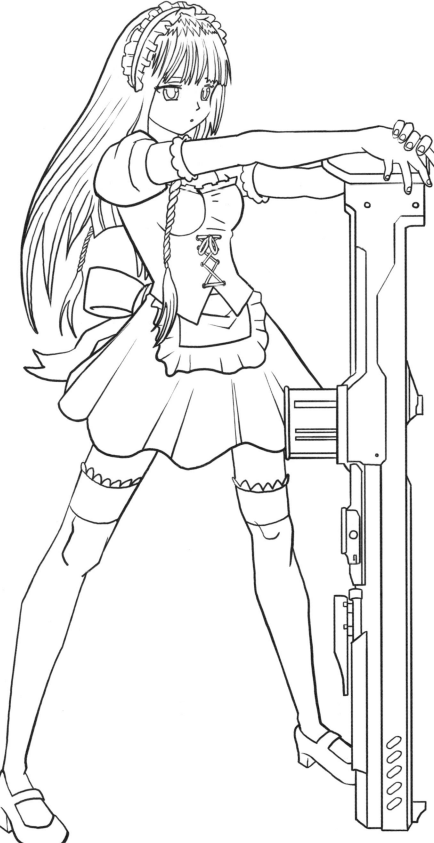

STEP 5

Use your lining pen to go over the lines that will be visible in the final drawing. Put the finishing touches to her costume and add the details to her hair and weapon. Erase any pencil lines.

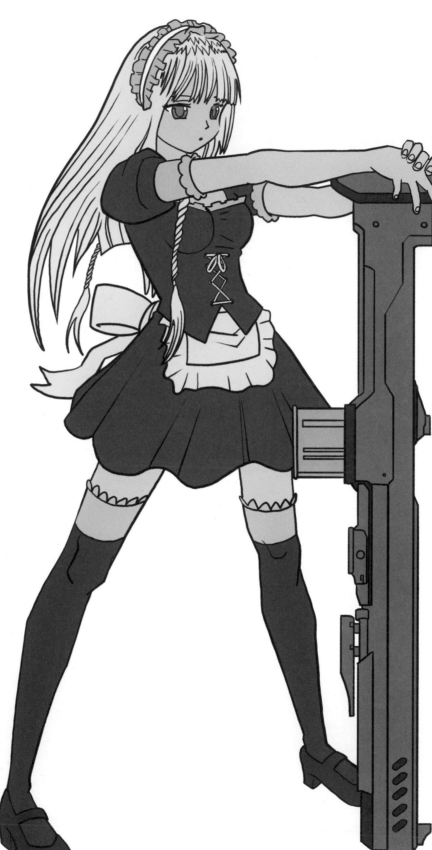

STEP 6

We used a uniform colour for this character's complete outfit. A dark blue like this requires a lot more highlighting at the next stage to add detail.

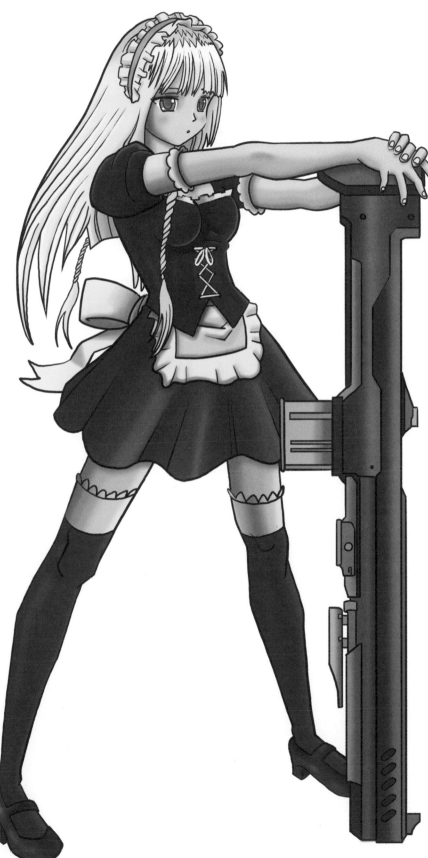

STEP 7
The use of highlights
on the darker clothing
bring out the folds.
Elsewhere note
how the addition of
shadows brings depth
and definition to the
character.

CYBORG ASSASSIN

The melding of human and machine shines through in this character. The ribbing on the suit mimics the muscles of the human form, emphasizing the biomechanical essence of this cyborg killer.

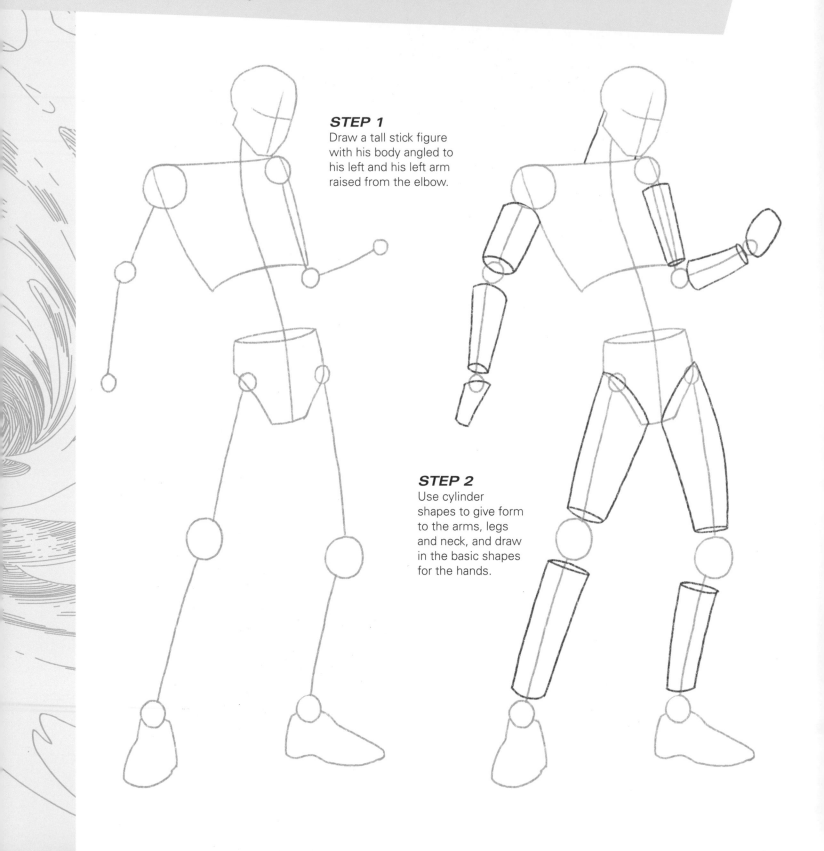

STEP 1
Draw a tall stick figure with his body angled to his left and his left arm raised from the elbow.

STEP 2
Use cylinder shapes to give form to the arms, legs and neck, and draw in the basic shapes for the hands.

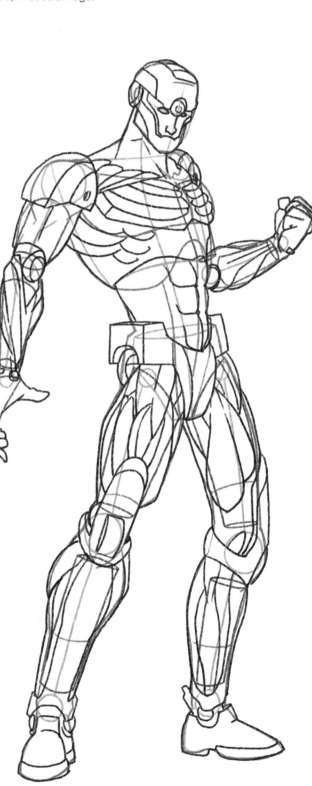

STEP 3
Draw the facial features and the basic anatomical details. This character has a narrow waist and wide, muscular legs.

STEP 4
Draw the muscles in the chest, abdomen, legs and forearms, along with the helmet and the mechanical parts of the upper arms, pelvis and knees.

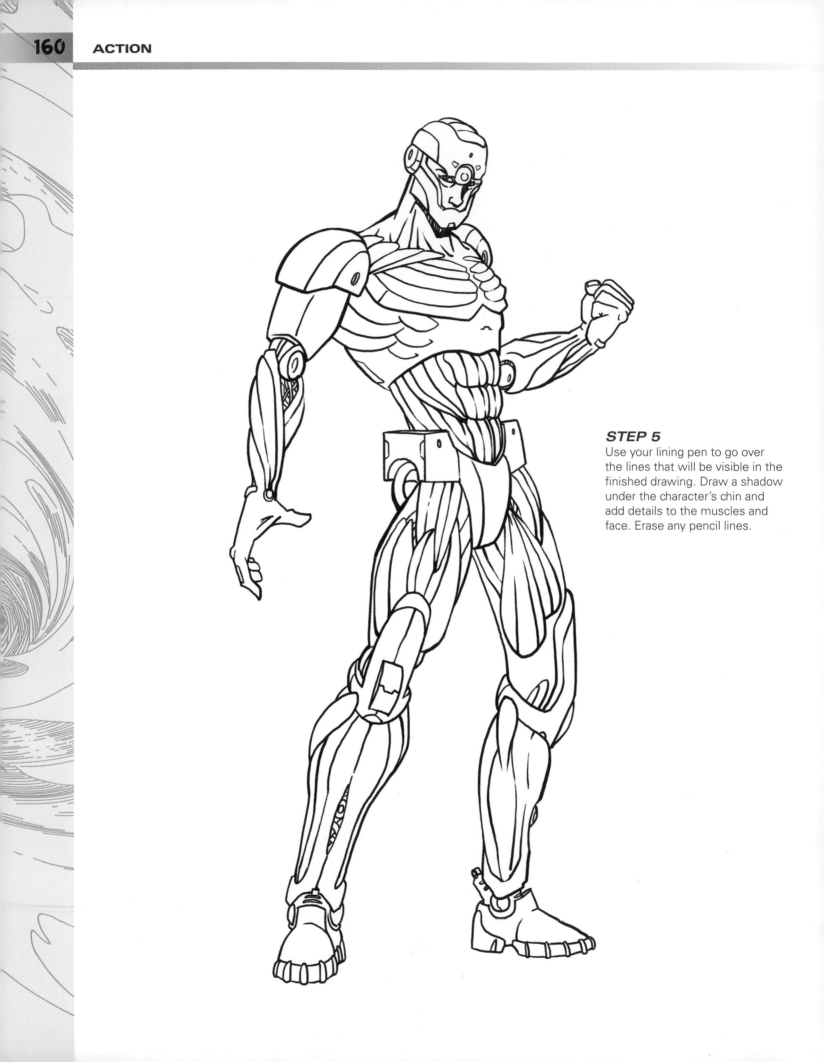

STEP 5
Use your lining pen to go over
the lines that will be visible in the
finished drawing. Draw a shadow
under the character's chin and
add details to the muscles and
face. Erase any pencil lines.

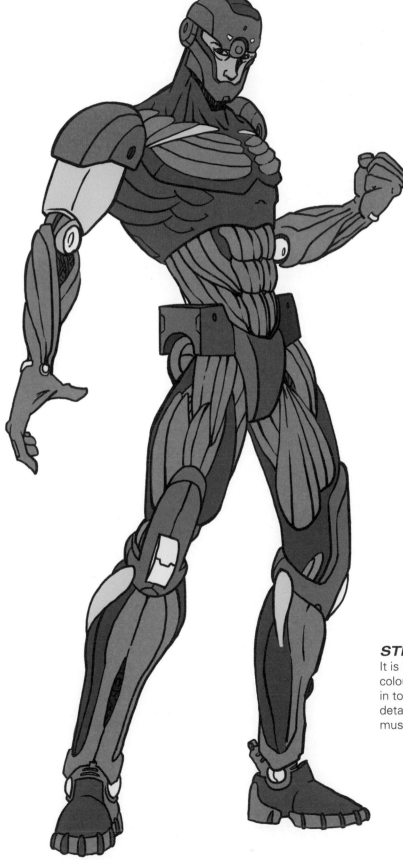

STEP 6
It is important to keep the colouring of the muscles light in tone – too dark and the details that identify them as muscles will be lost.

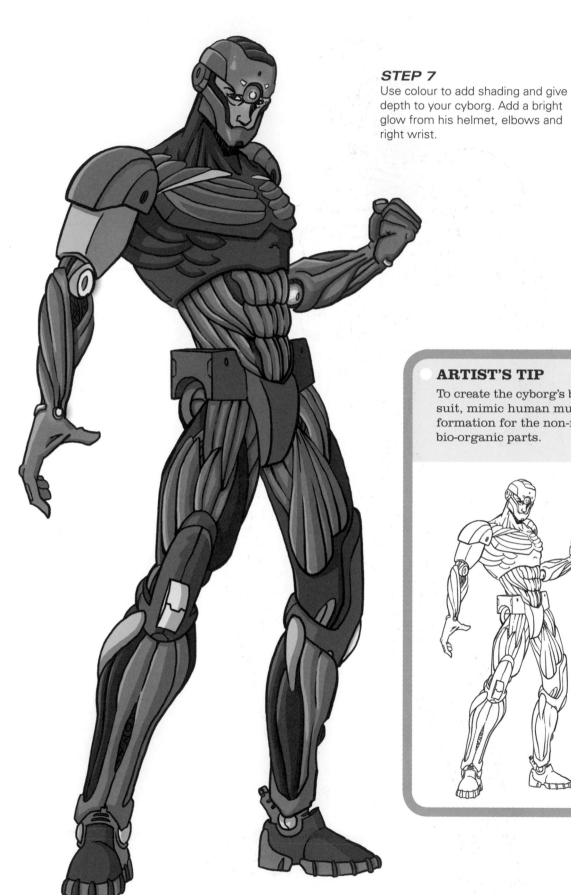

STEP 7
Use colour to add shading and give depth to your cyborg. Add a bright glow from his helmet, elbows and right wrist.

ARTIST'S TIP

To create the cyborg's bio-suit, mimic human muscle formation for the non-metallic, bio-organic parts.

ROMANCE

Spanning the styles and influences of both the shojo and josei genres, romance is a world of handsome men and beautiful girls with amazing dresses and hairstyles.

As if constantly caught in a wind machine, romantic characters won't wear an item of clothing unless it can flow stunningly in the breeze, enhancing their sometimes ethereal looks and character.

Pay close attention to the design of hair and the creative use of ribbons and materials when drawing characters in this section.

TIPS AND TRICKS

Learning the basics of drawing fabric and clothing is essential if you want to create interesting outfits for your characters. Below are various examples of how the shape of fabric changes.

Most materials take on the form of whatever they are placed over. Experiment by taking a piece of plain cloth and placing it over different shapes. Start with a rounded object, such as a ball, which gives relatively uniform folds.

With the ball on a flat surface, the cloth has few folds before it settles; a hood or voluminous sleeves would fit this shape. Where the cloth hangs freely, it makes a suitable study for a long skirt. Shining a bright light from one side will show the shadows the cloth casts on itself.

How fabric looks when hanging from a hook or pinned at the shoulder on a dress.

With the addition of a second hanging point fabric sags between the two, affecting the folds.

RUNAWAY RIBBONS

Ribbons will add a feminine feel to a garment, and if drawn properly can bring movement to your image.

To practise drawing a ribbon, start with a squiggly line.

Next, draw another equally squiggly line next to it.

Connect the tops and bottoms of the lines. Now use your inking pen or a dark pencil to line the edge like this.

Erase the extra lines and add shading to give the ribbon form, putting in darker shading where the shadows will fall.

Using the same technique, you can make longer, thinner ribbons that look as if they are flowing in the wind. Adding a curl at the end will emphasize their floating nature.

ANGEL

An ethereal angel can be used very effectively to deliver devastating news, help your characters or add a twist to your stories. The wings on this stunning example take time and work to get right, but the end result is worth the effort.

STEP 1
Draw a tall, slim stick figure with wide, feathery wing shapes extending from her shoulders. She has a feminine, pointed chin and her feet are hanging down because she is flying.

STEP 2
Use cylinder shapes to give form to the figure's slender arms and legs, then draw the lines marking the sides of her long neck and the basic shapes for her hands. Sketch in the train of her dress, which is floating down behind her legs.

STEP 3
Draw her basic anatomical details and facial features, including her wide, rounded eyes. Complete the drawing of her hands and wings.

STEP 4
Give the angel long, flowing hair, then add detail to her facial features, feet and wings. Draw her dress and mark the creases where it wraps and falls around her body.

STEP 5
Use your lining pen to
go over the lines that
will be visible in the
finished drawing, and
erase any pencil lines.

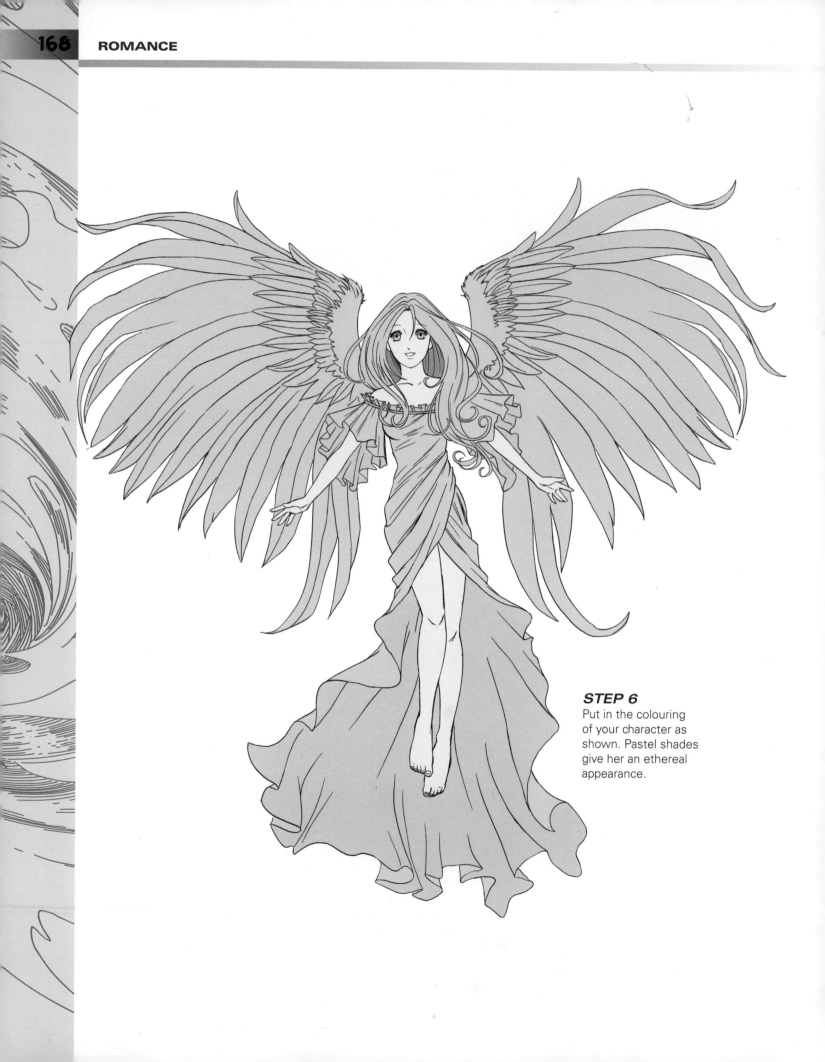

STEP 6
Put in the colouring
of your character as
shown. Pastel shades
give her an ethereal
appearance.

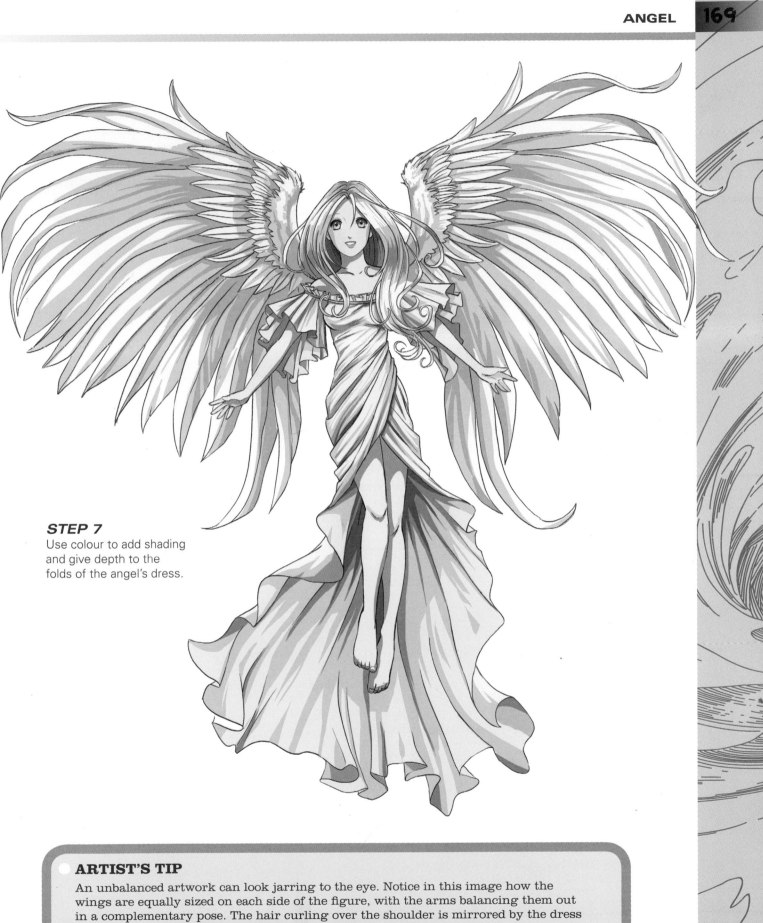

STEP 7
Use colour to add shading
and give depth to the
folds of the angel's dress.

● ARTIST'S TIP

An unbalanced artwork can look jarring to the eye. Notice in this image how the
wings are equally sized on each side of the figure, with the arms balancing them out
in a complementary pose. The hair curling over the shoulder is mirrored by the dress
billowing out further down, leading to a well-balanced image.

HANDSOME SUITOR

Even though this young fellow is bearing gifts, his form makes a good male base character for many scenarios. Try putting him in different clothes and poses and then make up storylines to go with them.

STEP 1
Draw a tall stick figure with long legs. His right arm is extended towards the viewer, so his forearm is foreshortened.

STEP 2
Use cylinder shapes to give form to the character's arms and legs, then draw the lines marking the sides of his neck.

STEP 3
Draw the young man's basic anatomical
details and facial features, then draw his
hands. His right hand is holding a box of
chocolates and the fingers of his left are
curled inwards.

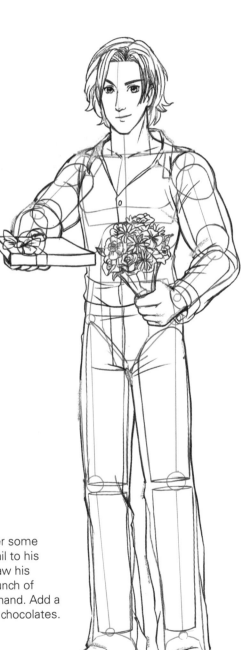

STEP 4
Give your character some
hair, then add detail to his
facial features. Draw his
clothes and the bunch of
flowers in his left hand. Add a
bow to the box of chocolates.

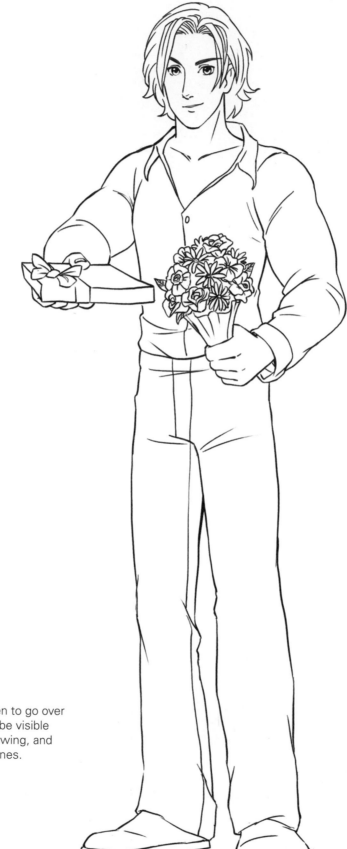

STEP 5
Use your lining pen to go over the lines that will be visible in the finished drawing, and erase any pencil lines.

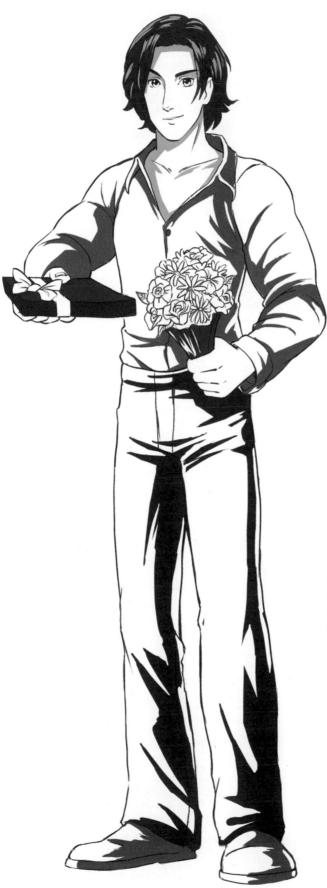

STEP 6
Colour the flowers and bow,
then put in the colouring of
your character using lighter
shades as shown.

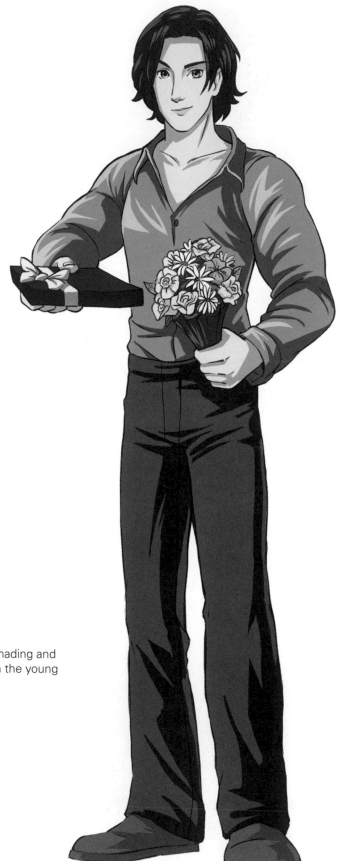

STEP 7
Use colour to add shading and show the creases in the young man's clothes.

KIMONO MAIDEN

This beautiful maiden offers excellent opportunities for you to practise drawing flowing hair and clothes, as well as showing you how to create smooth, curving shapes as the basis of characters.

STEP 1

Draw a basic stick figure of a girl's torso, arms and head. Her legs will be hidden beneath a long skirt, so be sure to leave space on your paper for this. Her right forearm is bent upwards towards her shoulder.

STEP 2

Use cylinder shapes to give form to the girl's arms and draw two lines marking the sides of her neck, along with the basic shape of her left hand. Now draw the outline of her wide, floor-length skirt.

STEP 3
Draw the girl's basic anatomical details and facial features, then draw her hands. Her right hand is resting on her right collarbone and her left is scattering flowers. Now draw the folds at the bottom of her skirt.

STEP 4
Complete the girl's dress by adding long, flowing sleeves and a crossover bodice with a wide sash. Now draw her long, straight hair, which frames her face and fans out behind her back. Add details to her facial features and a few flowers just above her left ear.

STEP 5
Use your lining pen to go over the lines that will be visible in the finished drawing, and erase any pencil lines. Add petals to the flowers the girl is scattering and draw the bow shape behind her head.

STEP 6

Colour the flowers and the inside of her sleeve, then complete the colouring of your character using lighter shades as shown.

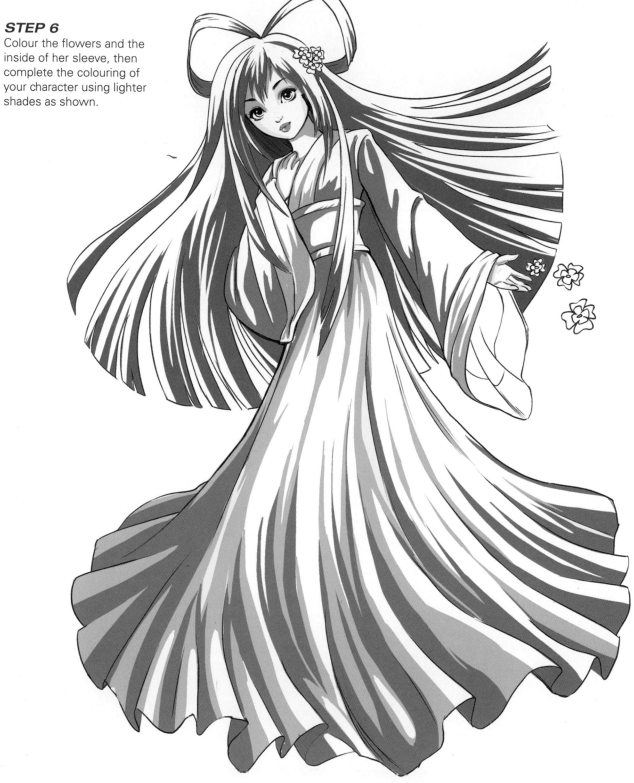

STEP 7
Use darker colours to add shading and define the folds of her full skirt.

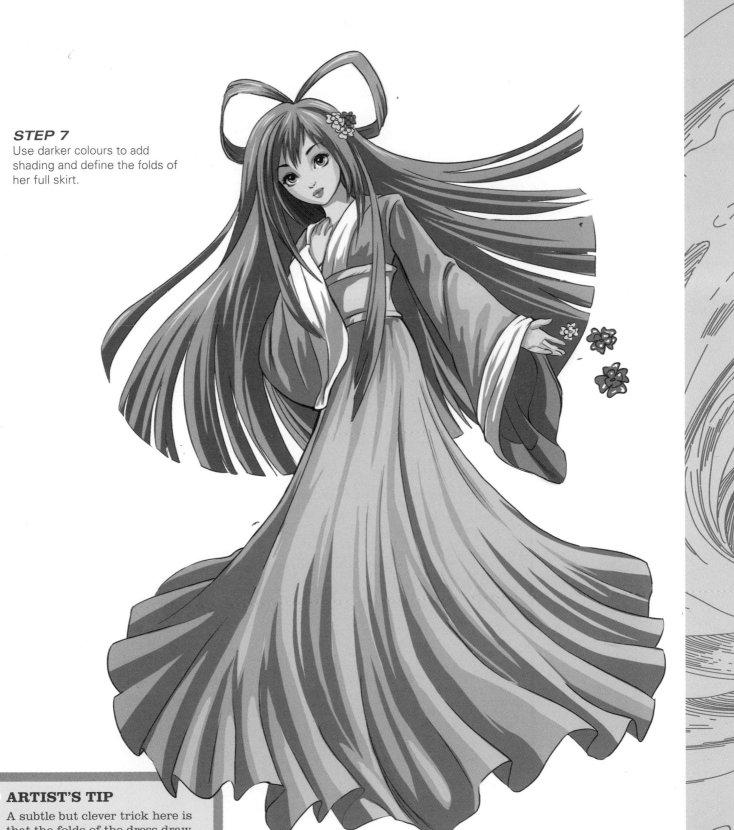

● ARTIST'S TIP

A subtle but clever trick here is that the folds of the dress draw the viewer's eyes up the dress to focus the attention on the face of the character.

LOVESTRUCK TEEN

Romance can also be represented by chibi-type characters, as shown with this wide-eyed little lady.

STEP 1
Draw a basic stick figure of a girl with a large head and rounded body, lying on her front and resting on her elbows. Her right leg is hidden behind her body, so just the top of her heel is visible.

STEP 2
Use cylinder shapes to give form to her arms and left leg, then draw a cylinder shape to mark the position of her neck, which will be hidden by her head. Draw the basic shapes of her hands, which are supporting her head.

STEP 3
Draw the girl's facial features, hands and the outline of her body and shoes.

STEP 4
Give her a fringe, a hairband, a pony tail and bunches in front of her ears. Add details to her facial features and draw some hearts above her head to show she's thinking of love. Complete this stage by drawing her clothes.

STEP 5
Use your lining pen to go over
the lines that will be visible
in the finished drawing, and
erase any pencil lines.

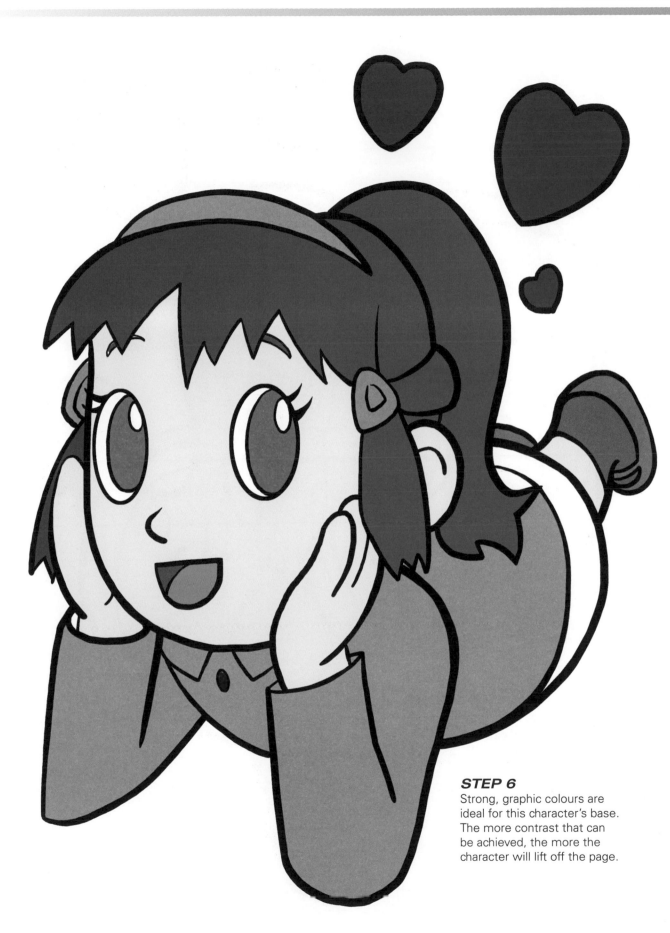

STEP 6
Strong, graphic colours are
ideal for this character's base.
The more contrast that can
be achieved, the more the
character will lift off the page.

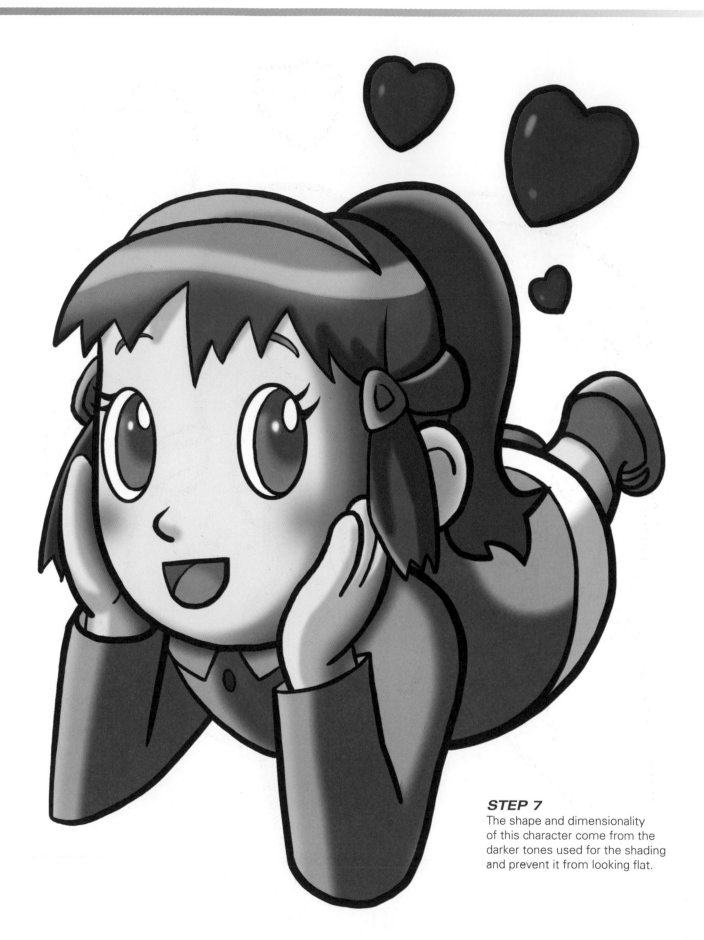

STEP 7
The shape and dimensionality of this character come from the darker tones used for the shading and prevent it from looking flat.

MECHA

Often massive in proportion and bristling with the deadliest of weapons, mecha come in all shapes and sizes. That said, it's not out of the ordinary to see much more human-sized mecha creations featuring in manga.

Let's face it though, if offered the choice between a friendly little mech who can do all the chores around the house and a city-destroying behemoth of a creation, we'd all choose the latter.

TIPS AND TRICKS

Grinding gears, hot oil, the clank of metal and the whine of hydraulics can only mean a huge mecha is approaching. Mecha machines can be some of the most fun creations to draw and they allow you to really let your imagination run wild. Bearing a few simple techniques in mind will help you to create mecha that will leave all who see them in awe.

Bigger is better

Playing with the scale of surrounding elements can be key to drawing outstanding mecha. A simple way to make your mecha massive is to reduce the scale of your backgrounds.

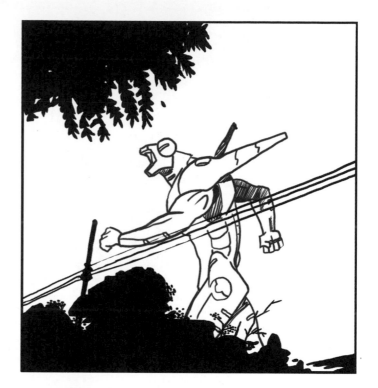

Adding a small set of power lines and shadows that are edged with leaf shapes has massively increased the apparent scale of this mech.

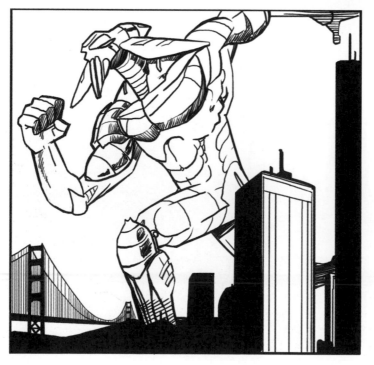

You can place your mech in a city quite easily by drawing scaled-down building silhouettes. Notice how a small bridge in the background also increases the scale.

Rust and oil rocks

Adding a bit of wear and tear to your creation will make it look more battle-hardened and believable. Of course, there is a place for pristine mechs when they first roll off the production line, but one that looks as if it's seen a bit of action is much more fun to draw.

Rust can be added to your mech by creating patches like these on the main metalwork. You can lightly shade them or, if colouring, use varying tones of brown to create the right look.

Damage from scrapes and bangs is easy to add with some simple dark crosshatch shading. If you want to show larger patches of damage, add some slightly thicker lines among the shading to indicate a dent.

Oil leaks show your mech has had a rough time. Drips from places where the metal joins, coloured in black with important white highlights along the drip, indicate that this mech is in need of attention if its vital fluids are not to leak away.

Try a new view

To give your mech massive scale without taking up the whole page, adjust your viewpoint from a standard straight-on pose.

Using foreshortening to make the upper body parts smaller will create height. Thicker lines for your inking as you get lower down the body will also help greatly with this sense of scale and weight.

SKID-ROW MECH

In a futuristic world there might be some rusty old robots like this just waiting for their time to be useful again. It's a neat twist to create a mech that isn't shiny new but looks like it has had a rough life.

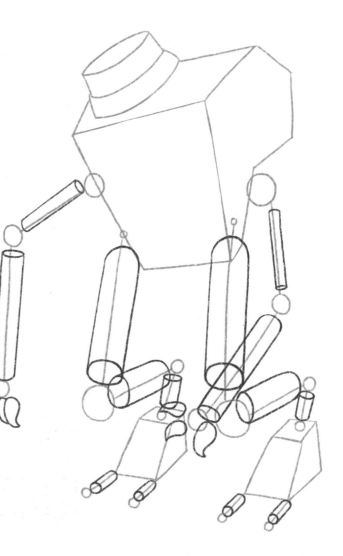

STEP 1
Draw a robot stick figure with high ankle joints leading to wedge-shaped feet.

STEP 2
Use cylinder shapes to give bulk to your robot's arms and legs and draw two narrow cylinders extending from each foot. Add three claws at the end of each arm.

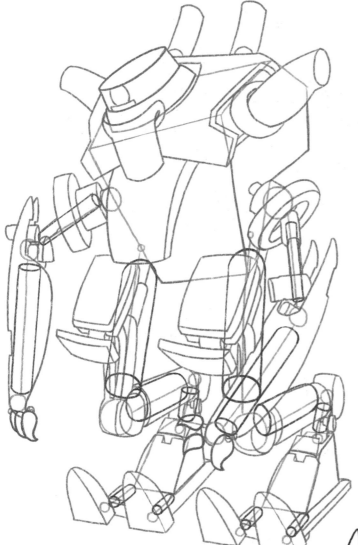

STEP 3
Add more parts to your robot, which is made up of a jumble of components.

STEP 4
Draw in the details on the robot's various parts, as shown.

STEP 5
Use your lining pen to go over
the lines that will be visible in the
completed drawing and add the
finishing touches, including some
basic shading, as shown. Erase
any pencil lines.

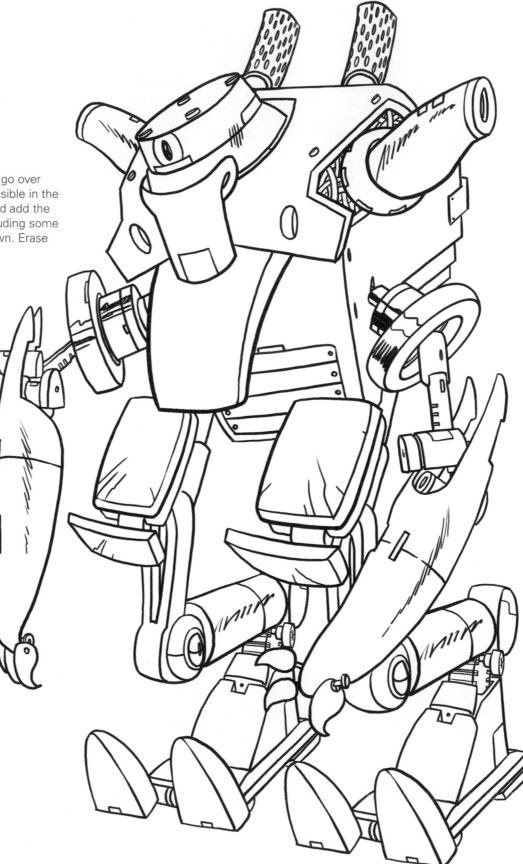

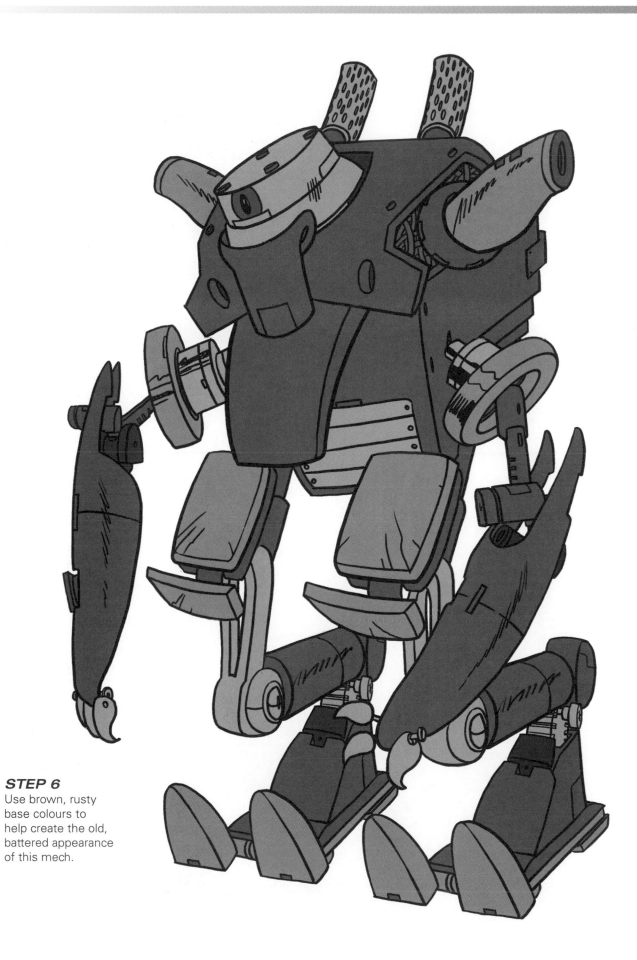

STEP 6

Use brown, rusty base colours to help create the old, battered appearance of this mech.

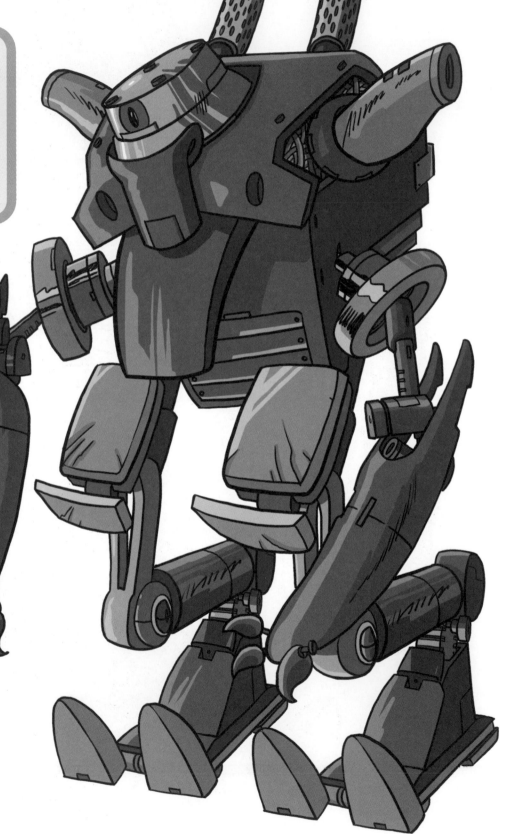

ARTIST'S TIP
Dull colours make the mech appear homemade – lots of bright colours will make it look like an expensive, factory-made machine. Try looking around your home for general household items you can build into your design as well.

STEP 7
Complete the shading using darker colours. Here, the light source is on your right.

HARD-EDGED MECH

The sharply angled blades on this mecha could easily transform into wings to aid it in flight both on this planet and beyond. They could even be turned into some kind of helicopter-style rotor.

STEP 1

Draw a stick figure with his right shoulder angled towards you. His feet are pointed downwards and there are two spikes extending from his hips.

STEP 2

Use rectangular box shapes to give bulk to his arms and legs. Draw the line of his neck and wedge shapes for his hands.

STEP 3

Draw the angular shapes that make up the robot's body. Add the large blade that extends from the back of his neck, then give your robot mechanical fingers, a helmet and eyes.

STEP 4

Put the finishing touches to your robot by drawing blades extending from his shoulders, upper arms and hips. Add details to his helmet and body, as shown.

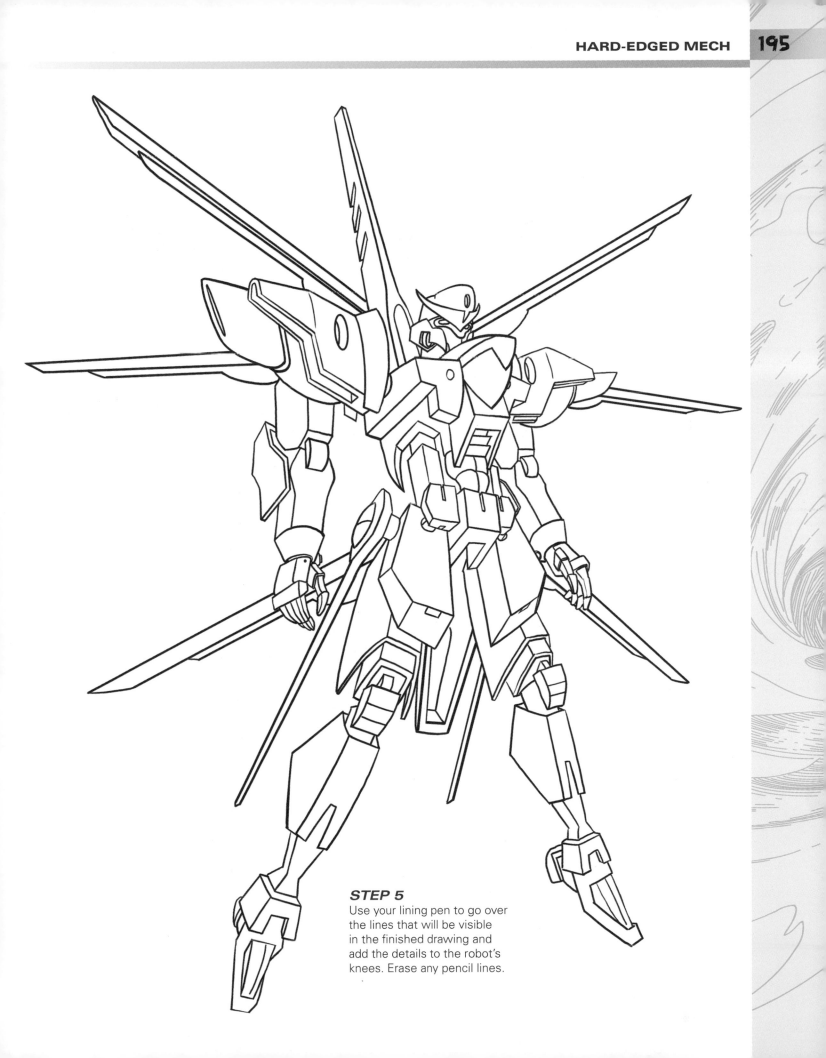

STEP 5
Use your lining pen to go over the lines that will be visible in the finished drawing and add the details to the robot's knees. Erase any pencil lines.

STEP 6
Pay close attention to the colouring – with so many angles and edges it would be easy to lose all the fine detailing.

STEP 7
When adding.shading and highlights, it is important to avoid making too many dark shadows. This will preserve the fine edges of your mech.

CORPORATE MECH

Designed by big business to carry out every conceivable task 24 hours a day to replace human workers and save money, these mechs can be seen in all of the cities of the future.

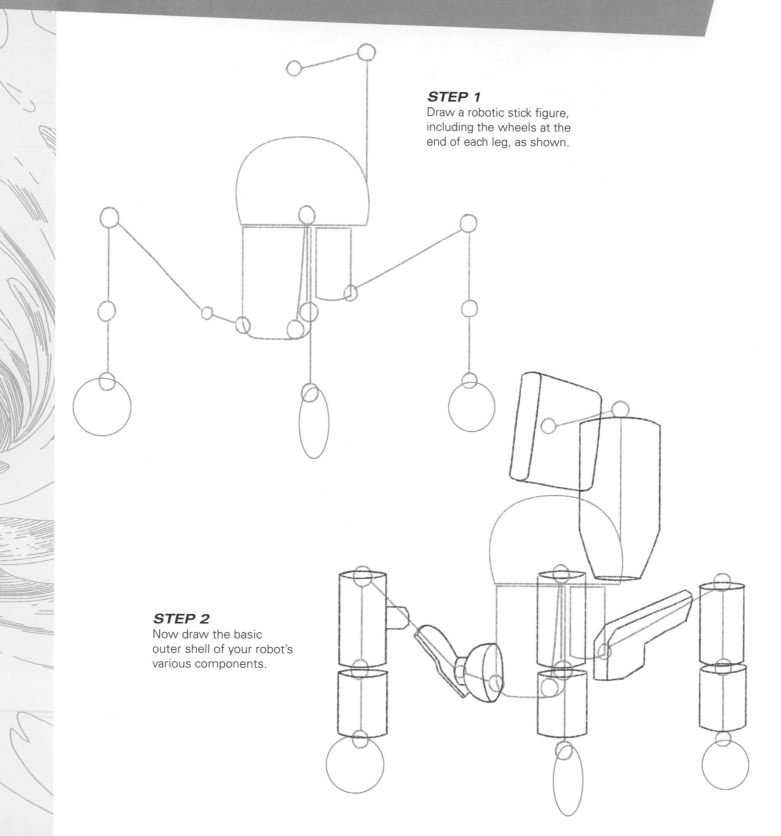

STEP 1
Draw a robotic stick figure, including the wheels at the end of each leg, as shown.

STEP 2
Now draw the basic outer shell of your robot's various components.

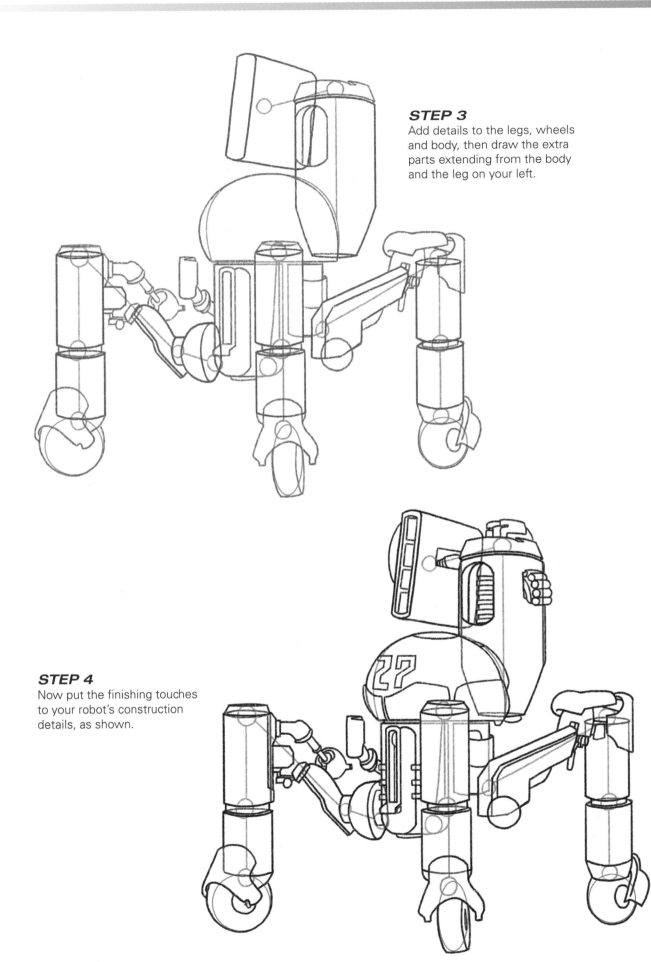

STEP 3

Add details to the legs, wheels and body, then draw the extra parts extending from the body and the leg on your left.

STEP 4

Now put the finishing touches to your robot's construction details, as shown.

STEP 5

Use your lining pen to go over
the lines that will be visible in the
finished drawing, and erase any
pencil lines.

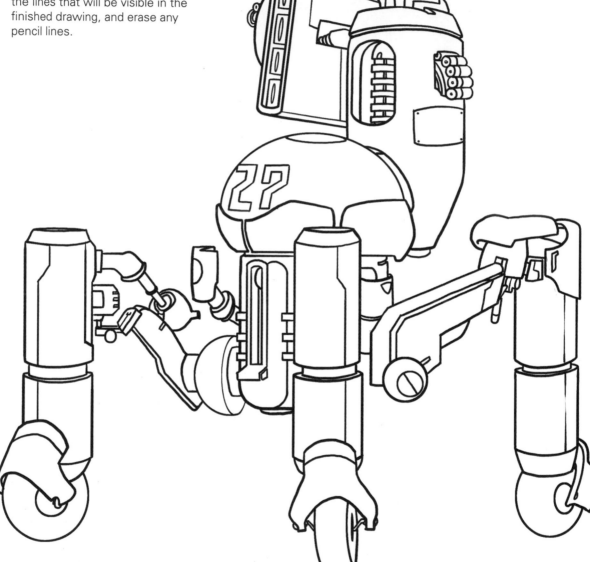

STEP 6

The colouring has to be appropriate for a corporate product. Design-led accents such as the orange dome.and detailing help to create the right effect.

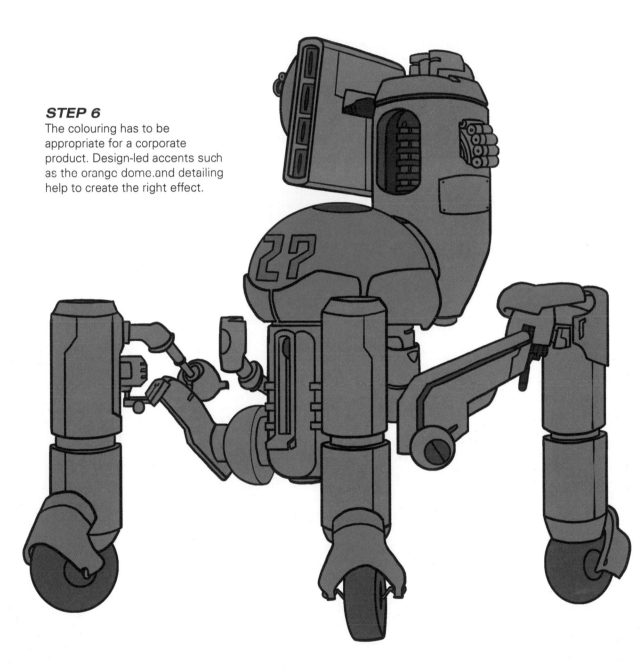

STEP 7
Use darker colours to add
shading to your drawing. In
this case the light is coming
from the left-hand side.

MECHA TEAM

The story options are endless with this interesting pair: physical presence joins forces with spiky intelligence, perhaps? You could explore storylines where the kid can act as the mech's conscience.

STEP 1

You will need to draw two stick figures for this illustration – a giant robot in a crouching position and a boy standing where the robot's right hand will be.

STEP 2

Use cylinder shapes to bulk out the limbs of both figures and draw the lines of their necks. Draw the basic shapes of the hands for the boy and the robot. The robot's right hand is extended beneath the boy with the palm facing upwards.

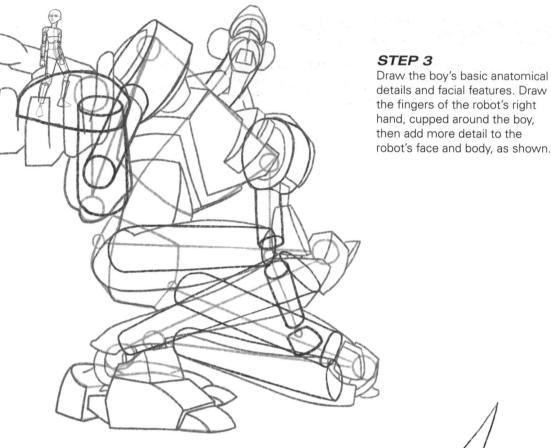

STEP 3

Draw the boy's basic anatomical details and facial features. Draw the fingers of the robot's right hand, cupped around the boy, then add more detail to the robot's face and body, as shown.

STEP 4

Give the boy some clothes, hair and a baseball cap. Add large blades to the robot's shoulders and more detail to his face and body parts.

STEP 5

Use your lining pen to go over the lines that will be visible in the completed drawing. Add pockets to the boy's shirt and put the finishing touches to the robot. Erase any pencil lines.

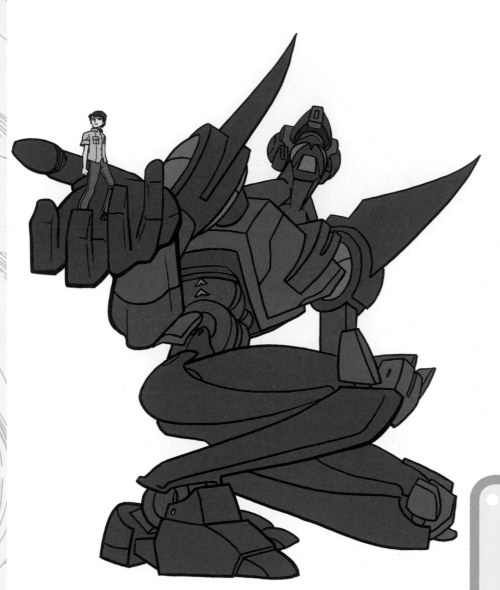

ARTIST'S TIP
Even though you won't see it on the final image, it's important to know how the furthest arm is positioned so you can get the perceived balance of the character's pose right.

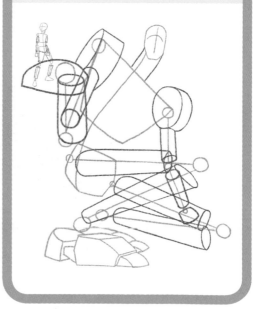

STEP 6
Different tones of red have been used for the base colours. These help to define the various planes of the mech, while keeping a uniform colour scheme.

STEP 7
Use darker colour to add shading. The light source is on your left, throwing a shadow of the robot's head onto the blade extending from his left shoulder.

GOLIATH SAMURAI

Here we have taken a bit of old feudal Japanese history and mixed it with some mech technology to create a building-sized monster of a machine.

STEP 1
Draw a large stick figure with huge feet and a small head. There are two poles extending from his shoulders.

STEP 2
Use cylinder shapes to give bulk to his arms, legs and the two poles. Note that the lower parts of his arms and legs are far larger than the upper parts. Draw in the lines of his neck and the basic shapes for his hands.

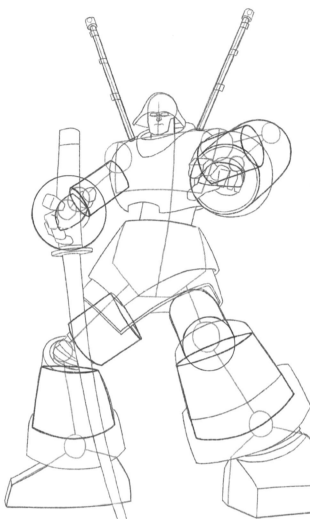

STEP 3
Draw the facial features and fingers, then give your robot a helmet, armour and a large sword. Add details to the two poles.

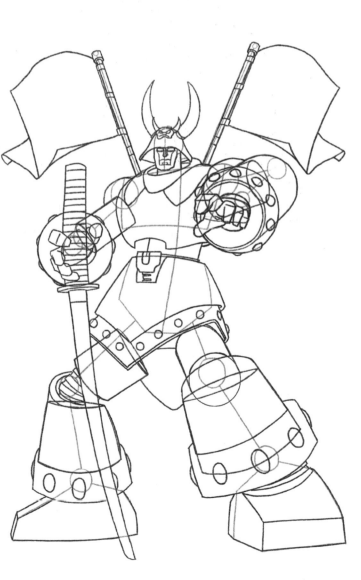

STEP 4
Draw two flags flying from the poles and add horns and a fierce face motif to the robot's helmet. Add details to his face, armour and sword, as shown.

STEP 5

Complete your robot by adding shading around his face and under his chin. Draw Japanese characters on the flags and the shaft of his sword and add the pattern on the sword's hilt. Use your lining pen to go over the lines that will be visible in the finished drawing, and erase any pencil lines.

● ARTIST'S TIP

Notice how perspective has been used to enhance the mech's massive scale. This has been achieved by making the dimensions of the character's top half slightly smaller.

STEP 6
This base colouring looks rather flat, but the correct use of shading at the next stage will give this formidable character a cool, metallic sheen

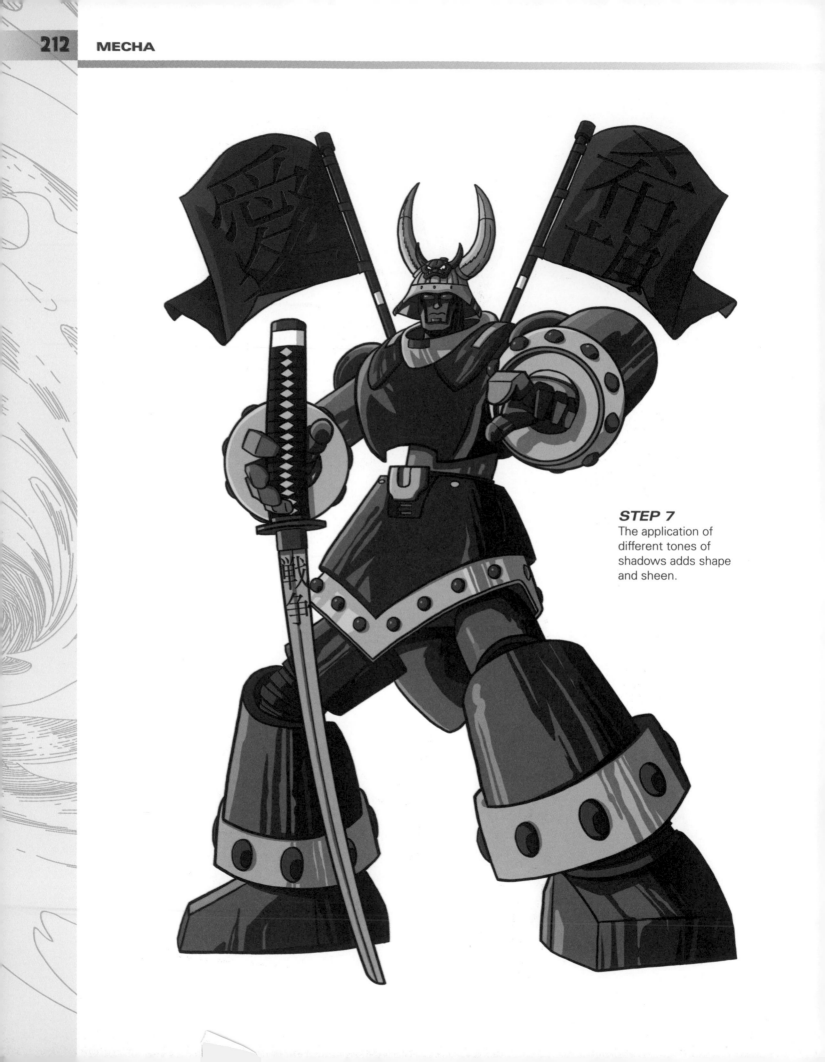

STEP 7
The application of different tones of shadows adds shape and sheen.

BACKGROUND CHARACTERS

No matter how amazing your main characters, or how gripping your story, if your world does not feature some everyday people living in your villages and cities it's going to look a bit odd.

From the friendly shopkeeper who warns your heroes not to continue on towards the creepy castle, to the frantic office worker who gets caught up in a huge mecha battle, everyone has their part to play in developing your story lines.

SALARY MAN

We tried to make this character realistic, with his dejected expression and slumped posture. Alongside the extraordinary in manga there have to be normal people for whom dodging mechas and mutant invasions is just a tiresome part of modern life.

STEP 1
Draw a basic stick figure with his shoulders stooped, his arms hanging loosely at his sides and his knees bent. He looks as if he is weighed down by the pressure of work.

STEP 2
Use cylinder shapes to give form to your character's arms and legs, then draw the lines marking his neck and the basic shapes for his hands.

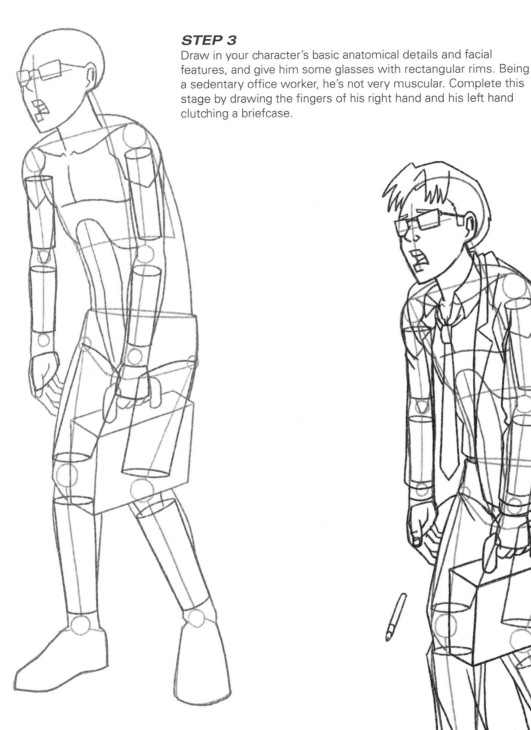

STEP 3
Draw in your character's basic anatomical details and facial features, and give him some glasses with rectangular rims. Being a sedentary office worker, he's not very muscular. Complete this stage by drawing the fingers of his right hand and his left hand clutching a briefcase.

STEP 4
Give your character some hair and a suit, shirt and tie. Add details to his facial features and shoes and draw the pen that he has dropped.

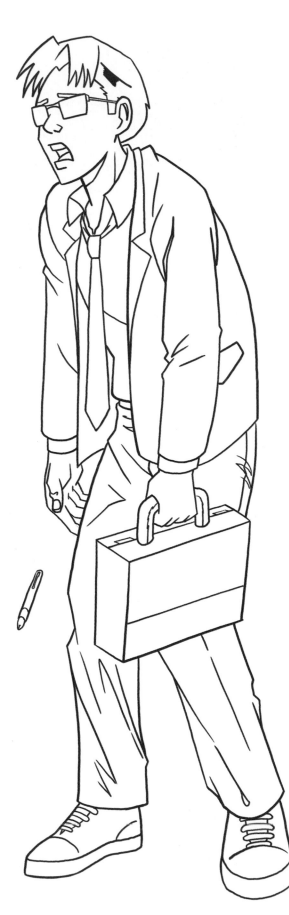

STEP 5

Use your lining pen to go over the lines that will be visible in the finished drawing, and erase any pencil lines. Put the finishing touches to his clothes, case, shoes and pen.

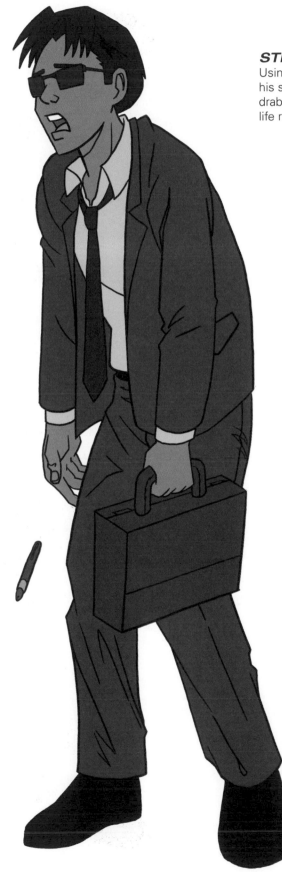

STEP 6
Using a dull, single colour for his suit emphasizes just how drab and boring this character's life really is.

STEP 7

Use highlights and shading to bring out the folds and bagginess of the suit. You want it to look as care-worn as the character.

● ARTIST'S TIP

Giving the character a slouched shoulder pose makes him look tired and worn-out, while the dropped pen and open-mouthed pose suggest complete despair.

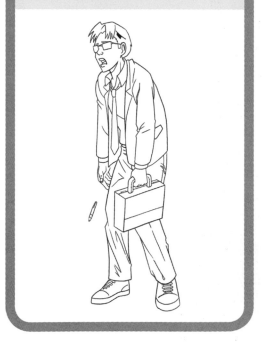

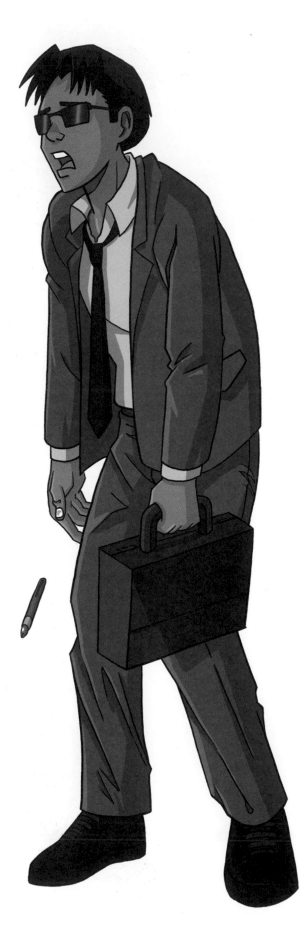

OLD LADY

Knowledge of the basics of structure can be used to create any type of character, as you will discover here. Our little old lady could easily have been morphed into somebody else. It took just a couple of steps to fix her identity.

STEP 1
Draw a basic stick figure of a short, elderly lady with both arms extended from the elbows.

STEP 2
Use cylinder shapes to give form to the lady's arms and legs, then draw the line marking the side of her neck and the basic shapes of her hands, which are resting on the handle of a walking stick.

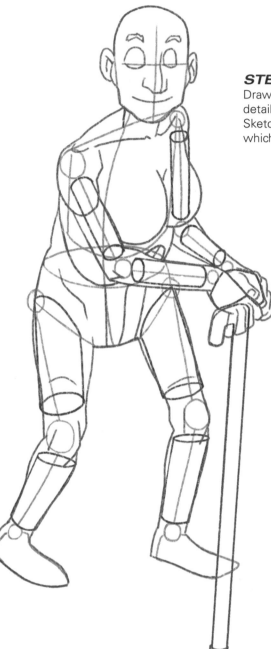

STEP 3
Draw your character's basic anatomical details – note that her body is quite stout. Sketch in her facial features and her fingers, which are wrapped around the stick.

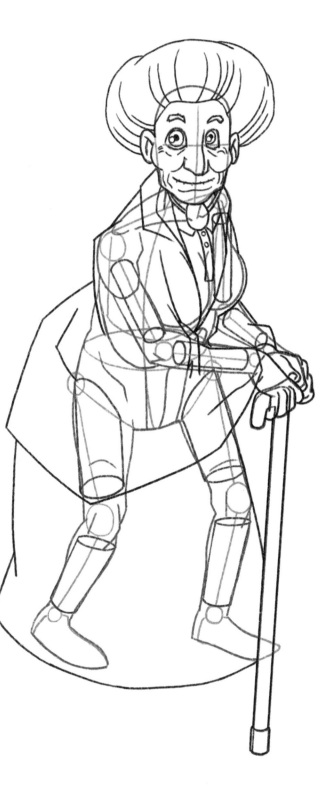

STEP 4
Give your character some hair and a blouse, a cape and a full-length skirt. Add details to her facial features and walking stick, then draw her necklace.

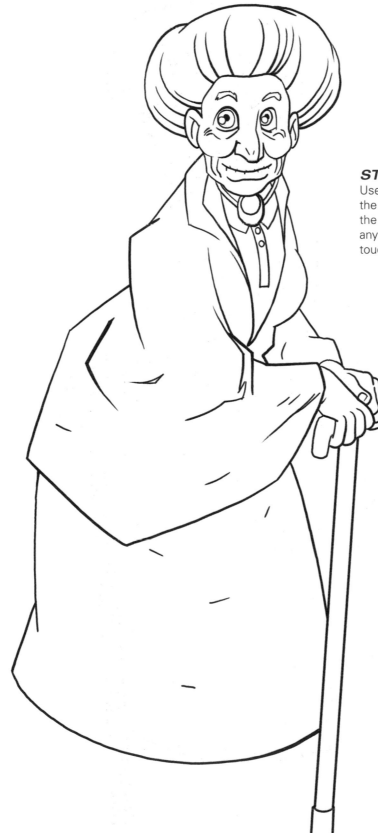

STEP 5
Use your lining pen to go over the lines that will be visible in the finished drawing, and erase any pencil lines. Put the finishing touches to her necklace.

STEP 6
We decided to use a single colour for her dress, but you could shade her top half in a different tone to create the effect of a shawl.

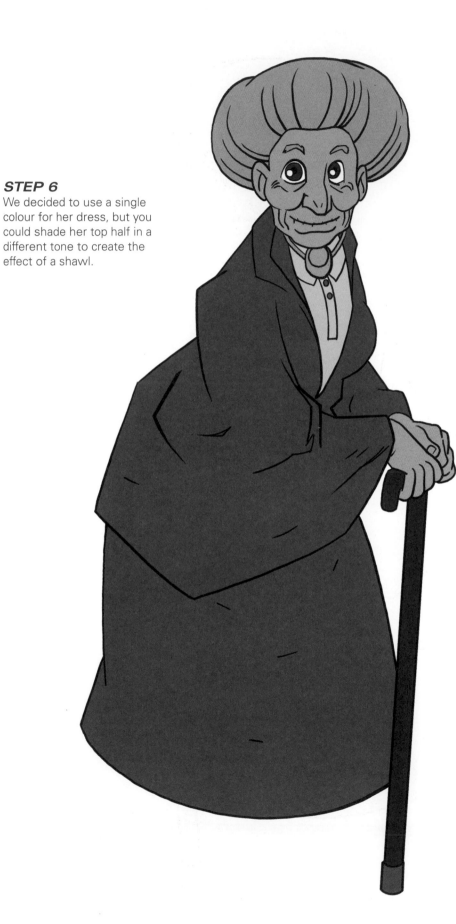

STEP 7
Notice how the shadowing helps to define the flow of her arm beneath the material.

ARMY GENERAL

We have given this mature military man a solid, strong body shape. For male characters you don't have to resort to rippling muscles on every part of the body to make them look impressive.

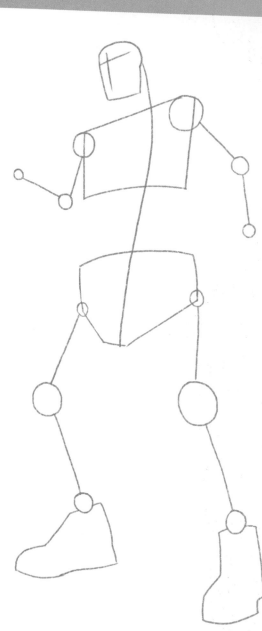

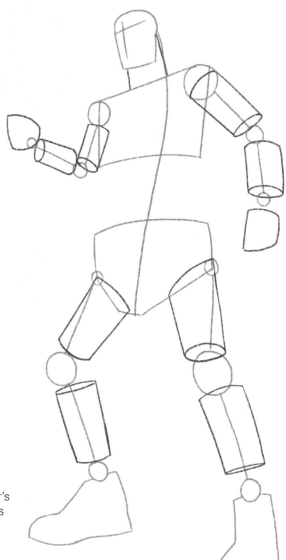

STEP 1

Draw a basic stick figure with his right arm raised from the elbow. We are looking up at this tall, imposing figure, so his legs and pelvis are large in comparison to his upper body and his eyeline is higher than normal.

STEP 2

Use cylinder shapes to bulk out your character's arms and legs, then draw the lines marking his neck and the basic shapes for his hands.

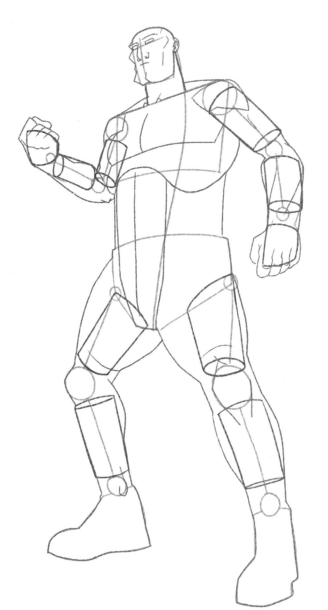

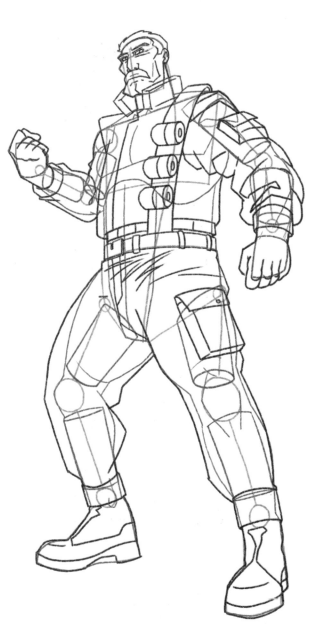

STEP 3

Draw in the muscles in his arms, legs and torso. Add his basic facial features – he has a craggy face and a cleft chin. Draw the fingers of his clenched fists.

STEP 4

Give your character some hair and a moustache, then add detail to his facial features. Draw his clothes, his belt and the shoulder strap holding his ammunition.

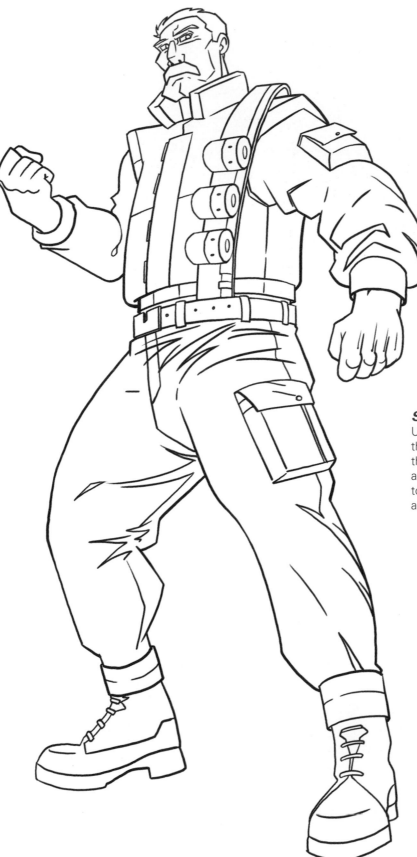

STEP 5

Use your lining pen to go over the lines that will be visible in the finished drawing and erase any pencil lines. Put the finishing touches to his clothes and accessories.

STEP 6

Loose material is also a feature of this character's clothing. You will have to pay close attention to the shadowing and highlighting at the next stage to bring out the folds.

STEP 7

Use shading to give depth to your character, bearing in mind the direction of the light when you are drawing the shadows.

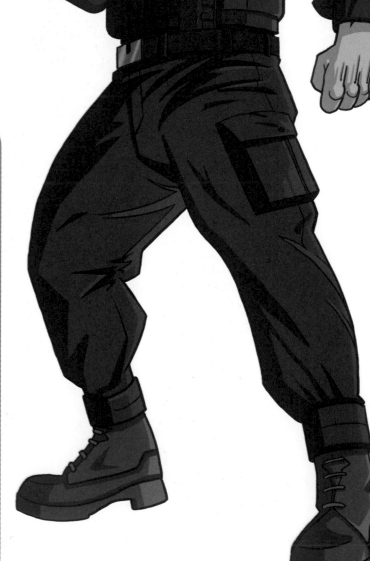

● ARTIST'S TIP

To enforce the impression that this is a leader of men, not only does the pose have to be slightly threatening but your perspective is from below so you are literally looking up to him.

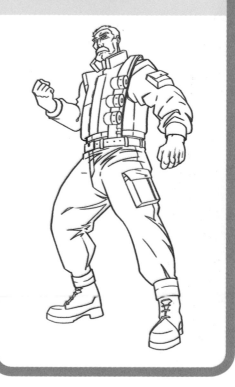

SHOPKEEPER

Not everyone in the world is six feet tall and devastatingly handsome. At first glance our shopkeeper might seem undistinguished but he's absolutely bursting with character, from his bushy moustache right down to his quirky little shoes.

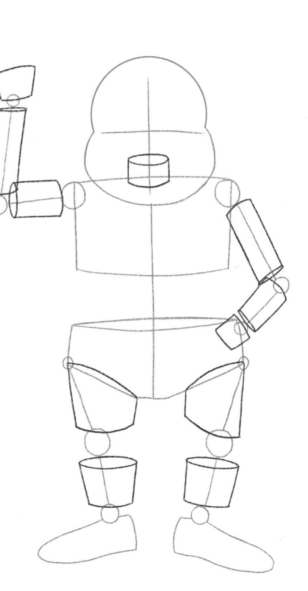

STEP 1
Draw a short, stocky stick figure with his right arm raised from the elbow and his left arm bent, with the hand behind his back. Both feet are turned outwards.

STEP 2
Use cylinder shapes to bulk out your character's arms and legs. His legs are short and wide. Draw a cylinder to mark the position of his neck, although this will be hidden behind his beard. Sketch in the basic shapes of his hands.

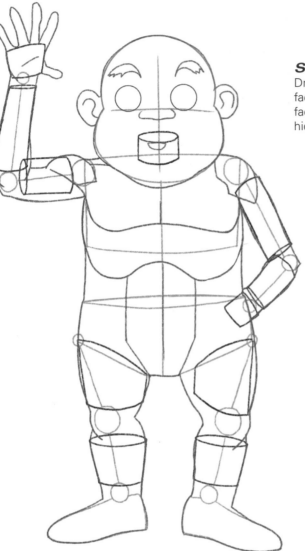

STEP 3

Draw your character's basic anatomical details and facial features. Draw his right hand with the palm facing forwards as if he is waving. His left hand is hidden behind his back.

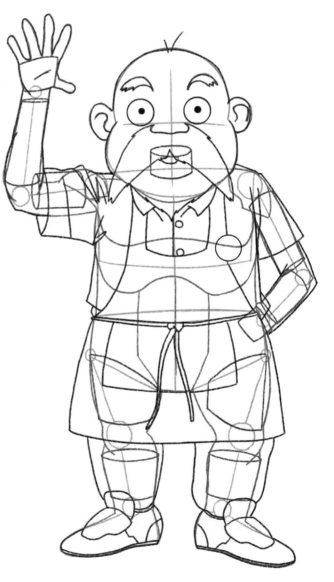

STEP 4

Give your character a tuft of hair, a large moustache and a pointed beard. Complete his facial features and draw his clothes, including his apron and badge.

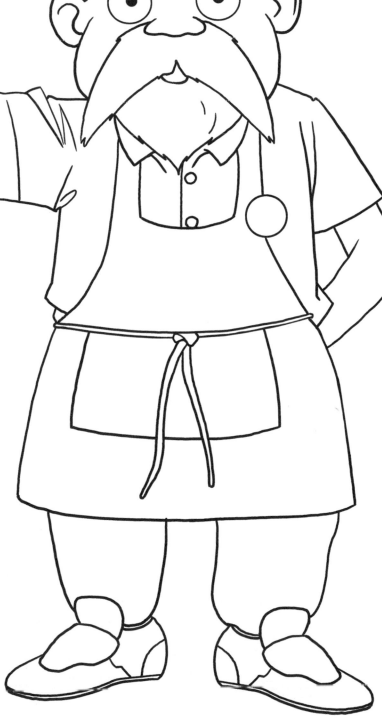

STEP 5

Use your lining pen to go over the lines that will be visible in the finished drawing, and erase any pencil lines. Add a couple of wrinkle lines above the shopkeeper's eyebrows.

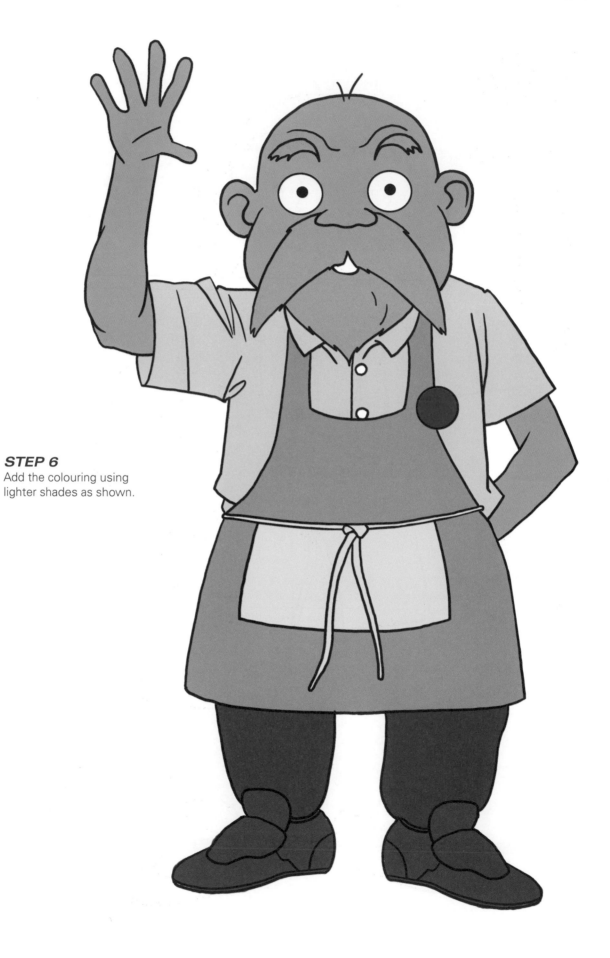

STEP 6
Add the colouring using
lighter shades as shown.

STEP 7
The light is coming from the shopkeeper's left-hand side. The curved shadowing on the front of the apron makes the character's stomach look round and chubby, giving him a friendly appearance.

SHARP-SUITED GANGSTER

The very angular and pointed style of this gangster gives him an overwhelming air of menace. Just looking at him you can tell he doesn't say much, but he's capable of heinous acts without a second thought.

STEP 1

Draw a basic stick figure of a tall man with his left arm hanging straight down and his right arm bent at the elbow. He is looking you straight in the face.

STEP 2

Use cylinder shapes to give form to your character's arms and legs, then draw the lines marking the sides of his neck and the basic shapes of his hands.

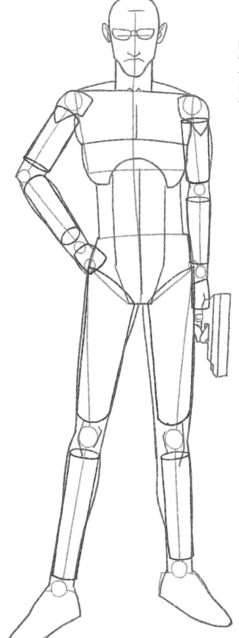

STEP 3

Draw your character's basic anatomical details and facial features. His eyes are hidden behind his glasses. Draw the gun in his left hand. The thumb and first finger of this hand are wrapped around the gun and his right hand is tucked inside his pocket.

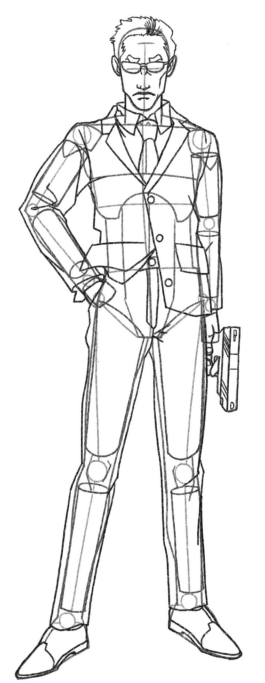

STEP 4

Give your character some hair and eyebrows. Add details to his facial features and gun. Now it's time to draw his suit, shirt, tie and shoes. Note how one side of his jacket is lifted up by his left arm.

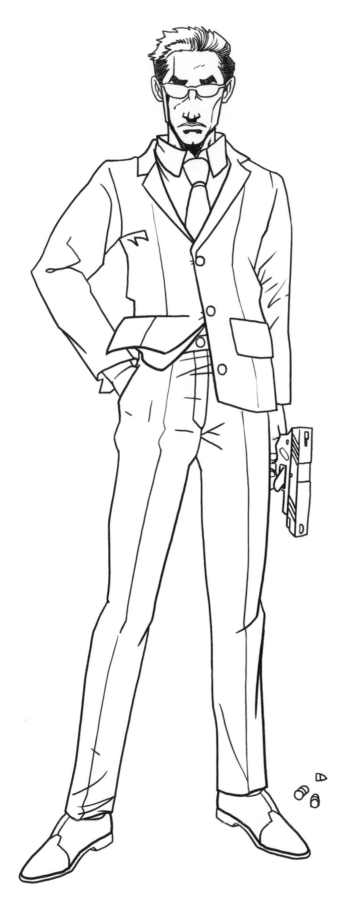

STEP 5

Use your lining pen to go over the lines that will be visible in the finished drawing, and erase any pencil lines. Colour the gangster's eyebrows and the sides of his hair black. Add a shadow under his chin and the creases in his suit. Draw the discarded bullet casings on the ground.

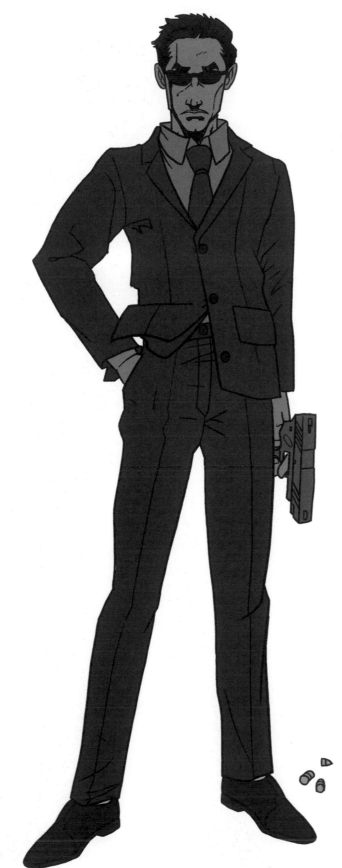

STEP 6
Put in the colouring of your character, as shown.

STEP 7

Use black and some dark colours to add shading. Use a light pen to add some highlights on his sunglasses and the edges of his suit where the light hits them.

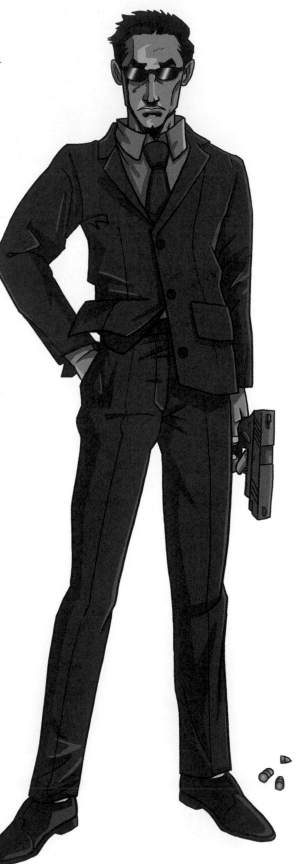

● ARTIST'S TIP

Using very sharp, straight lines for your shadows and highlights will help to make this gangster look even more angular and smart. This will add to the impression of him as a deadly professional.

POWERFUL PUNCHES

**We have already shown you how to add power and speed to your kicks (p.40).
Now we look at how to get the illusion of power into a punch.**

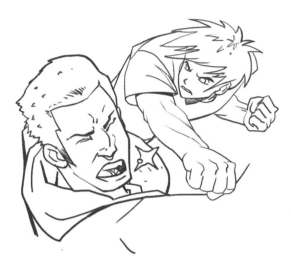

This punch looks like it hurts, but it lacks that real 'oomph' element.

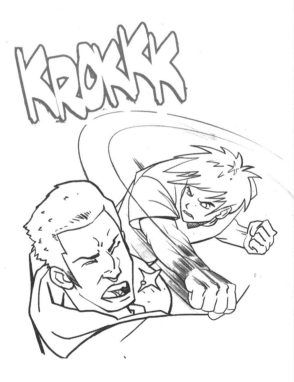

Movement lines and sound effects take this image on to a different level.

FLYING FISTS

Breaking the outline of the limb into motion lines, rather than giving it a solid edge, will help you sell the idea that the arm is in motion and travelling at some speed.

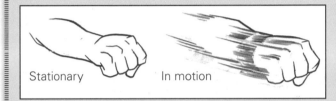

Stationary In motion

SWOOSH AND SOUND

Movement lines and sound effects lend excitement to fight scenes.

Swoosh lines show the direction of the punch and give the illusion of speed.

A large sound effect adds impact. You can make up words to fit the noises you hear in your fight scenes.

IMPACT AND DEBRIS

Impact flashes can help show the power of the hit. They are better used at the point of impact.

Small impact flashes.

Minor debris can imply blood or spittle.

COLOUR AND TONE

Even though manga was traditionally black and white, the popularity of colour manga has risen greatly in recent years, with computer programs now making colouring easier than ever.

 A key to good colouring, whether by hand or by mouse, is understanding how to use shadow and light to get the maximum effect, even if you are using a limited colouring palette.

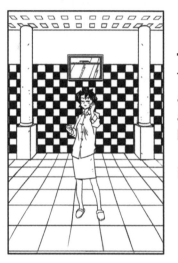

Talking tones

The majority of manga is still printed in black and white, so mastering the art of shading and achieving consistency with the light source is key to producing authentic-looking manga.

 Let's start with a strong black and white image.

We now need to add an imaginary light source to be able to throw shadows into the scene to help add form and depth. Here, our original image has had its light sources indicated to make things clearer before we move on to the next step. As you can see, the sources of the light come from the window on the back wall and from the holes in the roof.

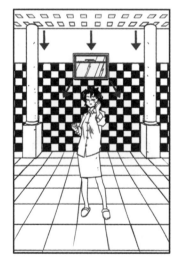

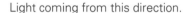

Light coming from this direction.

Light shadows cast here.

Darker shadows cast here.

Darkest shadows cast here.

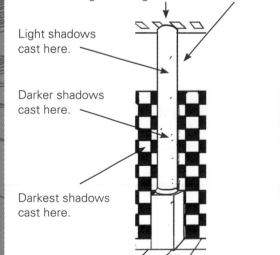

Anything the light hits directly will be left white, while anything that may be blocking the light will leave a shadow on the opposite side to that where the light hits the item. The further away from the light source the item is, the darker the shadow will be.

 Here you can see one of the columns from the back in the first panel without any shadowing and in the second panel with shadows added.

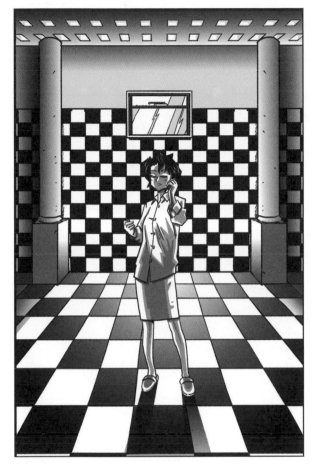

Here is the image with all its shading and toning added. Notice how the floor is lighter nearer the window where more light is being cast. Also notice how the shadows are cast across the floor from our character's legs, letting you know the light source from the window is stronger than the light coming from above.

When colouring, you have to take into account reflected light as well as the various light sources.

Reflected light is a secondary light source provided by the lighting from your main source bouncing off the environment. The shadows created are less strong than where the light is being blocked by an object.

The entire image with the line work removed and just the shadows on show almost creates a complete image on its own.

● ARTIST'S TIP

What you have learned about shading can easily be applied when you're working in colour, by using different tones of the same colour to add shadows.

Set yourself three darker shades of colour for your three levels of shadow depth and use only those shades until you feel confident blending between the different tones.

Lighting faces

When you're lighting faces, think about the materials that surround your character and the amount of light they would reflect. Below are some of the usual ways of lighting faces, showing you the sources of the main lighting and the sources of the reflected light and their effects.

➡ = *MAIN LIGHT* ➡ = *REFLECTED LIGHT*

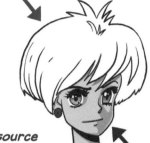

Main source from upper left; reflected light from lower right

This is the most basic and popular way to light a face.

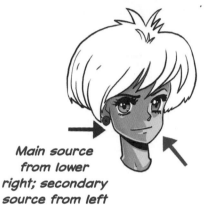

With most of the face blocking the light, there is minimal reflected light. A subtle secondary light source coming from the left adds a highlight line to the jaw.

Main source from lower right; secondary source from left

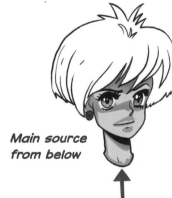

Main source from below

Heavy shadows are created on the face as it blocks almost all of the light. This approach is ideal for giving your character a creepy look.

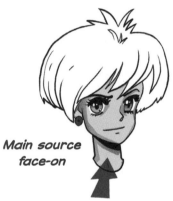

A light source pointing directly at a character creates few shadows. This approach saves time when colouring but is dramatically limiting.

Main source face-on

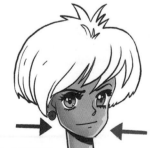

Main source from behind; reflected light from right

Here most of the face is in shadow. A subtle degree of reflected light produces highlights on the jawline, creating an ominous mood.

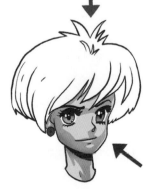

A main source from above gives minimal reflected light from below. A second, subtle light source adds more definition. Knowledge of anatomy is necessary for this kind of lighting to work successfully.

Main source from above; secondary light from right

COLOURING STYLES

Here are the different stages you can take your colour through. When it comes to colouring manga any of these styles are acceptable, depending on the amount of detail you want to include, from flat colour to fully realized colour with complete shadows and highlights.

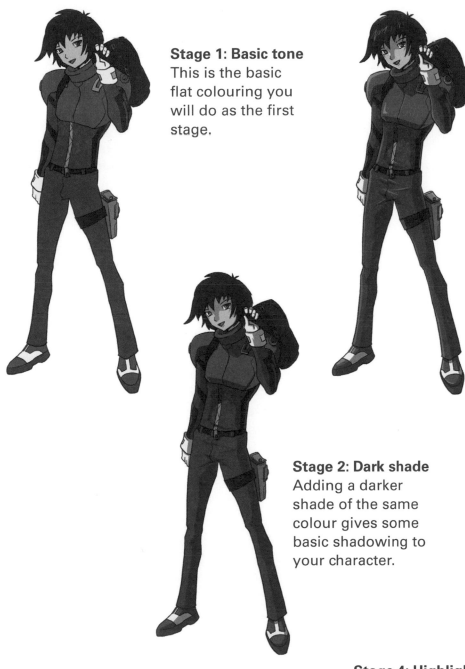

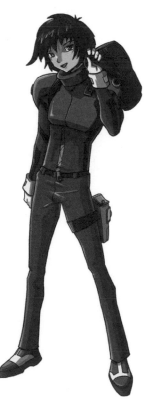

Stage 1: Basic tone
This is the basic flat colouring you will do as the first stage.

Stage 3: Light shade
Adding lighter shades of the same colour at certain points gives more definition and a touch of three-dimensional quality.

Stage 2: Dark shade
Adding a darker shade of the same colour gives some basic shadowing to your character.

Stage 4: Highlights and shadows
Extra highlights at selected points create a fully defined character with a much more solid look overall.

COMPOSITION

The term 'composition' refers to the design of your picture – how the individual parts that make up your piece of work are arranged and interact with each other to create an effect. Good compositions have a massive impact on your viewers and the experience they take away from your art.

When you're composing an image, preplanning will save you a lot of problems and possible messy revisions later on. Before you start drawing, you should think about your image as a whole. Try to picture in your mind what you want your finished image to look like and remember to include any background, focus lines and speech bubbles.

Your next choice is whether your image will work best in portrait (vertical) or landscape (horizontal) format. Portrait can be used to bring focus to an intense character moment, while landscape is good for portraying fast-moving action or large scenes with detailed background elements or many characters. Either panel format can be used as you please – that's what keeps your art interesting.

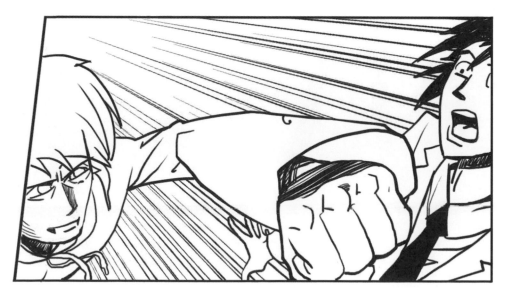

Breaking the image into thirds makes it far more interesting visually and suggests much more going on in your piece.

Rule of thirds

An image that is divided into two halves – for example, where the horizon line is exactly halfway down the composition – tends to be boring.

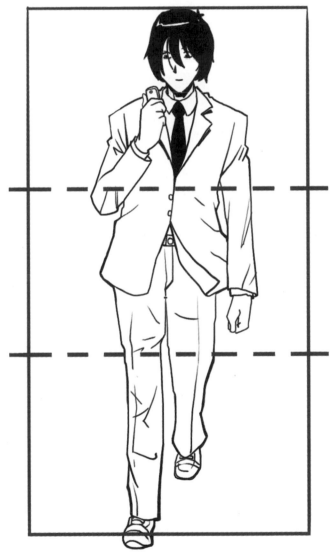

The rule of thirds can also be applied using the character's body and clothing to form the divisions in the image.

Thumbnails

An ideal way to plan out your image before committing to fully drawing it is to use thumbnails.

These are simple rough sketches, often with stick figures, that help you to plan out your image on paper before you move on to doing your final artwork. Here are some examples of thumbnail scenes.

BASIC THUMB

MORE DETAILED THUMB

Focal points

When planning an image it's also important to think about the focal point – the specific part of the image you want the viewer's eye to be attracted to. This could be a character's eyes that display emotion, a weapon or item they are holding that is important to the plot of your story, or even something as seemingly unimportant as a switch on a control panel.

You can do some of this by using focus lines (see pp.36–7). You can also use perspective and foreshortening (see pp.32–5). Other ways include making a character's clothing folds or body position flow towards the element you want to draw attention to.

Using thumbnails is an excellent way to work out what you will need to do to pull the focus towards the element you want to feature.

Showing less of the overall body and head draws the reader to the character's eyes.

Using foreshortening to bring the arm closer to the viewer and making the item break out of the panel will draw the viewer's gaze towards the object in the character's hand.

Negative space

Negative space can become an artist's greatest friend if used correctly. This term refers to the space immediately around the subject you are drawing, as opposed to the subject itself. Negative space can be used in conjunction with backgrounds and other images to help form shapes that push focus in the direction you want.

Negative space can also be used when it's reversed to add interest to your images. If you think of a silhouette of someone's profile, this is a great use of negative space, as it creates the image by outlining the main character without actually showing him or her.

Paying attention to the area directly around the image you are drawing will give you many opportunities to add to your artwork by using negative space.

Focus lines draw your eye to the character's hand without breaking out of the panel.

PLACING YOUR CHARACTER INTO A WORLD

Although manga uses a lot of backgrounds that consist only of focus lines and often panels with no background detail at all, you will still need to be able to place your characters into locations to give your story context.

The mistake many artists make early in their work is to fail to match the perspective and size of their characters to the location they place them in.

By using perspective correctly and approaching elements of your scene as individual blocks, you can avoid having backgrounds that look wrong and out of perspective with your creations.

One way of making an image is to draw your characters first, then add the background around them. However, this can cause problems if you wish to place your character behind, or interacting with, other elements in the image, unless you considered these before you started drawing and adjusted your character's pose accordingly.

Another way is to approach the scene as a whole, creating your character and the background at the same time. This allows much more creative freedom to adjust the scene to perfectly fit a character.

BAD PERSPECTIVE

GOOD PERSPECTIVE

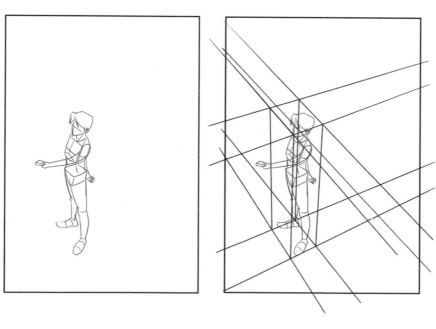

Building your background

Place a rough outline of your character on the page at the size you want him or her to appear.

Lightly draw a box around the character then, using a ruler, extend the edges of the box out. Add an extra line (shown in red) to denote your character's eye level.

EVERYTHING COMES IN BOXES

If you imagine that every item you are placing has its own box around it like your character, scenes can be created as if you were using building blocks to make your image.

You now have your perspective guidelines and can begin placing items in the scene using the guidelines to ensure everything works in the correct perspective.

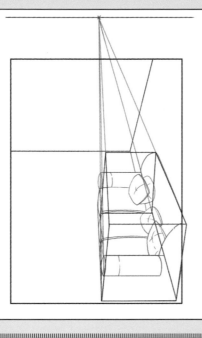
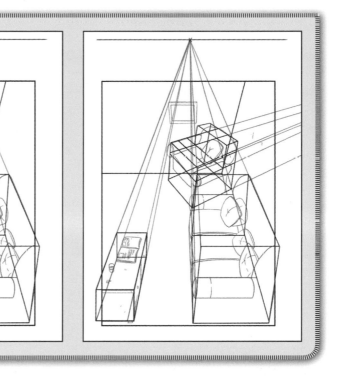

HANDLING THE CUTTER

If you find your scene is becoming overcrowded or confused with all your construction lines, simply complete the items that are in your way so they are ready for inking, then erase their guidelines and move on to the next item in your scene.

Once you have removed your construction lines you can add shading to complete your image.

BUILDING BETTER BACKGROUNDS

Your backgrounds will engage the viewer if you think of them as another character in your story. Always be specific in what you portray and make it appropriate. By doing this you will make your world believable.

Detail is key
A battered waste bin might fit your story line better than a pristine one.

A table in a private eye's office would look more realistic with stains and dents than one that looks perfect.

Everything matters
Look at these two pictures of a seedy backstreet. Which do you think looks more like the sort of street you'd find a dangerous gang member hanging out in?

What's over there?

Try not to limit your backgrounds to what is immediately apparent. Use the distant background area to hint at something more going on beyond what you can see.

There are a number of tricks you can use:

Here a toned background suggests further depth.

This road leads to other areas out of the reader's view.

Layered toning adds more depth on various planes of vision.

Less can be more

There's no need to include a fully drawn background on every single panel. Try to include one per page to let your reader know the location where the scenes are set, but also use different angles and close-ups in the other panels, where you can include selected pieces from your overall background.

PANELS AND LAYOUTS

No matter how amazing your art, if you don't lay out your panels correctly on the page all your work will be for nothing. Your story needs to flow from panel to panel so the reader can move through it smoothly and coherently, while at the same time not being overwhelmed by too much information on each page.

Before you start drawing the panels for your comic, plan your layouts by sketching them out roughly on a piece of paper.

The width of the gutters between the final panels is important in order to use negative space for clarity on your page. While horizontal gutters don't need to be the same width as vertical ones and panels can be any shape, make sure that all the horizontal gutters are of equal width and all the vertical gutters also match each other.

Bad – uneven gutters *Good – even gutters*

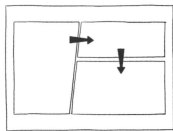 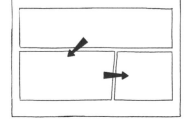

Make sure your panels flow correctly. Once you have sketched out your panels, see where your eyes are naturally drawn to when looking at the page and make sure this follows the flow of your story. Show the page to friends so you can check that their eyes also follow the same path.

Layouts

Just as important is working out the layout and flow of your story. If you don't plan this the reader will become confused and lose interest.

In deciding how you want your story to flow, bear in mind where you will need establishing shots and where you may need larger panels for impact.

Make sure you include at least one panel on the page which shows a detailed background whenever you change scene. This helps the reader to understand where the scenes are taking place and also means you don't need hugely detailed backgrounds in every panel.

Don't try to put too much in a panel at once. Trying to include an entire student's room in a single panel, for example, will make it confusing.

Instead, show a portion of the room from a certain angle then, as you move the story through the panels, show different views of the same room.

Transitions are important to your story. Never jump between scenes you have not introduced before. For example, having two characters talking to each other in what your reader knows from the establishing scene panels is a park, then suddenly jumping to another character on a phone in a completely different location, will only confuse. Instead, use an extra establishing panel – see below.

The golden rule is: don't assume your reader knows the flow of your story. If you haven't told them something, they cannot guess what you were thinking when you drew your layout!

FROM PICTURES TO WORDS

Speech is handled a little differently in manga from how it is seen in Western comics. Many mangas read from right to left rather than left to right, and they feature a lot of vertical text rather than horizontal, since they follow the traditional Japanese way of writing.

Whereas Western speech and thought bubbles have a small 'tail' to show who is speaking or thinking, manga 'tails' tend to be more delicate or even completely absent. To distinguish between characters, their speech bubbles may have differing shapes to each other, with the edges changing shape to reflect the tone of voice.

However, as manga has gained in popularity, much of it that is produced outside Japan follows the standard Western convention of text layout. Whether you choose original or Western layouts is up to you. Remember, though, when

adding your speech bubbles, that a lot of manga uses its characters' faces and situations to convey emotions, whereas Western publications prefer to spell out in the text what their characters are thinking and feeling. This is an important point when you are considering your text for your manga comic.

Manga sometimes overlaps speech bubbles into the next frame as a way of visually guiding the reader through the page or giving an overall visual flow to the page. This is something to remember when planning out your speech placement.

THINK WORDS AND PICTURES

When planning out your comic page, remember that the words are as important as the imagery in a lot of stories, so make sure you leave space for your text, even if it involves doing complete mock-up pages with speech bubbles indicated. This will ensure you have enough space to fit everything in without having to make adjustments to your art later on.

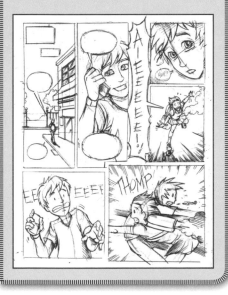

Here's a selection of speech and text bubbles used in manga.

STANDARD BUBBLE

This is used for the majority of speech, but remember that it can be shaped for each character.

ANGER BUBBLE

This is for occasions when a simple exclamation mark just doesn't get across the intensity of the conversation.

THOUGHT BUBBLE

While it is used in some manga this is a more Western approach, as thoughts are often represented in manga as text without a bubble.

SQUARE BOX

Used for giving information and exposition about plot and location, this can also convey a character's internal monologue.

TRIPLE DOT

This speech bubble is used when a character has nothing to say or is speechless in reaction to something. It can also denote that a character is thinking.

THE FINISHED PAGE

Here is a complete page using what you have learnt in this book to give you an idea of what is achievable when you put everything into practice.